BAROQUE AND ROCOCO

BAROQUE AND ROCOCO

Germain Bazin

NEW YORK AND TORONTO
OXFORD UNIVERSITY PRESS

TRANSLATED FROM THE FRENCH BY JONATHAN GRIFFIN

© 1964 THAMES AND HUDSON LTD, LONDON

Library of Congress Catalogue Card Number 64–22488

All Rights Reserved

Printed in Great Britain

Contents

Introduction

The belief in the absolute value of the Classical conception of art, a prejudice established by the Renaissance and revived at the end of the eighteenth century in the movement known as the 'Neo-Classical', caused every departure from that kind of art to be considered inferior. One result has been that some of the great styles created by Western civilization bear names that at first were terms of contempt: Gothic, Baroque, Rococo. Among the various meanings of the word 'baroque', the one that seems to have been chiefly current among artists and theorists of art goes back to the term used by jewellers in the Iberian Peninsula to denote an irregular pearl – so that 'baroque' meant 'imperfect'. As for the word 'rococo', it was common in the workshops of the French cabinet-makers in the second half of the eighteenth century, as a term for the sinuous and fretted forms of Louis XV furniture.

The word 'rococo' has remained attached to eighteenth-century art, but 'baroque' has acquired a much wider acceptance. Modern theorists of art have been inclined to discern in Baroque art a formal value resulting from a vital attitude, whose character is to some extent complementary to the Classical, so that the whole history of forms might be summed up as an alternation of Baroque and Classical. The German theorist Wölfflin has described the formal characteristics of each of these two tendencies. Classical art does not turn its back on nature – it is an art of observation, but its aim is to go beyond the disorder of appearances and to seek that deeper truth which is the underlying order of the world. Classical compositions are simple and clear, each constituent part retaining its independence; they have a static quality and are enclosed within boundaries. The Baroque artist, in contrast, longs to enter into the multiplicity of

6

phenomena, into the flux of things in their perpetual becoming – his compositions are dynamic and open and tend to expand outside their boundaries; the forms that go to make them are associated in a single organic action and cannot be isolated from each other. The Baroque artist's instinct for escape drives him to prefer 'forms that take flight' to those that are static and dense; his liking for pathos leads him to depict sufferings and feelings, life and death at their extremes of violence, while the Classical artist aspires to show the human figure in the full possession of its powers.

The object of this book is not to discuss the value of these theories; it is to study the art of the West in the seventeenth and eighteenth centuries. This art is known by the generic name of 'Baroque art', although it includes expressions of Classicism side by side with those of Baroquism. 'Baroque *style*' applies more particularly to the art of the seventeenth century, and the term 'Rococo' to that of the eighteenth.

Baroque began towards the end of the sixteenth century, and had its first impulse from Italy. Rococo suffered a counter-attack from Neo-Classicism, to which it finally succumbed in England, France, and Italy in 1760 or thereabouts. None the less, at a distance from the creative centres, in the more remote regions of which Western civilization took possession, especially in Latin America, Baroque continued for some years after 1800. The absence of co-ordination in time between the various styles practised in Europe is a remarkable phenomenon of seventeenth- and eighteenth-century art. Various styles exist simultaneously in neighbouring regions, sometimes in the same country. At a given moment different arts may not be in step. Sometimes architecture is moving towards Classicism, while the minor arts are Baroque. And yet the general tendency of the period was towards a unity including all the arts in a single expressive purpose, convergent towards a single aim. This tendency was realized to the full in the Versailles of Louis XIV – and again in German Rococo, which may be considered as, in a way, the apotheosis of the

Baroque. But at this very moment Italy, France, and England were tending to detach themselves from the Baroque and to develop towards a new form of the Classical idea of art, which was called Neo-Classicism and took its inspiration from the art of antiquity, now known more directly and closely through the discovery of the cities of the Campagna and Sicily – and soon of Greece and the Middle East also. Neo-Classicism was the culmination of that Classical idea of art by which some artists had always been inspired even during the full effervescence of the Baroque, and which was indeed the dominant idea of French aesthetics and the one to which English aesthetics aspired. This never prevented France and England from continuing with forms of expression that were frankly Baroque, though without being really conscious of this, for consciousness of a Baroque idea of art opposed to Classicism came later – in the seventeenth century the leading Baroque artists were convinced that they were highly respectful towards antiquity. To try to reduce this period to a phenomenon of bipolarity, Classical versus Baroque, would be vain; there are works of art that cannot easily be fitted into one or the other of these concepts, witness the realism practised by most of the Dutch painters.

The so-called Baroque period is in fact the period of Western civilization that is richest in expressive variety – it is the moment at which each of the peoples of Europe invented the artistic forms best fitted to its own genius. The variety was increased by an intense traffic and interchange of forms; never had Western civilization known such active international exchange in the intellectual field. This internationalism was not checked by the differences in religious belief – in marked contrast with the nationalism of the next century, in which creative artists were to live confined within the narrow circle of the culture of their own country (Delacroix was to be a French – more exactly, a Parisian – painter, as against Rubens, who worked in Italy, France, Spain, and England, and was a European painter).

The political antagonisms that result in wars (indeed the effect of war itself was limited in the eighteenth century) created between the nations no opposition on the plane of civilization and culture. This effervescence of artistic exchange began in the early part of the seventeenth century. Rome was then the point of attraction for the whole of Europe, as the School of Paris was to be during the first half of the twentieth century. Flemish, Dutch, and German artists came to Rome to study the masterpieces of the Renaissance – and soon also those of the modern artists; and it was not long before this stay in Italy, considered essential to a complete artistic education, was encouraged by official institutions. By the end of the reign of Louis XIV, although the movement towards Italy had not slowed down, France in turn was beginning to be the object of considerable interest. In the eighteenth century Italy and France supplied the rest of Europe with a large quantity of 'specialists' who brought to the countries that welcomed them the forms of 'modern' art. This exchange of influences was equalled only by the recipients' power of assimilation. The French or Italian origins of German or Russian art were soon made unrecognizable by the transformation which the artists imposed on them. These original forms soon lost their national characteristics and were absorbed into the new environment.

Travelling, at this time, was not prevented by its inconvenience, and its slowness was more favourable to a thorough knowledge of the countries visited than is the extreme speed of transport nowadays. By the end of the seventeenth century it was generally agreed that every cultivated man must complete his education by a tour of Europe, which would give him first-hand knowledge of the diverse forms of its civilization. Princes and members of the *bourgeoisie* took to the road, visited the cities, and were received at the various Courts while the intellectuals exchanged an active correspondence which, in the scientific field, prepared the way for the scientific periodicals. They often responded willingly enough when invited to the Court of a prince, even in a foreign country. Catherine II had her philosophers,

Diderot and Grimm, and Frederick II had his, Voltaire – as in the preceding century Christina of Sweden had entertained Descartes.

The seventeenth and eighteenth centuries saw the climax of the system of government based on the absolute power of a monarch belonging to a family that claimed power by Divine Right. In the Catholic countries this conception mingled naturally with the prevailing religious faith. The country in which this alliance between the Divine and the Monarch was most completely realized was Austria – there, though no longer more than a symbol, the idea of a Germanic 'Holy Roman Empire' was still alive in men's minds. In France, on the other hand, the conception of monarchy was much more secular. And indeed the idea of the Divine Right of Kings was not dominant throughout Europe – it received a rude shock in England, where Parliamentary monarchy came into being; and the Low Countries, wresting their autonomy from Spain, had set up a régime which, though authoritarian, was also democratic. It is certain that the idea of Divine Right, both religious and monarchical, encouraged the sumptuous display of which there was so marked a lack in *bourgeois* Holland. But the intense need for creative art had a deeper cause; this was a longing for escape, a kind of flight into the imaginary, in contrast with the progress made during the seventeenth and eighteenth centuries by Positivism in the exact sciences – and soon also in the moral sciences. No other period so clearly contradicts the theory of Taine, according to which art is strictly determined by environment; for no artistic civilization has been so fertile in contradictions, in paradoxes. These reflect its prodigious variety and the expansiveness of its creative impulse, which are without parallel at any other moment in the history of art.

Seventeenth-Century Italy

It was Italy that created the system of formal values proper to the art later known as Baroque. This was worked out in the artistic circles of Rome and Bologna in the years round about 1600; that is, during the pontificates of Sixtus V (1585–1590) and Paul V (1605–1621). The Church, though it had lost an important part of the territories of Europe to the Reformation, drew a sense of triumph from the fact that it had managed to preserve from heresy the Catholic dogma, which had been clearly defined by the Council of Trent. In spite of its losses the Church had a lively feeling of its universality, strengthened by its expansion over all parts of the world, into regions till then unknown to the West, where its missionaries were fighting a spiritual battle to convert the natives to the Christian religion.

Having renounced the dreams of temporal hegemony that had haunted some of the Renaissance pontiffs, the new popes transferred the will to power to a spiritual empire, whose grandeur must now be reflected by Rome, its capital. They felt that they were, in a way, the heirs of the Roman emperors, and they wished to revive, in the Eternal City, the grandiose style of ancient Rome. This revival was all the easier to accomplish since the artists looked for their examples to the works of art of ancient Rome (those of Greece being almost unknown to them). These examples, found in Hellenistic or more often in later works, encouraged them to elaborate that 'oratorical' style which was natural to the programme of apòlogetics or propaganda allotted by the Council of Trent to religious art. Its task was to state

the grandeur of the Catholic Church by producing impressive monuments – but also, by all the means that lay in the power of the figurative arts, to attest the truth of the Faith.

The transformation of Rome into a Papal city had been begun by the Renaissance popes. The first major step had been the rebuilding of St Peter's as the central church of the Catholic faith – a conception due to Pope Julius II. Then, at the time of the Counter-Reformation, certain popes, notably Sixtus V, aided by the genius of such architects as Domenico Fontana, had planned huge straight streets which would lead the eye to churches – or to obelisks taken from the ruins of ancient Rome – and would doubtless at the same time make easier the movement of the crowds caused by the pilgrimages. Under the pontificates of Urban VIII (1623–1644) and Alexander VII (1655–1667) the master, more or less, of the town planning of the Eternal City was Bernini, and at this time the grandiose plans of Sixtus V were realized. A great number of palaces, churches, and colleges were built – together with monasteries and convents for the new Orders brought into being by the Counter-Reformation, the most active of which was the Society of Jesus. New squares and streets were made. But the chief work of the popes was St Peter's and its surroundings. For the church itself, the central ground-plan, once so dear to Julius II, Bramante, and Michelangelo, was rejected; its significance as symbolizing the universality of God had been acceptable to the Church, but was now considered as of pagan inspiration. The feeling of a return to the great period of early Christianity, when the Church was triumphing over paganism, gave a new value to the old basilical ground-plan, which was also better fitted to the practical needs of worship. In 1605, therefore, a colossal nave with side aisles and an imposing narthex were added to St Peter's by the architect Carlo Maderno. Bernini later worked on this framework, to give it a sumptuousness worthy of the old Christian basilicas; to this end he covered the walls with a polychrome decoration of marbles, stucco, bronze, and gold, peopled it with huge statues by himself and others,

and devised liturgical furniture of bronze on a scale commensurate with the monumental building (*Ill. 11*). At the far end of the church the *Cathedra Petri* (Throne of St Peter), borne up by the four Doctors of the Church (*Ill. 2*) rises before a golden Glory (1647–1653). This had been preceded by the *baldacchino* (1624–1633) above the Tomb of St Peter: its form was taken from that of the ciborium of the early Christians, but enlarged to gigantic dimensions – it is eighty-five feet high – and having a new feature, the use of twisted columns, known as 'solomonic'. Bernini took their shape from some fourth-century marble columns surviving from the Basilica of Constantine – and indeed used these columns themselves in the decoration added by him to the piers which stand about the *baldacchino* and support the cathedral dome. Another early Christian element, the parvis or *atrium*, was the inspiration for the gigantic *piazza* built by Bernini in front of St Peter's (1657–1666), into which the crowds could come to receive the benediction *urbi et orbi*; but here, as elsewhere, the artist made an innovation by giving this *piazza* an oval shape and surrounding it with colonnades that have four ranks of Doric columns (*Ill. 1*).

Italy was then the cynosure of Europe. During the first half of the seventeenth century its princely Courts set the tone of civilization, and for the Northern countries just emerging from the horrors and brutality of the wars of religion it held up the example of the refinements of civilized life. Adorned with the prestige of the excavated masterpieces of the ancient world and the masterpieces of Michelangelo and Raphael, Rome attracted artists from all countries. They were drawn, too, by the new work that was being carried out there. Some of them – such as Rubens and Van Dyck from Flanders, Van Baburen and Terbrugghen from Holland, Elsheimer from Germany, and Simon Vouet from France – stayed in Rome for long periods and took back to their countries the principles that would help them to move on from Mannerism. Others – such as the Frenchmen Poussin, Claude Lorraine, and Moïse Valentin – established

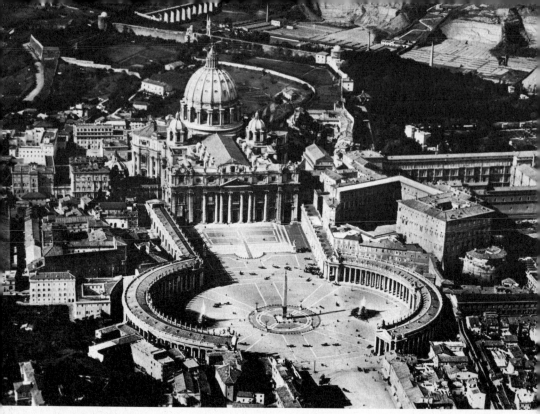

1 St Peter's from the air showing the Piazza and Basilica. As transformed by Maderno (who added a nave to Michelangelo's central plan on orders from Pope Paul V), St Peter's resumes the theme of the old Basilica of Constantine. The great space before the cathedral is the work of Bernini, a Baroque re-interpretation of the Greek or Roman *atrium*. The Church was anxious to return to early ideas, as this shows.

themselves in the Eternal City and became part of the Roman School, which, with the distancing effect of history, now seems comparable to what the School of Paris was to be at the beginning of the twentieth century.

ARCHITECTURE

The Italian architects of the seventeenth century were faced by a vast volume of orders to carry out. The buildings most required were churches. These were constructed on a great variety of ground-plans, the commonest being that with a single nave, lateral chapels, and a

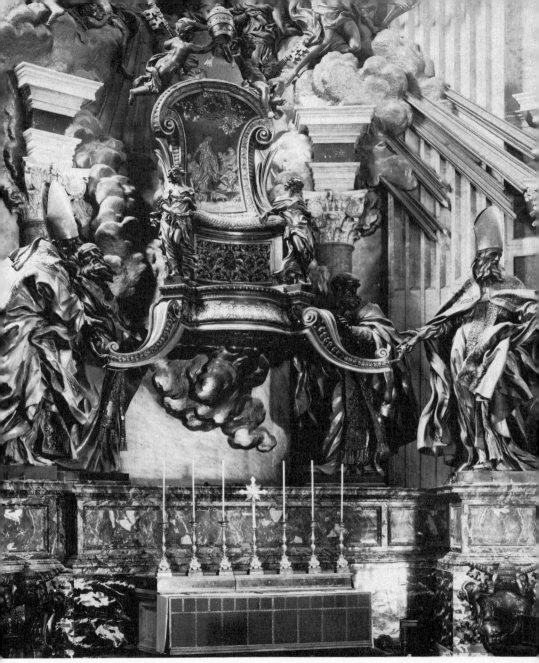

2 Detail of the *Cathedra Petri* or Throne of St Peter, from St Peter's, which was begun in 1656 by Bernini in bronze, marble and stucco on the orders of Alexander VII. The humble relic of a wooden stool was given the most sumptuous of Baroque settings in which the unity and universality of the Catholic Church were reaffirmed.

simple apse – but a large dome over a crossing with low transverse arches. This was the plan which, in the preceding century, the Jesuits adopted for the Gesù in Rome (built by Vignola and Giacomo della Porta from 1568 to 1577), because it had the merit of collecting the faithful in the single nave, so bringing them within easier reach of the pulpit and associating them more closely with the ceremony of the Mass (*Ill. 3*). The two architects gave this church a façade with two storeys of columns, corresponding well to the compact ground-plan. Both the plan and the façade of the Gesù were to become very popular throughout the Christian world; yet even with the Jesuits they were not adopted exclusively. The basilical type with side aisles to the nave, though less common, was not abandoned, and architects took pleasure in devising (chiefly for churches of relatively small size) more complex ground-plans – oval, circular, or in the form of a Greek cross – in an effort after fresh combinations of surprising effects (*Ill. 4*).

Rome had inherited from Florence the palace closed in like a fortress, a quadrilateral built round a *cortile*, of which the finest example in the preceding century had been the Palazzo Farnese by

3 The Gesù, Rome, was begun in 1568, on designs by Vignola. Its plan is a synthesis of the central plan (established by the grand scale of the dome) and the basilical plan (reduced, however, to a single nave, the aisles being replaced by chapels).

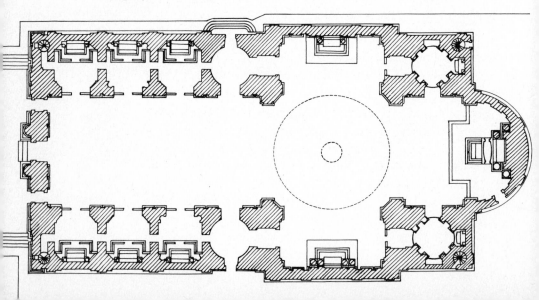

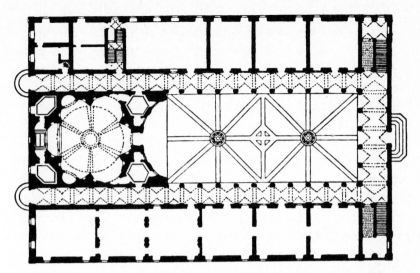

4 Plan of S. Ivo della Sapienza, Rome. Francesco Borromini had a passion for springing curves and counter-curves and for varying his space endlessly: he thus achieved a great wealth of architectural expressiveness, even in buildings of modest dimensions.

Antonio da Sangallo the Younger. This type remained the most frequent, though with façades now covered with Baroque ornamentation. The articulated plan of the Palazzo Barberini at Rome (*Ill. 5*), no doubt by Bernini, in which the block of the building is divided to form an H, remains an exception.

The country-house, successor to the villas of the ancient Romans, had reached its height in many fine examples during the sixteenth century, when it had been one of the principal productions of the Mannerist spirit. In these the house, or *casino*, faced a terraced garden whose figurative and allegorical programme symbolized the association of the prince with the forces of nature. This architectural theme was continued in the seventeenth century, with a tendency to give the *casino* itself a more monumental style, and on occasion to allow an artificial world of statues to mask nature. The finest of these palaces are near Rome at Frascati, a place already much used by the ancient Romans as a refuge from the city.

17

Among the many kinds of buildings constructed in Italy in the seventeenth century, the greatest originality is to be found in the theatres. Palladio, at the end of the previous century, had shown the way by reviving the Roman *odeon* in his Teatro Olympico at Vicenza, which was designed for performances of the plays of antiquity. This form was developed and adapted to opera of a spectacular kind, which required large stages capable of accommodating the now fashionable changes of scenery in full view of the audience – and also to give the spectators greater comfort by placing them in semicircular tiers of boxes. Rome at the time of Bernini developed a stage that could house the new machinery; the boxes were introduced in Venice.

5 Façade of the Palazzo Barberini, Rome, whose elevation was derived from Sangallo's courtyard of the Palazzo Farnese. Here, however, the Classical device of placing the orders in tiers has been given a Baroque twist by means of richer ornamentation and a trick of perspective.

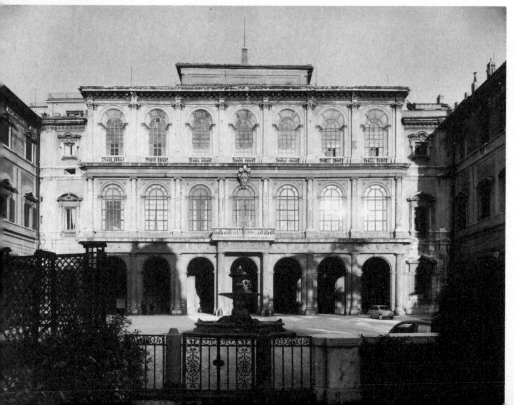

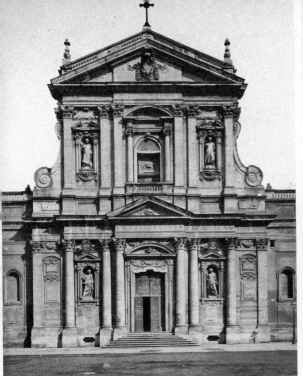
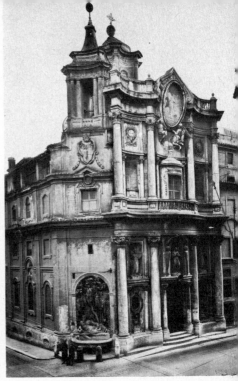

6 The façade of the church of S. Susanna, Rome, is derived from that of the Gesù, which Carlo Maderno had enriched with more sumptuous decoration; but it retains the correctness of Classical elevations.

7 In his façade for S. Carlo alle Quattro Fontane, Rome, Borromini breaks with the Classical elevations by the play of curves and counter-curves which he introduces.

Seventeenth-century Italy was a country of builders, and provided opportunities for a large number of talented architects. Many of these came from the region of the Lombard lakes, which had supplied Europe with constructional specialists ever since the Middle Ages. They were now attracted to Rome by the fever of building that prevailed there. In the Eternal City the century opened with Carlo Maderno (1556–1629), a Lombard, who built the nave of St Peter's (*Ills. 11 and 6*); and for more than half a century Bernini (1598–1680) made his style the dominant one, a style aiming at effects of grandeur, which were attained by the clear distribution of powerful masses and by the rich polychrome ornamentation of the interiors.

The painter Pietro da Cortona (1596–1669) also devoted himself to architecture, especially in the latter part of his life. It was he who raised the most elegant cupola in Rome, that of San Carlo al Corso. Carlo Rainaldi (1611–1691) continued the Bernini spirit. This had been opposed, even in Bernini's lifetime, by the architect Francesco Borromini (1599–1667), who was responsible for the enchanting Church of San Carlo alle Quattro Fontane (*Ill. 7*) and for San Ivo della Sapienza (*Ill. 4*). Borromini abandoned Bernini's effects of power in repose in favour of a dramatic style, aiming at an architectural expression of movement – he introduced a multiplicity of curves and counter-curves and a great complexity in the distribution of spaces, and he did not hesitate to transgress the rules of the ancient orders (which Bernini had applied respectfully) in order to create new

8 The elevation of Palazzo Pesaro, by Baldassare Longhena, shows how the Roman style of palace with tiers of orders was introduced into Venice. It was enriched with carved decoration in the Venetian manner.

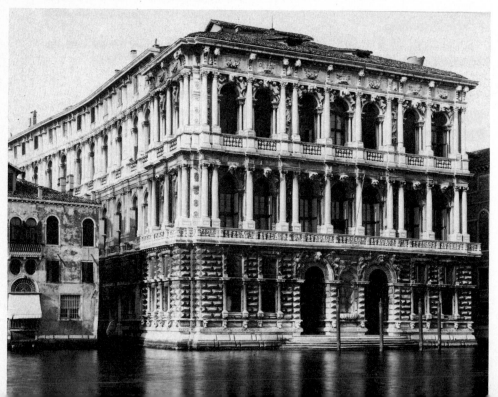

proportions and new ornamental motifs. However, in his interiors he abandoned polychrome ornamentation in favour of white stucco, thus relying on sculpture that was integral to the architecture.

Following the examples given by Rome, Baroque architecture spread throughout Italy, tending to exaggerate the element of plastic and ornamental exuberance at the expense of that expressive power of masses and of the whole, to which Bernini attached particular importance. In Venice Baldassare Longhena (1598–1682), who built the Salute Church and the Palazzo Pesaro (*Ill. 8*), adapted the Baroque to the 'decorative' style which had arisen in that city during the preceding century. Florence, with its wealth of monuments from the Renaissance and the Mannerist period, built little in the seventeenth century. Naples, on the other hand, filled itself with Baroque churches, palaces, and monasteries. At the Certosa di San Martino, Cosimo Fanzago (1591–1678) retained certain Renaissance elements in the cloister but went resolutely Baroque in the church itself. In Naples and Sicily the marble decoration of the churches is more meticulous than anywhere else in Italy, amounting to ornamental compositions carried out in marquetry. The influence of Spain, which dominated southern Italy politically, encouraged the Sicilian architects to develop a monumental style overcharged with mouldings and ornamental statues. This style reached its greatest magnificence in the extreme South, in the city of Lecce, where Giuseppe Zimbalo created several buildings alive with ornamentation (*Ill. 9*). It was continued in Sicily, in the cities rebuilt after the 1693 earthquake.

Generally speaking, while in Rome itself architecture crystallized into a Berninesque formalism, the spirit of invention went its own way in the marginal regions of Italy, especially at Turin. When he came to Turin in 1666, Guarino Guarini (1624–1683), a Theatine priest from Modena, had already designed several churches for Messina, Lisbon, Prague, and Paris. In Turin he built the Royal Chapel and Santa Sindone Chapel, the Church of San Lorenzo, and

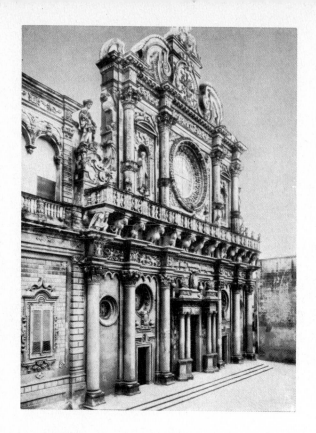

9 The Church of S. Croce, Lecce, built by Riccardo, was given a new façade by Zimbalo. The city of Lecce in Apulia was the earliest example of a whole town treated as a stage-set on a vast scale – a Baroque practice later repeated in the cities built in Sicily after the 1693 earthquake.

the Palazzo Carignano. Guarini continued Borromini's conception of dramatic architecture. His preference went to central ground-plans and circular forms, and even when he used a ground-plan with a lengthened nave he enlivened it with oval bays. Fascinated by geometry and mathematics, he introduced a multiplicity of inter-secting planes, of leaping curves and counter-curves, and separated his vaults by combinations of interlaced groins that remind one of Gothic and Moslem architecture (*Ill. 10*). To Guarini, architecture was essentially expressive. For the Santa Sindone he attained a symbolic effect – suitable to this funerary chapel in which the winding-sheet of Christ is venerated – by a distribution of light that is full of mystery. The style of Padre Guarini contains all the principles of Rococo; exemplified in many buildings, it

22

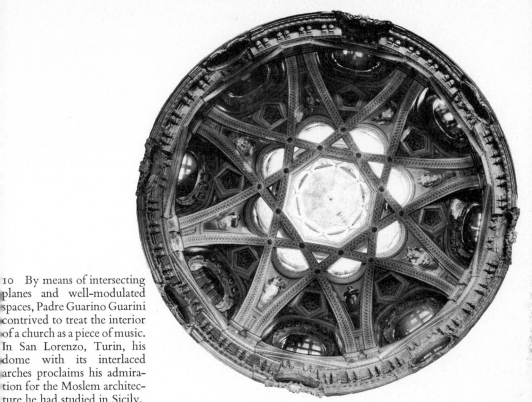

10 By means of intersecting planes and well-modulated spaces, Padre Guarino Guarini contrived to treat the interior of a church as a piece of music. In San Lorenzo, Turin, his dome with its interlaced arches proclaims his admiration for the Moslem architecture he had studied in Sicily.

was to have a great influence in Central Europe during the next century.

SCULPTURE

The figurative arts of the Baroque period, especially in Italy, are governed by an aesthetic that considered art as a means of expressing the passions of the soul. Psychology made considerable progress in the seventeenth century, and the problems of the passions pre-occupied a number of philosophers. Biologists laid down the first principles of physiognomy, and several artists or critics formulated treatises on expression, one of the most famous of these being by the French painter Charles Le Brun. These treatises indicate how the technique of art should render the various passions – love, suffering,

23

anger, tenderness, joy, fury, warlike ardour, irony, fear, contempt, panic, admiration, tranquillity, longing, despair, boldness, etc. All these feelings had to be depicted at their extreme form – a tendency culminating in the passionate outbursts of the plays of Racine. These movements of the soul were exteriorized by movements of the body and the face – that is, by action. The outward manifestations of a state of saintliness became those of a transport of passion. The saint of the Baroque period is a confessor of the Faith – he demonstrates the Faith by word, by martyrdom, and by ecstasy. The apologetic or propaganda mission appointed by the Church for religious art helped to turn sculpture, like painting, into rhetoric. The acting parts allotted by the artists to the figures they depicted were those of which they were constantly seeing examples in opera, where the various forms of art – musical, plastic, and dramatic – converge. Indeed, opera may perhaps be considered as the major art of that time, the one from which all the others were derived, including even architecture; for many monumental effects were first tried out in the theatre before being realized in stone.

The artists – especially the sculptors – sought also to justify the principles of this rhetoric by reference to examples from the decadence of the ancient world, brought to light in excavations and unceasingly studied and measured in the effort to rediscover their secrets. It should not be forgotten that almost all the sculptors of this period, including Bernini, were restorers of ancient statues. The restoration at that time aimed at putting together the whole work of art, and so became largely a reinterpretation. The 'Laocoön' group, which was the work of Rhodian sculptors of the first century and had been brought to light again in a Rome vineyard in 1506, continued to exert an almost magical attraction for the sculptors. They thought it the most perfect example ever produced of the expression of grief, and therefore the most sublime form of expression. It even became the inspiration for the attitudes of martyrs and the face of the dying Christ.

11 The whole perspective of the nave of St Peter's, built by Maderno and richly ▶
decorated by Bernini, converges on the *baldacchino* and, beyond this, on the golden
glory radiating from the Apostle's throne.

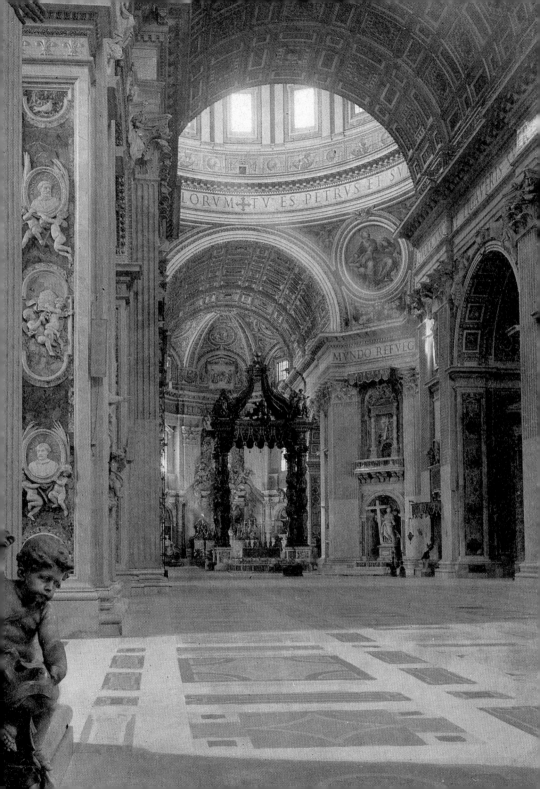

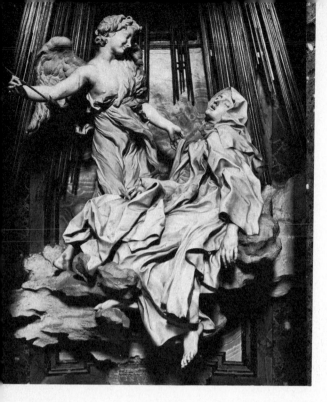

12 Ever since Salomon de Brosses wrote his account of his Italian journey in the eighteenth century, Bernini's *Ecstasy of St Teresa*, S. Maria della Vittoria, Rome, has been interpreted as a profane expression of voluptuousness. In reality the artist has contrived to show how the body of the Saint becomes suddenly lifeless at the inrush of the Holy Spirit.

Bernini's prodigious facility enabled him to produce a considerable quantity of sculpture, even while he continued to work as an architect and to write operas. He tried to give marble a quivering quality of life, in competition with painting. He expressed the whole gamut of the passions – from the brutality of the warrior (in his 'David') to ecstasy ('The Ecstasy of St Teresa' (*Ill. 12*), at Santa Maria della Vittoria, Rome), and showed himself capable, in his 'Apollo and Daphne', of catching the very moment when, breathing out her soul in a last cry, the nymph experiences her metamorphosis into a laurel. To his portrait busts he gave the mobility of life (as in the bust of Cardinal Scipione Borghese (*Ill. 13*), Galleria Borghese, Rome), and in his bust of Louis XIV (Versailles) he created what is surely the most elegant image of regal sovereignty. In the Tombs of Urban VIII and Alexander VII in St Peter's he treated the theme of death with a new dramatic power.

26

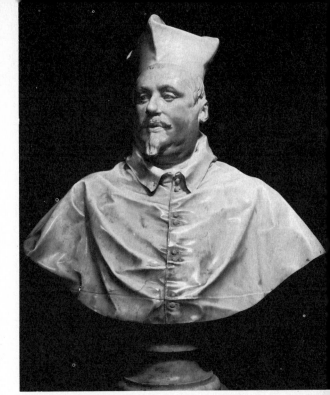

13 Bernini's sculptured portrait of Cardinal Scipione Borghese, his first patron, in the Galleria Borghese, Rome, is striking in its vitality. Bernini produced a profound transformation in the portrait bust. During the Renaissance, this had tended to represent the sitter in a kind of petrified immortality. Bernini shows the sitter in the full liveliness of action.

The output of Francesco Mochi (1580–1654), though small, was extremely original (*Ill. 14*). It was distinguished from that of Bernini by a certain refinement retained from Mannerism (as in the equestrian portraits of Alessandro and Ranuccio Farnese at Piacenza). Alessandro Algardi (1595–1654) allowed less freedom to his temperament than did his contemporary Bernini; his manner is more directly inspired by antiquity. The Flemish sculptor Francesco Duquesnoy (1594–1643) introduced into the Baroque turmoil a note of moderation that brought him close to the Classical mood (*Ill. 15*). At the end of the century the style of Bernini crystallized into a formalism practised by clever artists devoid of genius.

PAINTING

In the last years of the sixteenth century and the first years of the century that followed, there appeared in Rome two great works of

27

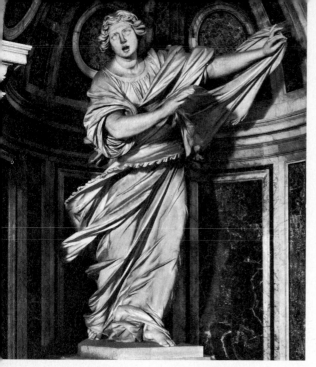

14 Francesco Mochi's *St Veronica*, St Peter's, Rome, is a good example of the Baroque attitude to art, of its striving to represent feelings and passions by movement and action.
15 It contrasts strikingly with the classical calm of *St Susanna*, S. Maria di Loreto, by Francesco Duquesnoy.

art which may without exaggeration be called the two poles on which seventeenth-century painting in Europe rests: the ceiling frescoes of the Galleria Farnese in the Palazzo Farnese, painted by Annibale Carracci from 1597 to 1604; and the great canvases on the life and martyrdom of St Matthew painted by Caravaggio between 1597 and 1601 for the Contarelli Chapel in the Church of San Luigi dei Francesi.

At one time historians of art, blinded by the Classical prejudice, used to contrast Caravaggio with the three Carracci, representing him as a rebel, a destroyer of the art of painting – as Poussin had already said. The truth is that Caravaggio is as constructive as the Carracci, and we should guard against allowing the judgement of his work to be coloured by our knowledge of his life, which was

28

that of a criminal hunted by the police. Our own period, which has rehabilitated him as a painter, tends to treat him as one of those *peintres maudits*, rejected by society, in whom we are too ready to see the greatest genius. In reality, though some of his more Academic contemporaries were alarmed by certain pictures of his, which they rejected as too much of a break with the past, Caravaggio was admired by the artists and art lovers of his time as a great innovator. When his pictures were refused by churches, some Maecenas at once came forward to buy them.

Caravaggio (1573–1610) was a painter of temperament; the desperate energy with which he repainted the *Calling* (*Ill. 16*) and *Martyrdom of St Matthew*, in the effort to master his dramatic style, is

16 The *Calling of St Matthew*, in the Contarelli Chapel, S. Luigi dei Francesi, Rome (detail) was painted by Caravaggio before the *Martyrdom*. It represents a scene of low life on a monumental scale, and in it Caravaggio seems to be taking leave of his early, 'worldly' manner.

evidence of an empirical and impulsive method. But it is untrue that he was trying to break with what had gone before, that he was trying to destroy the Renaissance idea of art. His many borrowings from the art of antiquity, from Savoldo, from Michelangelo, and even from Raphael, prove the contrary. Caravaggio's work was not negative; his aim was to restore full corporeal density to the unstable figures of Mannerism. He was doing the same thing as Giotto emerging from Byzantinism and Masaccio from Gothicism; he was trying to make the human body the only subject of painting, in accordance with the true Italian and Mediterranean tradition. No one in the whole of Italian painting ever pushed this anthropomorphism further – in his case, it went so far as to eliminate everything in a picture that was not the human presence. The Renaissance painters had sought to achieve definition of the human body by means of an overall lighting that brought out all the aspects. They proceeded by means of light, and for them shade was merely the means of accentuating light. Inheriting this tradition, the Mannerists had ended by reducing their figures to pale phantoms. Caravaggio started from shade; he made his athletic and plebeian bodies emerge from the shadow by strokes of light. His system of violent lateral lighting made muscles and volumes stand out in a depthless space that has no reality except through human presence (*Ill. 18*). In his effort to recover the full force of this corporeal presence, which had vanished in the deliquescence of Mannerism, he was led to seek it where it has its elementary power – in the people; indeed, the Carracci were also doing this, though in a more temperate way. When he had to paint sacred scenes, the parts in these were played by poor people. He returned, in a way, to the spirit of the Gospels, and this sanctifying Populism, this implication that the humble are nearer in spirit to the truth, was to give life to a considerable part – the more profound part – of seventeenth-century religious painting. The people in Caravaggio's paintings are bound together by dramatic relationships which raise all the problems of life, grief,

17 *Mercury Giving the Golden Apple of the Garden of the Hesperides to Paris* by Annibale Carracci, one of the frescoes of the Galleria Farnese. The decoration of this gallery in the Palazzo Farnese, Rome, between 1597 and 1605, was the source of all mythological painting in the seventeenth century.

and death. From his painting there emerges a pessimistic impression of human destiny, and it was not surprising that Caravaggio's art opened the way to that anxious exploration of the soul which attracted many of the painters in the seventeenth century.

While Caravaggio was attacking his canvases in the Contarelli Chapel, Annibale Carracci (1560–1609), aided by his brother Agostino (1557–1602), was painting in light and cheerful colours on the ceiling of the Galleria Farnese of the Palazzo Farnese the stories of gods and goddesses from Ovid's *Metamorphoses* (*Ill. 17*). Caravaggio was at grips with the essential drama of human destiny; the Carracci were giving joyful expression to the Olympian dreams in which the

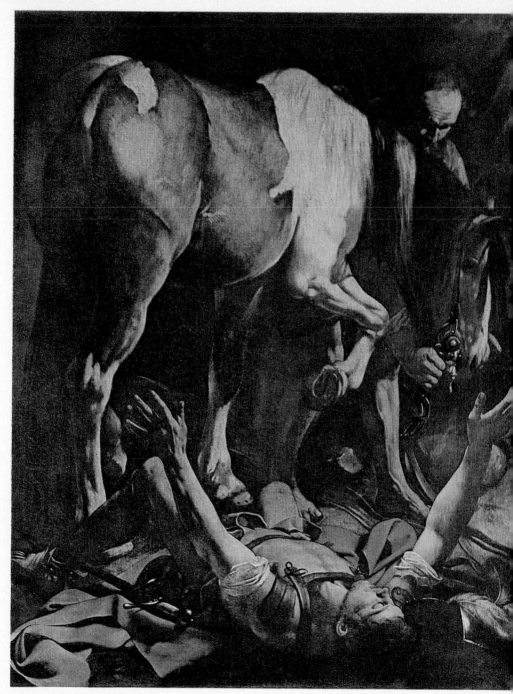

18 In the two pictures which he painted for the Cerasi Chapel, S. Maria del Popolo, Rome
the *Conversion of St Paul* (above) and the *Crucifixion of St Peter*, Caravaggio was in full pos-
session of his genius. The scene is reduced to its essentials, and is played by men, no longer
by actors: an intense feeling of reality results.

humanist princes of the time, with their inimitable way of life, took such pleasure. It may safely be said that this gallery in the Palazzo Farnese was the source of all the decorative painting that was to spread over the walls of the Roman palaces – and soon over those of Europe – and to turn the princely dwelling into an unreal place, an enchanted environment.

The style of the Galleria Farnese was borrowed from 'the best sources', those of the Renaissance – that is to say from Michelangelo and Raphael, whom the Carracci brought together in a synthesis whose secret was their own. It was, in fact, by the study of the masters – both those of antiquity and those of the recent past – that the Carracci succeeded in dominating Mannerism, in recovering both the feeling for ordered compositions and ease and truthfulness in the play of the figures. But they enlivened this imitative method of theirs by the study of nature – even, like Caravaggio, having recourse to models taken from the people. To remedy the decadence into which painting had fallen, Annibale, Agostino, and their cousin Lodovico (1555–1619) founded at Bologna in 1585 the Accademia degli Incamminati, in which the teaching was based on the study of the masters, of anatomy, and of the living model. The most gifted of the Carracci was Annibale. His vigorous realistic temperament sometimes drove him to treat popular subjects not far removed from those of Caravaggio. He laid down, also, what were to become the laws of the Classical landscape. Lodovico was distinguished by a more tender and mystical sensibility (*Ill. 19*). While at the Galleria Farnese in the Palazzo Farnese they were creating a paragon of mythological painting, the Carracci were also establishing the type of altar painting which (revived from Raphael) was to last until Ingres – a picture divided into two parts, the celestial world and the earthly world, carrying on a dialogue by all the resources of a holy rhetoric.

In the first half of the seventeenth century Bologna and Rome were closely bound together; the principal painters working at

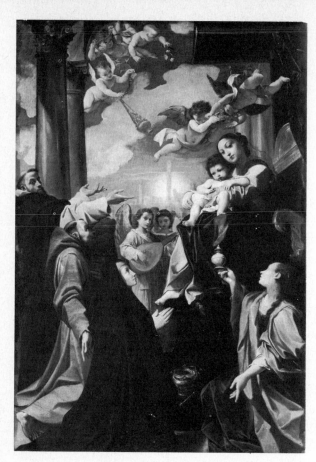

19 For *Madonna of the Bargellini*, Pinacoteca, Bologna, Lodovico Carracci derived his Baroque type of composition from certain pictures by Titian, adding to these a celestial plane, by which the upper part of the picture is filled with great beauty. The Renaissance 'sacra conversazione', in which all the people were motionless, has become a living conversation, in which men and saints are admitted on familiar terms into the presence of the sacred figures.

Rome came from the capital of Emilia, and painters constantly went to and fro between the two cities. The most representative artist of the Bologna School is Guido Reni (1575–1642) whose art, with its tempered Baroquism, has been described as 'Baroque Classicism' (*Ill. 20*). Domenichino (1581–1641) leant definitely towards Classicism, and so showed the way to Poussin (*Ill. 21*). It has, in fact, been noticed recently that Roman painting did not entirely surrender to Baroquism, and Classicism (which always tends to produce theorists) was not represented only by the French artists, Poussin and Claude Lorraine, who chose to live in Rome in order to be in close contact with antiquity. The transformation imposed on antiquity by the

Italian artists of this period must not make us forget that to return to antiquity was their constant object, whether they were Classical or Baroque.

Rome at this time was full of 'antiquaries', and the artist studied their collections. Above all, the museum of antiquities belonging to Cassiano del Pozzo was the meeting-place of artists as different as Poussin and Pietro da Cortona. The graceful mythological evocations of Albano (1578–1660) belong also to this Classical stream. Meanwhile Guercino (1591–1666), another artist from Emilia and, in a way, a deserter from the Academicism of Bologna, came under the influence of Caravaggio.

Caravaggio's style was at once imitated, in Rome itself, by a whole legion of artists who came from various parts of Italy (excepting Bologna) and even from Northern Europe. These acquired the name of *i tenebrosi*. The output of Caravaggio, though so small (it was all produced within about twenty years), opened out possibilities that were very divergent, indeed contradictory. Bartolommeo Manfredi (c. 1580–1620) took up certain subjects treated by the master and created *genre* painting, depicting scenes in taverns with life-size figures. The two artists who, in due course, produced the best examples of this manner were Moïse Valentin, the Frenchman who came to Rome and lived there till his death, and Terbrugghen, a

20 *Aurora*, by Guido Reni, Casino of the Palazzo Pallavicini, Rome, though a ceiling decoration, is composed in the form of a frieze as if painted on a wall. Here the artist was rebelling against the spatial researches which at that time were exciting such passionate interest in Lanfranco, Giovanni Battista Gaulli and Pietro da Cortona.

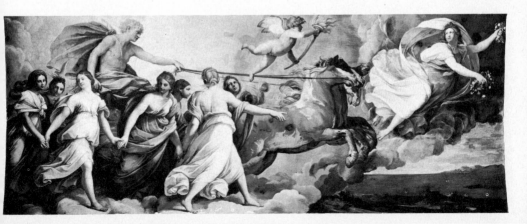

Dutchman who took the style back to Utrecht and started a whole School there. Under the influence of the Dutchman Pieter van Laer, known as Il Bamboccio, painters such as Michelangelo Cerquozzi (1602–1660) developed it to include open-air scenes with small figures. Other artists extended the human range implied in Caravaggio's work – among them Orazio Gentileschi (*c.* 1565–*c.* 1638) (*Ill. 22*), Carlo Saraceni (*c.* 1580–1620), and Giovanni Serodine (1600–1631) – while the painter who, specializing in religious pictures, came nearest to Caravaggio's monumental grandeur was the Neapolitan Giovanni Caracciolo (*c.* 1570–1637), known as Il Battistello (*Ill. 23*).

During the seventeenth century a great stream of sacred and profane forms, allegories and narrative paintings flowed over the walls, vaults, and ceilings of the palaces and churches in Rome and in other Italian cities. Of the decorative painters the one with the largest share of genius was Pietro da Cortona (1596–1669). It is safe

21 In *Diana Hunting*, by Domenichino, Galleria Borghese, Rome, the calm of the composition and the modesty with which the nudes are painted shows the feeling of restraint which is the sign of a mind that has turned towards Classicism.

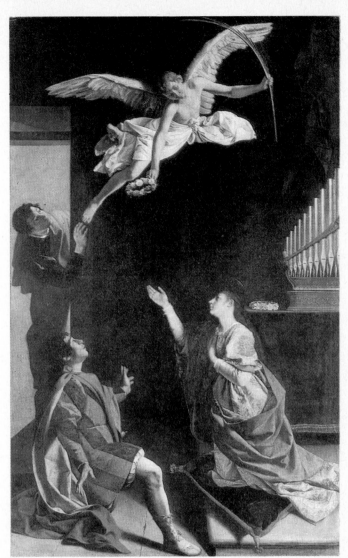

22 *The Martyrs St Cecilia, St Valerian and St Tiburzio with an Angel*, by Orazio Gentileschi, Brera, Milan, is a good example of the refinement of feeling of which Caravaggism was capable. The spiral movement of the composition, which so well expresses aspiration towards heaven, is a Baroque element foreign to the art of Caravaggio himself.

to say that it was he who most fully embodied the *joie de vivre* of the Baroque period, in his ceiling of the Great Chamber in the Palazzo Barberini (1633–1639) and – better still – in his frescoes at the Palazzo Pitti in Florence (1641–1646) (*Ill. 24*). An imitator of the clear and generous colour of the Venetian painters, Pietro da Cortona is, to some extent, the Italian Rubens.

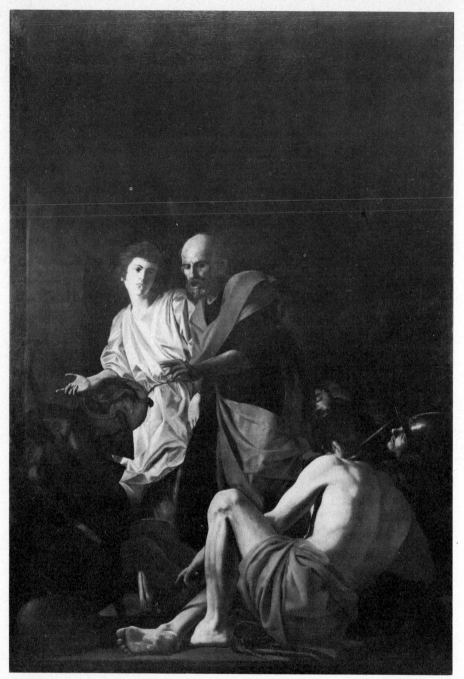

23 *The Liberation of St Peter*, Chiesa del Monte della Misericordia, Naples, is by Giovanni Caracciolo (Il Battistello), the painter who best understood the human range of Caravaggio's art. It was this artist from Naples who most fully assimilated the gravity and asceticism of that art, adding to it a personal note of contained emotion.

All through this century there was a steady development in that type of ceiling painting which gives the spectator a feeling of being overhung by a whole world of flying figures, that hover and soar in an imaginary palace, or through the open sky. This painting of figures in space was especially Baroque in spirit; its full flights take place mainly in the churches, since their size lent itself better to effects of perspective than did the inadequate dimensions of the rooms in palaces. Domenichino, Lanfranco, Pietro da Cortona, and Giovanni Battista Gaulli exemplify the principal stages of this art, before it reached its apogee with Padre Andrea Pozzo (1642–1709). This Jesuit priest, who also wrote several treatises on perspective, painted the *Glory of St Ignatius* (1691–1694) on the ceiling of the Church of St Ignatius in Rome, creating the masterpiece of this illusionist style (*Ill. 25*).

The cities of the Italian provinces, though declined from the pilot function they had fulfilled in earlier times, maintained an attitude of considerable independence towards Roman art, while keeping well informed about it. Some artists, such as Cristofano Allori (1577–1621) and Carlo Dolci (1616–1686) in Florence, and in Bologna Sassoferrato (1609–1685), took refuge in an archaism that appeared to disregard the march of time. At Bergamo, Evaristo Baschenis (1607–1677) painted still lifes with musical instruments (*Ill. 26*), and these were still fundamentally Mannerist. Venice was the meeting-place of artists from various parts of Italy, from abroad also, who continued happily the sensuousness and delight in colour that had been the mark of that city. The Genovese Bernardo Strozzi (1581–1644) (*Ill. 27*), the Roman Domenico Fetti (*c.* 1589–1623) (*Ill. 28*), and the German Johann Liss (who died in 1629/30) were there between 1621 and 1644; but the best colourist was a painter from Vicenza, Francesco Maffei (1600–1660), while Sebastiano Mazzoni (1611–1678) introduced into his paintings an element of caricature which brough them close to the Romanticism in which the other Italian Schools had become interested.

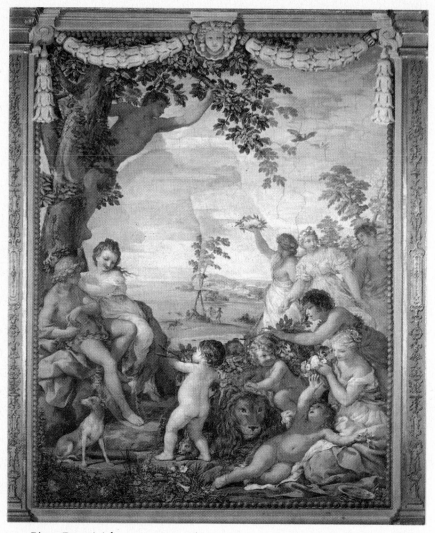

24 Pietro Berettini, known as Pietro da Cortona, was the Baroque artist *par excellence* in Rome. His light colouring and the joy of life make one think of Rubens in such works as *The Golden Age*, Pitti, Florence.

25 *The Glory of Saint Ignatius*, S. Ignazio, Rome, by Padre Andrea Pozzo. Designed to be viewed from a point in the centre of the nave, which is marked by a white stone, Padre Pozzo's ceiling for S. Ignazio produces the illusion of a palace opening on to the sky.

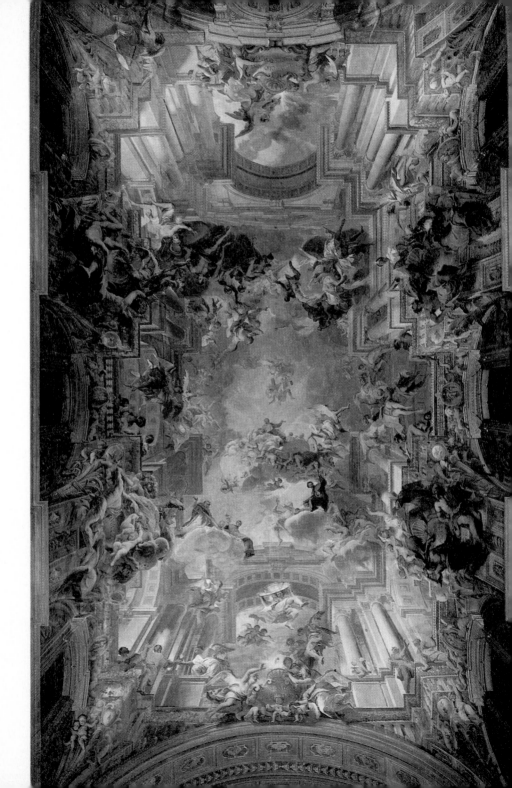

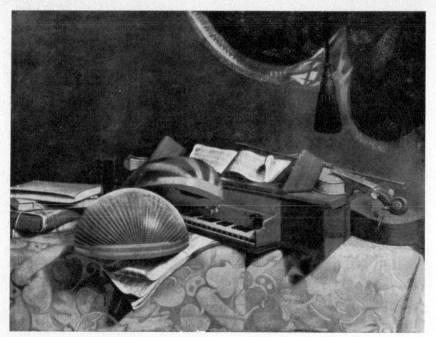

26 The Breschia painter Evaristo Baschenis has arranged the musical instruments of his *Still Life*, Palazzo Moroni, Bergamo – already a favourite motif with the Venetian painters of the Renaissance – so that they become independent still-life compositions.

27 The realism of Bernardo Strozzi, as shown in this kitchen scene, *The Cook*, Palazzo Rosso, Genoa, may have been stimulated by the example of the Flemish painters.

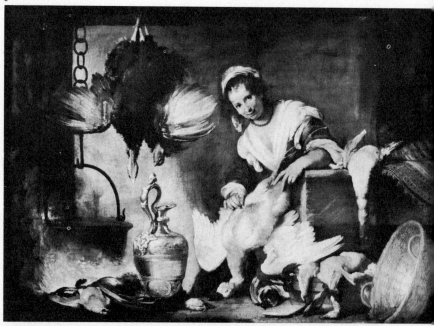

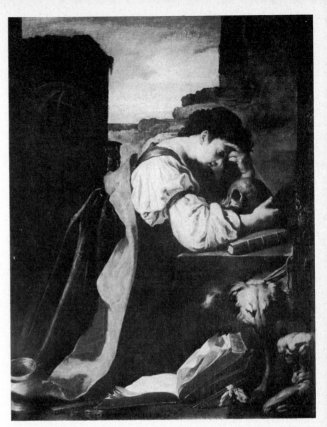

28 Domenico Fetti's *Melancholy*, Louvre, Paris, is the seventeenth-century equivalent of Dürer's famous engraving in the sixteenth. Dürer's engraving glorified the human mind as it confronts its inability to attain a knowledge of the real: Fetti's, a more humble and more Christian figure, is meditating on death and on the salvation of the soul.

This Romanticism may be considered as a reaction against the Baroque vitalism which the artists of Bologna and Rome had created. It took the form of a preference for trivial subjects, dramatic or bloody, and a taste for darkness. This provincial *tenebrism*, though more or less derived from Caravaggio, is essentially different from his, for its effect is to dissolve the figures in obscurity, whereas Caravaggio accentuated their density. In Milan, Francesco del Cairo (1607–1665), Il Morazzone (1573–1626) (*Ill. 29*), Giovanni Battista Crespi (1575/6–1632), known as Il Cerano, and Daniele Crespi (*c.* 1598–1630) (*Ill. 30*) enveloped the whole of their compositions in a thick darkness. At Genoa, where Van Dyck and Rubens had resided, the contact with Flemish painting led to some confusion. The dominant talent was that of Bernardo Strozzi (*Ill. 27*).

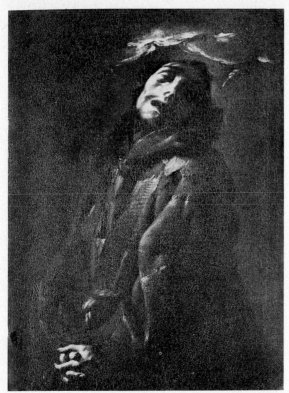

29 The 'tenebrism' of the Lombard painter Morazzone is very different from that of Caravaggio, who made use of strong contrasts of light and shade to bring out the diversity of his forms. Morazzone's people are phantoms, and the artist is striving with darkness for their possession. In *St Francis in Ecstasy*, Castello Sforzesco, Milan, he has painted St Francis like a suffering Christ, in full conformity with the mysticism of the period.

30 Several of the seventeenth-century schools of mysticism practised a strict asceticism, grounded on exercises in pious meditation. *The Meal of St Charles Borromeo*, Chiesa della Passione, Milan, by Daniele Crespi, shows St Charles Borromeo continuing to read during his frugal meal of bread and water.

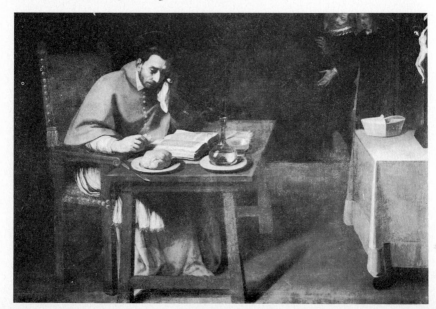

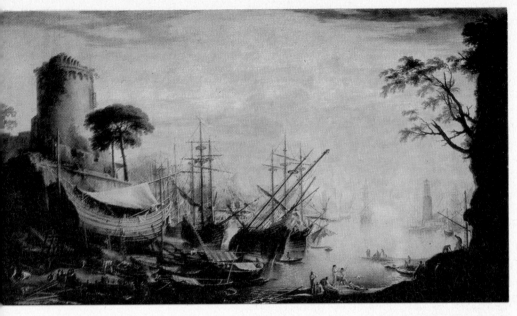

31 Salvator Rosa introduced drama into the vision of nature. He invented a formula of 'romantic' landscape in such paintings as *Harbour Scene*, Pitti Palace, Florence, which was destined to have a great influence, especially on Gaspard Dughet.

The most lively and prolific School was that of Naples. It drew directly on the art of Caravaggio, who had lived there and left several paintings that were much admired. The Spaniard Jusepe de Ribera (1591–1652), who took up residence there in 1616, brought into Caravaggism a bitterness, indeed a cruelty, which he transmitted to Mattia Preti (1613–1699). This School produced innumerable painters of historical scenes, still lifes, battles, landscapes, and *genre* scenes. A need for escape led two painters from Lorraine, whose works have been jumbled together under the name of Monsù Desiderio, to paint visions of fantastic architecture in an apocalyptic atmosphere (*Ill. 32*). Salvator Rosa (1615–1673), who was by turns a revolutionary, a bandit, a strolling player, and a writer of plays, harmonized his life with the Romanticism of his art (*Ill. 31*). His

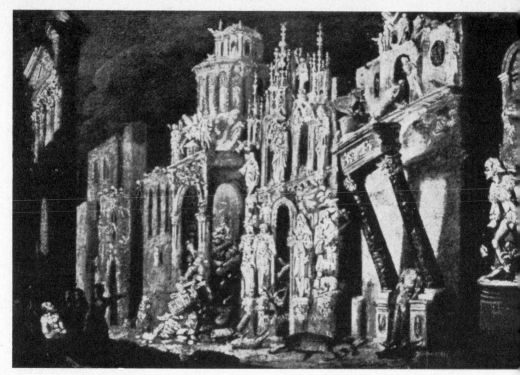

32 Criticism has recently split the mysterious Monsù Desiderio, painter of fantastic land-scapes in Naples, such as *The Destruction of Sodom*, Bagnoli Sanfelice Collection, Naples, into two people, both of them from Lorraine and working in the same studio: Didier Barra and Francesco de Nome.

innovation was to paint wild landscapes, which later influenced Gaspard Dughet in Rome. In the eighteenth century the Neapolitan School ended in what may be called the 'Confusionism' of Luca Giordano (1632–1705), an eclectic painter, indeed on occasion a faker, whose virtuosity earned him the nickname 'Fa Presto' (*Ill. 33*).

MINOR ARTS

Italian furniture at this time lagged nearly half a century behind the general development of styles. Until about 1660 the cabinet-makers remained wedded to the monumental forms of the Renaissance, as regards both the design and the ornamentation of their furniture. The types of pieces were still rather few; as in the Mannerist period,

cabinets were covered with gilt bronze fittings, miniature columns, and incrustations of precious marble.

The interiors of the Roman palaces were decorated in marble and stucco. These decorations were later imitated at Versailles, more or less at the moment when the Italians began – especially in Piedmont – to imitate the French style of decoration in gilded woodwork. At about the same time, Baroque 'vegetation' began to be grafted on structures that still remained architectural. By the end of the century and the beginning of the next one, a piece of furniture, especially if it was a console, became completely absorbed in these great eddies of volutes. In the furniture of the first third of the eighteenth century

33 The Neapolitan painter Luca Giordano who painted *Christ Expelling the Money Changers*, Chiesa dei Gerolamini, Naples, was nicknamed 'Fa Presto'. He was a virtuoso painter with a great gift for imitating the styles of other artists, and he produced tumultuous compositions full of figures with an extraordinary rapidity.

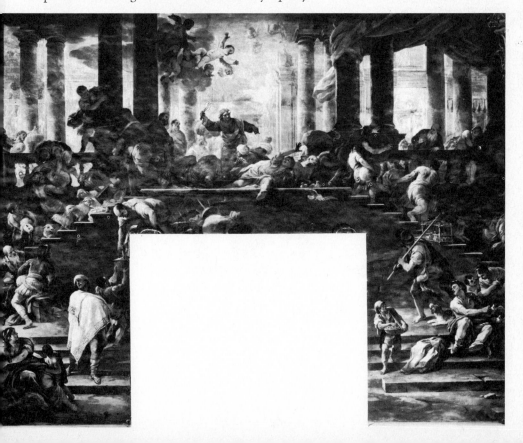

Baroque overloading was unashamed. It is represented by the Fantonis of Bergamo (Andrea, 1659–1734) and Andrea Brustolon of Venice (1662–1732), in whose hands a piece of furniture became merely a mass of carving (*Ill. 34*).

In several Italian towns, including Rome and Florence, tapestry factories were set up, deriving their style from the Flemish tapestries. It was not till later, in the first half of the eighteenth century, that the Gobelins spirit penetrated to Naples and Turin.

Genoa and Venice produced woven stuffs of the finest quality and the stamped velvets of Genoa were in demand throughout Europe.

34 It is hard to separate Italian Baroque furniture from sculpture. The most extravagant pieces were those by the Venetian Andrea Brustolon. Like this chair of his from the Palazzo Rezzonico, Venice, they are covered with carved figures.

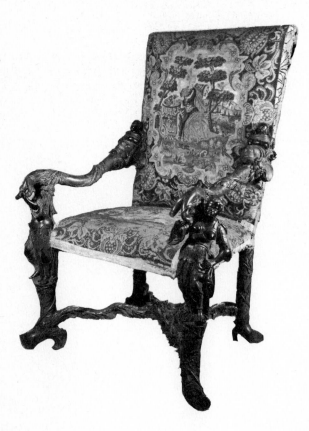

Seventeenth-Century Spain

The period that runs from the last years of the sixteenth century through the seventeenth century has been called Spain's 'golden century'. El Greco is usually included in it, though he died in 1614 and belongs to the Mannerist style. In the seventeenth century, Spain had only three sovereigns, Philip III, Philip IV, and Charles II (the last three Spanish Habsburgs), who tried in vain to keep up the hegemony over Europe exercised by Philip II. Yet this political decadence coexisted with the most brilliant period of Spanish literature and with the rise of the Spanish School of Painting. In Spain, as in France, the monarchy was absolutist, but this did not cause a centralization of the arts; the provincial centres remained very lively and entirely independent. In Madrid Velázquez, the favourite painter of Philip IV, set the tone for art at Court, but his influence did not extend beyond.

ARCHITECTURE

Secular architecture in the seventeenth century experienced a certain set-back, by comparison with the preceding century; it was the Church that dominated the art of building. (When, in the eighteenth century, Philip V wished to revive a Court architecture, he was forced to call in Frenchmen and Italians.) After the austerity imposed as a cure on it by Herrera at the start of the seventeenth century, Spanish architecture went Baroque slowly, with a tendency to work back to Mannerist forms. The Jesuits contributed to this movement. Fray Francisco Bautista (who died in 1679) built the Imperial College

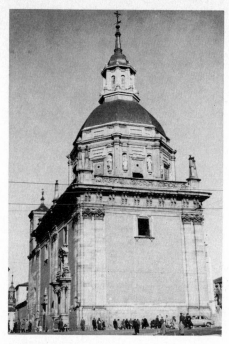

35 Pedro de la Torre's Chapel of San Isidro, Church of San Andrés, Madrid, is one of the earliest Spanish buildings in which the development of the Classical forms in the direction of the Baroque becomes apparent.

of Madrid (San Isidro) and the College at Toledo in a semi-Baroque style; both these buildings were in course of construction round about 1630. Spain developed a form of its own, the 'box-shaped church' with all its parts contained in a rectangular enclosure. The decisive turn from Mannerism to Baroque came in about 1640, with Pedro de la Torre's Chapel of San Isidro, belonging to the Church of San Andrés in Madrid (*Ill. 35*), but the Andalusian artists in stucco had already begun decorating church vaults with Baroque ornamentation. The baroquization of the façades took place between 1640 and 1670, in the form of an imitation in stone of the decorative woodwork of the church interiors. It was the altar-pieces, in fact, that tended to be the pilot art at this time. At Compostella and in Andalusia, round about 1660, the Baroque altar-piece with its solomonic columns and whirls of acanthus was perfected. Alonso Cano (1601–1667), painter, sculptor and architect, designed what was the first masterpiece of Spanish Baroque, the façade of the Cathedral of Granada (*Ill. 36*), in the year of his death. Spanish

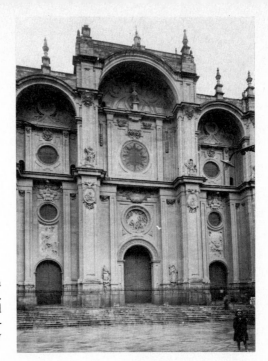

36 The façade of Granada Cathedral by Alonso Cano. Wealth of decoration and strongly contrasted forms almost obliterate the memory of the Classical schemes.

Baroque architecture flourished in full freedom from about 1680 to the end of the century and continued to spread during the eighteenth century, when Spain remained untouched by the Rococo.

SCULPTURE

In seventeenth-century Spain native artists confined themselves almost entirely to religious sculpture. (This had already been the case in the preceding century, and for the sculptures in the Escorial Philip II had had to call in Leone and Pompeo Leoni from Milan. When it was desired to cast an equestrian statue of Philip IV, recourse was had to a Florentine, Pietro Tacca.)

But the workshops producing polychrome sculpture in wood were very active, in response to a demand for carvings to fill the innumerable altar-pieces that were being placed in the Spanish churches, as well as for images of saints. These carvings were painted in a 'natural' style, with less sumptuousness than in the preceding century when a great deal of gold had been used. The workshops

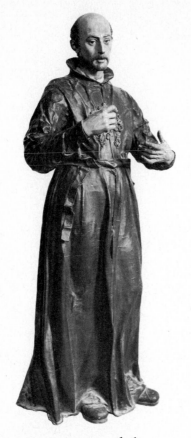

37 With figures such as *St Ignatius*, University Chapel, Seville, Martínez Montañés changed the direction of the Seville School of sculpture, which at the end of the sixteenth century was still Mannerist. He gave it a Classical tendency. Together with Zurbarán, he was the Spanish artist who best expressed the state of mind of the Saint, wholly concentrated on the inner life.

were concentrated about two main centres, each with its own tradition – Valladolid in Old Castile, and Seville in Andalusia. The polychrome sculpture produced at Valladolid had been through the full turmoil of Mannerism in the shape of the highly strung art of Alonso Berruguete and the Expressionism of Juan de Juní. The art of Gregorio Fernández (*c.* 1576–1636) derives directly from the Castilian Mannerism of the previous century, but transforms this Mannerism into Baroque through a more realistic feeling for pathos and a larger conception of rhythm. Fernández goes further than Berruguete and Juní in isolating the statue from the supporting altar-

piece, this being particularly marked in the altar-pieces he designed himself, which are there to support relief carvings and groups of figures. Gregorio Fernández specialized in expressing the suffering of the Virgin and of Christ in a passionate style that is truly Baroque (*Ill. 38*); its search for naturalism, and the eloquence of the gestures, place it firmly in that category.

At Seville, on the other hand, Juan Martínez Montañés (1568–1649) was a Classical artist; the attitudes of his figures are calm, the gestures restrained, the expression directed entirely towards meditation and the inner life (*Ill. 37*). Even when he is representing Christ

38　In contrast with the Seville School, the Castilian School of sculpture was dramatic in inspiration. At Valladolid, where Alonso Berruguete and Juan de Juní had founded the tradition of a passionate art, Gregorio Fernández took this tendency straight into the Baroque in his famous *Pietà*, Valladolid Museum.

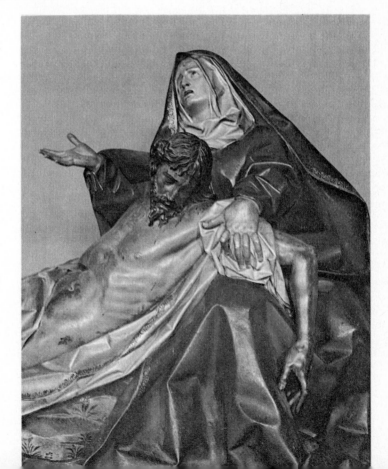

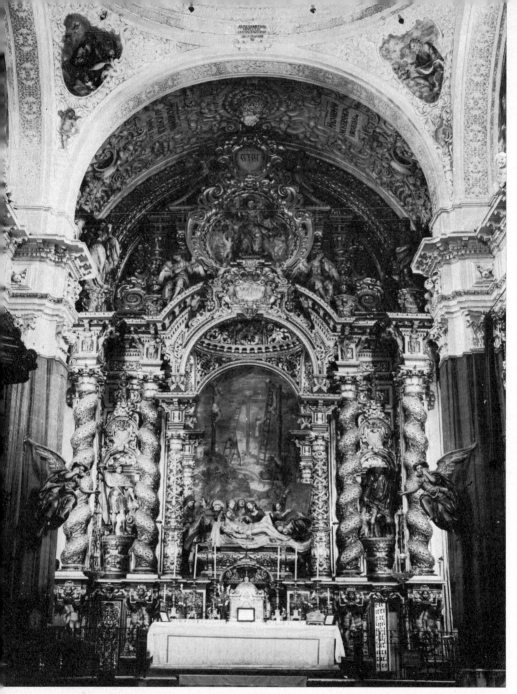

39 The High Altar of La Caridad, Seville, shows that after Montañés the Seville School of
sculpture moved towards a somewhat declamatory realism. Above a *Descent from the Cross*,
on designs supplied in 1670 by Bernardo Simón de Pereda, Pedro Roldán constructed a
huge altar-piece in gilded wood, which was the first to have a *baldacchino* and which exerted
considerable influence in both Spain and Portugal.

on the Cross, he tempers the rendering of suffering by the striving for beauty. His works have a painterly quality foreign to those of Gregorio Fernández; this is due to the superiority of the Andalusian painters over those of Castile at this time. Montañés designed altar-pieces in the same Classical spirit.

After Montañés the Seville School of polychrome sculpture degenerated rather quickly. Pedro Roldán (1624?–1700) introduced Baroque rhythm into the Seville style (*Ill. 39*). Pedro de Mena (1628–1688) of Granada was no more than a manufacturer of pious images, of an exaggerated realism often accentuated by theatrical costume. His master, Alonso Cano, in the few statues from his chisel, showed more originality and foreshadowed the graceful style of the eighteenth century (*Ill. 40*).

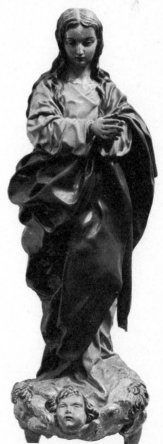

40 At Granada, while Pedro de Mena was starting the vogue for illusionist realism in devotional images, Alonso Cano expressed in *The Immaculate Conception*, Cathedral Sacristy, Granada, a feeling for gracious femininity, which was to be continued by the School down to the eighteenth century.

The chief centre of painting in seventeenth-century Spain was Seville. Whether *tenebrism* was introduced by the paintings of Caravaggio that were imported into Spain or was an indigenous creation is disputed. What is certain is that it already marks the work of Francisco Ribalta at Valencia (1565–1628), the master of Jusepe de Ribera (1591–1652). Ribera went to live in Naples – at that time a Spanish possession – where he found himself in direct contact with the followers of Caravaggio. He carried their characteristic effects further, in a manner that was sometimes rather artificial. Towards the end of his life, however, his art grew more relaxed, extending even to include the depiction of women (*Ill. 41*).

In the seventeenth century two tendencies met in Spain. The truly painterly one was represented by Pacheco (1564–1654) and Francisco Herrera the Elder (1576–1656). In contrast, the art of Francisco de Zurbarán (1598–1664) was dominated by sculpture, which was the pilot art in Seville during the first third of the century, owing to Juan Martínez Montañés. Zurbarán's figures are conceived in isolation like statues, and their vigorous modelling suggests that of woodcarvings. The realism of Zurbarán's work in Spain had a mystical object; by it he gave each of the sacred figures a pronounced individual character, yet made them appear illuminated by an inner inspiration (*Ill. 42*). The second half of his life coincided with the decadence of the style derived from sculpture, and Zurbarán, having lost his public, tried to adapt himself to the new painterly style by imitating – clumsily, it must be admitted – Bartolomé Esteban Murillo (1617–1682). As against the exalted mysticism of Zurbarán, Murillo's paintings display a more lovable kind of piety, attractive to ordinary people (*Ill. 43*). He was one of the few Spanish painters to allow himself to express feminine gentleness and tenderness. The most Baroque of these painters was Juan Valdés Leal (1622–1690), who specialized, like certain Italians, in 'temperamental painting'. Alonso Cano was more conventional.

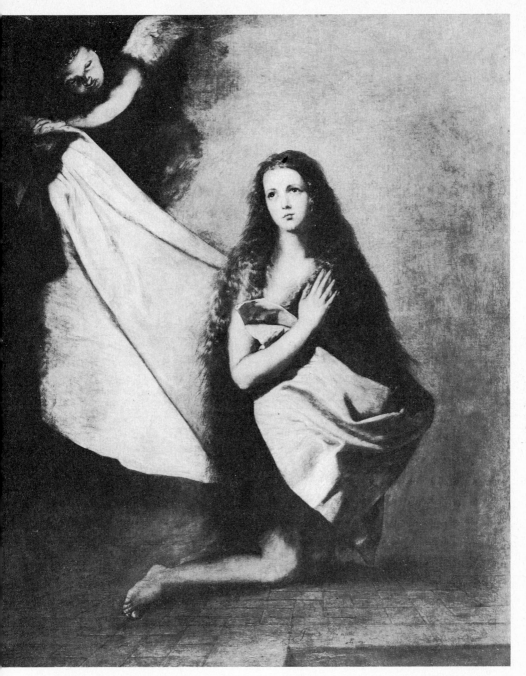

41 Ribera was a strange mixture: in him the instinct for cruelty characteristic of the Neapolitan School was pushed to the point of masochism; yet other works of his, like this *Saint Agnes in Prison*, Gemäldegalerie, Dresden, are filled with the feeling for femininity that characterizes the Seville School.

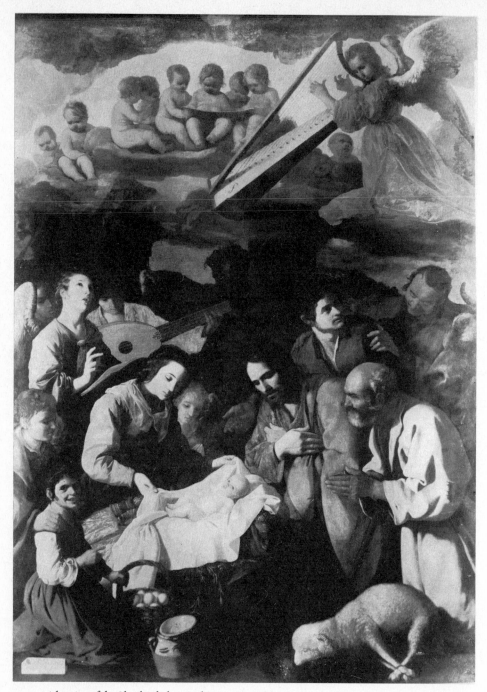

42 *Adoration of the Shepherds*, by Zurbarán, Grenoble Museum. The monumental and ascetic style of Zurbarán was not derived from a study of Caravaggio, but from the Seville tradition of sculpture. His informal manner of representing saints in the guise of people from the humbler classes was common throughout Europe in the seventeenth century.

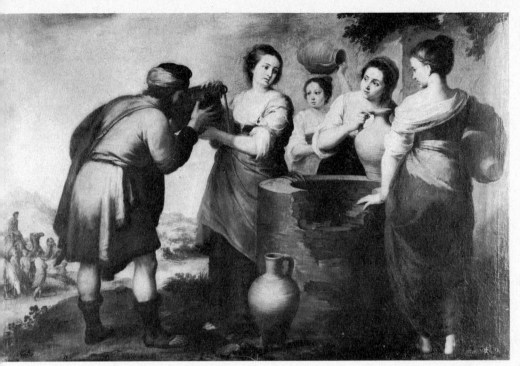

43 *Eliezer and Rebecca*, by Murillo, Prado, Madrid. In contrast with Zurbarán, Murillo (who also worked at Seville) represents a quite different conception, relying for effect on brushwork. Earlier he had had to struggle against the influence of Zurbarán before taking up the suave and blandishing style to which he owed his success.

Diego Rodríguez de Silva y Velázquez (1599–1660), whose father was Portuguese, was born and brought up in Seville. Though a pupil of Pacheco, he began in the harsh style imitated from sculpture, with pictures that were religious but, more often than not, enlivened by realism and satire. In these pictures still-life studies of kitchen utensils (*bodegones*) have a place of some importance (*Ill. 44*). When he was summoned to Madrid and became Court Painter to Philip IV, he changed his style radically. Confining himself almost entirely to portraits, he adopted a fluid manner, all fine shades, in which the form is elusive and melts into an atmosphere of indeterminate grey. Like Frans Hals, his contemporary in Haarlem, he made the movement of the brush the essential factor of pictorial expression. His brush, scarcely touching the canvas, drew from its handling of the

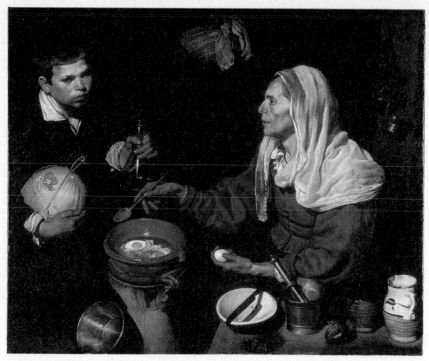

44 *Old Woman Cooking Eggs*, by Velázquez, National Gallery of Scotland, Edinburgh. We know from contemporary statements that Velázquez, in his early works, derived inspiration from the few pictures by Caravaggio he was able to see in Spain: this led him to combine popular realism with *chiaroscuro*.

colours evocative statements over which it did not linger – one is scarcely sure that they are there. In his portraits of Philip IV, of Court dignitaries, princes (*Ill. 45*), infantas and jesters, he gives expression to that profound feeling of loneliness that came naturally to the Spanish soul, for which there is in the world no reality but that of God. He endowed his portraits of clowns and beggars – a subject-matter in which Murillo saw no more than picturesque motifs – with a mood of harsh disenchantment. More than any other artist, Velázquez was in full possession of all the resources of painting, using them with discretion, with an assured economy of means, and without ostentation; he had a kind of sovereign ease, which enabled him to achieve the right tonality at all times and to disdain effects which merely display virtuosity.

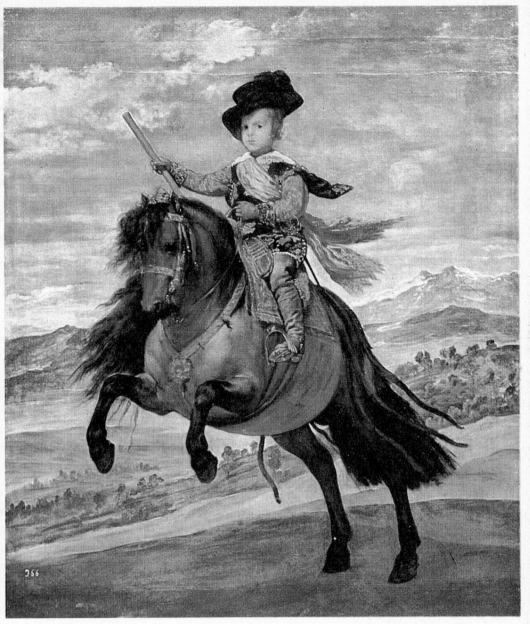

45 *Prince Baltazar Carlos on his Pony*, by Velázquez, Prado, Madrid. Velázquez moved on from the sculptural manner to the painterly. This portrait of the Infante Baltazar Carlos, with its broad landscape, is one of the most charming produced by this haughty painter.

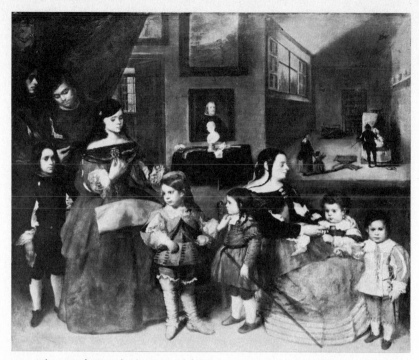

46 *The Artist's Family*, by J. B. del Mazo, Kunsthistorisches Museum, Vienna.
The pupils of Velázquez, among them his son-in-law Mazo, developed his refined
manner in the direction of a pathos anticipating that of Goya.

It was in the direction of a rather too noisy virtuosity that painting
in Castile developed after Velázquez – particularly that of his son-
in-law Juan Bautista del Mazo (*c.* 1612–1667) (*Ill. 46*), who some-
times collaborated with him, of his imitator Carreño de Miranda
(1614–1685), and of Claudio Coello (1642–1693), whose style is
more personal. The art of the Benedictine Juan Ricci (1600–1681),
a painter of portraits and religious pictures, is somewhat nearer to
the Italian manner.

THE MINOR ARTS
The minor arts in Spain, so rich in the sixteenth century, underwent
a real decadence in the seventeenth century; but a vigorous revival
was in store for them in the century that followed.

The Seventeenth Century
in the Southern Netherlands

The Truce of 1609 marked the political separation of the Northern Netherlands from the Southern Netherlands. The latter, which included Flanders, Brabant, and the Walloon districts, remained subject to Spain, and was represented by a governor who was usually an archduke. In the first half of the seventeenth century these governors were ostentatious and maintained a Court at Brussels. The Archduke Albert of Austria and his wife the Archduchess Isabella, the first governors of the Southern Netherlands in the seventeenth century, extended their protection to Rubens, as did their successor. None the less, the main artistic centre was not at Brussels but at Antwerp. In 1648 the closing of the Scheldt reduced the economic power of this city, yet during the second third of the century its wealth made a great centre of the arts possible. Here, by virtue of his genius, recognized throughout Europe, Rubens exerted a kind of sovereignty over the painters, and his work has given Antwerp an outstanding position in the history of Baroque art.

PAINTING
The study of Flemish art in the seventeenth century is best approached through painting, not through architecture; for the architecture of this region was about half a century behind that of Rome, the centre of the new movement, while its painting was in advance. The Baroque rhythm of the composition-in-movement, which Rubens was practising with mastery by about 1618 in such a picture as the *Battle of the Amazons* (*Ill. 47*), was not achieved in Rome until rather

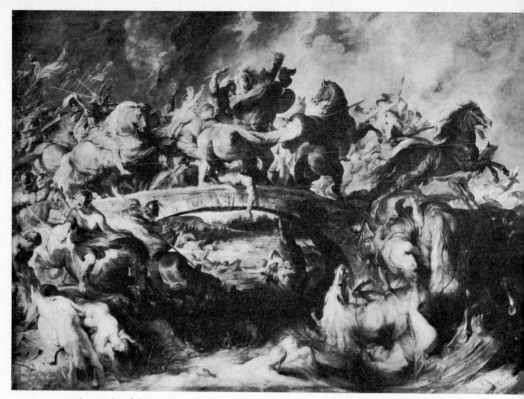

47 *The Battle of the Amazons*, by Rubens, Alte Pinakothek, Munich. Painted by Rubens in about 1618, when he was still young, this shows to the full the impetuosity of his talent. The whirlwind composition is typically Baroque, while the horse charging headlong into the fight was an image perfectly suited to this artist's passionate temperament.

later – between 1626 and 1631 – in a comparable picture, Pietro da Cortona's *Rape of the Sabines*.

Rubens (1577–1640) learned his trade during a visit to Italy which lasted several years (1600–1609). At this time he was hardly more than a tentative pupil, respectfully studying the masters; but he did receive some noteworthy commissions for churches, and became Painter-in-Chief and Artistic Adviser to Vincenzo II, one of the Gonzaga dukes of Mantua, whom he persuaded to buy Caravaggio's *Death of the Virgin* when it was rejected by the Church of Sant'Anna dei Palafrenieri in Rome. Such a picture as the *Fermo Annunciation*, painted between 1606 and 1608, of which he later made another

version for the Church of St Paul in Antwerp, shows that he was already in full possession of his art by the time he returned, in 1609, to the great port on the Scheldt. In 1613 he made a sensation with his *Raising of the Cross* (commissioned in 1610 by the Church of St Walburg, and now in Antwerp Cathedral), and he repeated the exploit by painting, between 1611 and 1614, his *Descent from the Cross* (now also in the Cathedral).

Before Rubens Flemish painting had been an intimate art, constantly showing traces of its origin in pictures meticulously painted for close examination by art lovers. Flemish artists, when called on to produce large-scale compositions, contented themselves with magnifying the dimensions of easel pictures; the result being those figures floating about in empty and unstable compositions, characteristic of the Mannerists. Rubens brought back from Italy the feeling for compositions on the grand scale where the figures were life-size or larger than life – figures on a scale proportionate to the space. This idea of integrating subject into space was essentially Baroque, and Rubens is the painter who embodied it in the most masterly conceptions. His pictures are not autonomous definitions of space – as

48 *The Château de Steen*, by Rubens, National Gallery, London. At the end of his life, Rubens's art tended to be meditative. His favourite dwelling-place was a country-house just outside Antwerp, from which his gaze could lose itself in the limitless calm of the Flemish plain.

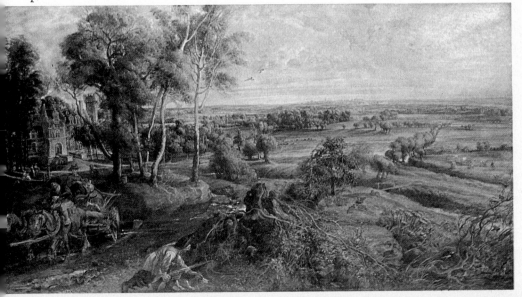

are the pictures of the Italians of the *Seicento*, who never completely succeeded in freeing themselves from concepts so firmly implanted by the Renaissance; each is a moment in the existence of the space in which we live, suddenly crossed by a drama which materializes in forms and colours. Strictly speaking, Rubens does not compose, for this presupposes an operation of analysis and deduction followed by a synthesis; in a single impulse his imagination creates a living organism, whose many elements are associated spontaneously in the relationship that is necessary to produce *an action*. Rubens's wonderful handling, which quivers with life, is not merely a form of sensuality, it is a dynamic expression. His brush moves from form to form without ever lingering, in a kind of whirling rush, and out of this nebula of colour and light, as his sketches show, a world comes gradually into being.

Rubens had what the Italians lacked, the feeling for light. Though he had studied attentively the beautifully balanced compositions of the Carracci and had appreciated the corporeal density attained by Caravaggio, he rejected both the formers' abstract lighting and the latter's nocturnal opacity. In his work light is not 'lighting'; it is the matter, the very fluid with which he imbues his colours. And shade for him is not an absence of light, as it is with the Caravaggists; it is a form of luminous vibration, warmer, more muted, more mysterious. Rubens owed this exceptional feeling for light to his Flemish predecessors, deriving it from its source in the art of Van Eyck. It was from there that he took the magic of his transparent handling, and no one after him succeeded in using this technique so felicitously (*Ill. 48*). He made of it a single generous fluid element, capable of evoking any form in the world in all its living truth – that is to say, in that perpetual becoming which is life: animals, trees, plants, threatening mountains and vast plains with limitless skies, old men full of wisdom, muscular heroes, children with flesh like fruit and, above all, those women whose beauty embodies the great force of universal creation – love.

The Italian painters guided the brush across a surface, which they clothed with forms. The Italian nearest to Rubens, Pietro da Cortona, in the most Baroque of his pictures, such as *The Rape of the Sabines* or *The Battle of Constantine*, worked with a movement from side to side and, in accordance with the tradition of that School, associated his forms closely together in a single impetus, yet conceived them as though they were carvings. Rubens, on the other hand, treated the canvas in depth; he came and went outwards and inwards unceasingly, melting his foregrounds into his distances in a unity of space. It was only in their ceiling paintings that the Italians had succeeded in expressing space. They had needed the size of the church naves to burst the bounds of the picture, and in this way they were well within their tradition, which was a tradition of monumental decorative artists. The few square feet of a picture were enough to enable Rubens to suggest a far greater depth of limitless space than Padre Pozzo had created with all his artifices of perspective. In this Rubens also was in the tradition of his own country – that of Van Eyck, who included the whole world in the few square inches of the landscape of his *Rolin Madonna*, and of Brueghel, who, surpassing even Van Eyck, united breadth and depth in the encircling space of his *Merry Way to the Gallows*.

Broken in by industrious study to every kind of technique, and armoured with the tremendous virtuosity which he perfected in the first few years after his return to Antwerp, there was nothing Rubens could not do. He could create in three years (1622–1625) the monumental sequence of the Medici Gallery (*Ill. 49*). In 1635 he could, within a few months, orchestrate his *Triumph of the Infante Ferdinand*. Finally, in the easel pictures of the second half of his life, after his marriage with Hélène Fourment, he could linger over dreams of love and of the universal forces of life and the cosmos (*Ill. 50*). These were pictures he painted for himself, independently of commissions, as the confessions of an enchanted spirit that, when alone, saw the beauty of the world with an intensity heightened by

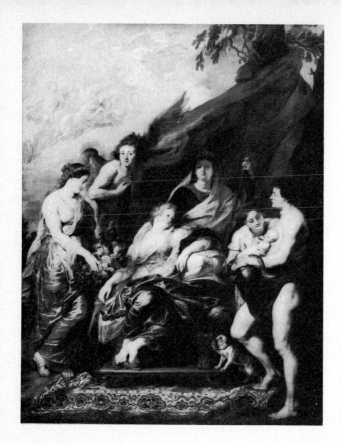

49 *The Birth of Louis XIII*, by Rubens, Louvre, Paris. In three years, 1622–1625, with very little assistance, Rubens painted the twenty-one large-scale pictures which Marie de Médicis, the Queen and Regent of France, had ordered from him, to celebrate the main actions of her life.

the feeling of inevitability that the time was approaching when he must leave it all.

Rubens is, unquestionably, the most nearly universal of painters – more so even than Titian, whose horizons were to some extent limited by the anthropomorphism of the Renaissance. At a time when many artists, now using painting as a means of personal expression, were finding it difficult to fit in with, or were driven to break with, the society that surrounded them, Rubens was the one who with the greatest ease achieved a harmony between the exigencies of his time and those of his spirit, without sacrificing the one to the other – doubtless because he emanated a compelling power of harmony from the balance he had succeeded in creating in his own life.

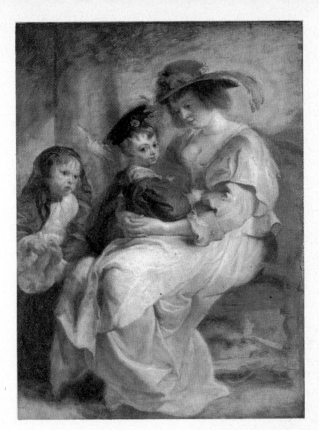

50 *Hélène Fourment and her Children*, by Rubens, Louvre, Paris. Rubens strove to keep all the freshness of a sketch in this picture – a tender representation of his young wife, who was sixteen when he married her at the age of fifty-three, and of two of the children he had by her: Claire Jeanne and François.

All the works of Rubens follow upon one another – one calls forth the others – and together they create a limitless world. Rubens painted a world; Van Dyck (1599–1641) painted pictures. In the 'Italian' manner, Van Dyck was an adept at covering painted surfaces with life. His impressionable temperament enabled him to imitate Rubens in Antwerp so well that, in some cases, historians find it hard to distinguish their pictures. He travelled in Italy from 1622 to 1627 and was sensitive to the art of Titian – but also to the somewhat corrupt atmosphere of Genoa, where he set up his extremely productive studio from 1623 to 1627. At length he found a place agreeable to his refined tastes in the aristocratic Court of Charles I, by whom he was employed in 1620, 1632–1634, and 1635–1641. He modified

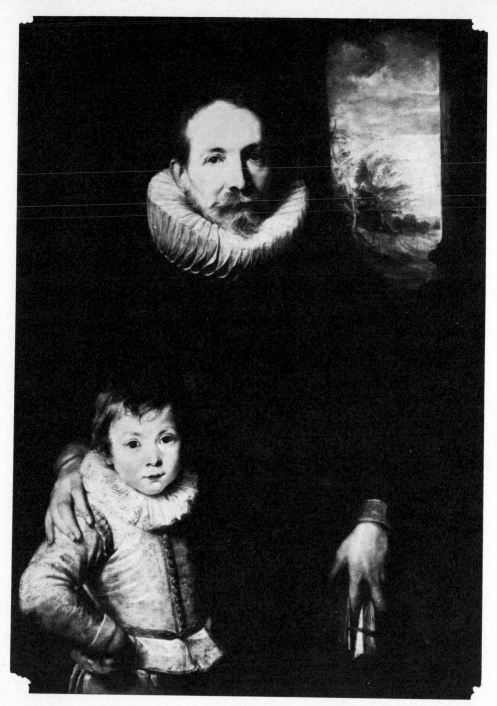

51 *Portrait of Jean Grusset Richardot and his son,* by Van Dyck, Louvre, Paris. This portrait belongs to Van Dyck's Antwerp manner, which was very different from the final manner adopted by him in England. The artist has taken Rubens's flowing handling and has made it his own, but is already concerned to lend a certain distinction to his *bourgeois* sitters.

Rubens's plebeian generosity with the elegance of Titian, and left to posterity the most accomplished image of the 'gentleman' (*Ill. 51*) before Rigaud's development of the portrait of the *honnête homme* at the Court of Louis XIV.

Jacob Jordaens (1593–1678) took Brueghel's peasant subjects and transposed them to the school of Court pictures and pious pictures (*Ill. 52*). The greasy heaviness of his handling, in contrast to the fluidity of that of Rubens, seems an expression of the soil.

52 *The Four Evangelists*, by Jordaens, Louvre, Paris. In the seventeenth century, following the example given by the Carracci and by Caravaggio, painters depicted the Evangelists as robust men of the people. This picture, which dates from between 1620 and 1625, is painted in vigorous and thick brushwork – a technique very different from that of Rubens.

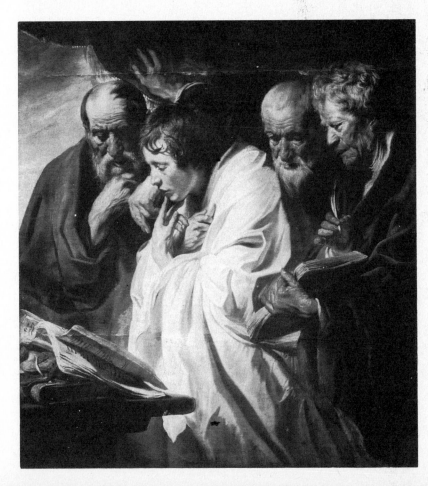

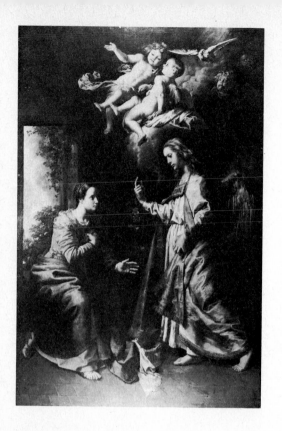

53 *Annunciation*, by Theodoor van Loon, Scherpenheuvel Onze Lieve Vrouwekerke (Montaigu), Antwerp. In Antwerp itself there was a whole school of painters who seemed unaware of Rubens's existence: they went back to the old Flemish tradition of Veenius and Van Moort, enriched by Italian influence. Theodoor van Loon recalls the first-generation Caravaggists.

Among the Antwerp artists who took up the new 'Italian' manner with its life-size figures, some – such as Gerard Seghers (1591–1651), Theodoor van Thulden (1606–1669), Caspar de Crayer (1584–1669), and Erasme Quellin II (1607–1678) – underwent the attraction of Rubens, with whom on occasion they collaborated, but soon leaned towards Van Dyck, whom they found easier to assimilate. Others such as Jan Janssens (1590–1650), Abraham Janssens (1573/4–1632), and Theodoor van Loon (*c.* 1581–1667) – formed a centre of resistance and turned their attention more towards Italy (*Ill. 53*). Cornelis de Vos (1584–1651) was a meticulous portraitist, more of a craftsman than a painter.

One type of painting practised by Rubens originated a *genre* – that of the 'hunting scene', where man and exotic beasts or game from

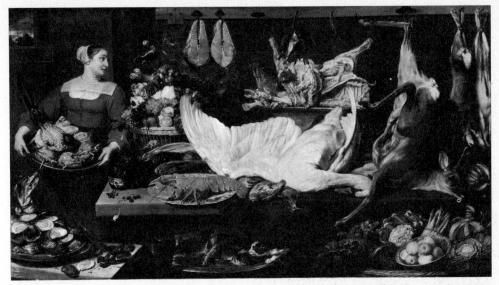

54 *The Larder*, by Frans Snyders, Musées Royaux des Beaux-Arts, Brussels. The *genre* of the still life composed of things to eat was created at the end of the sixteenth century by the Antwerp painter Pieter Aertsen. Frans Snyders gave it a decorative amplitude that belongs to the Baroque spirit.

our own part of the world were brought together in compositions full of movement. Frans Snyders (1579–1657) and Paul de Vos (1596–1678) took up this *genre*, one of them with real painterly felicity, the other as a mere supplier. Game and all sorts of other things to eat led on to life-size still-life paintings, which Snyders executed in a decorative manner (*Ill. 54*) and Jan Fyt (1611–1661) with a sensuousness that proved equal to rendering the unctuous quality of the fur and feathers and the flesh of the fruit (*Ill. 55*).

55 *Trophies of the Hunt*, by Jan Fyt, Albert New-port Gallery, Zürich. The animals, alive or dead, painted by Jan Fyt have less decorative value than the compositions of Sny-ders, but he was the more skilled of the two at rendering the quality of pelt and plumage.

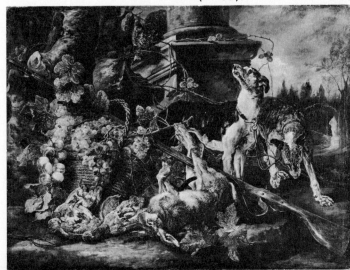

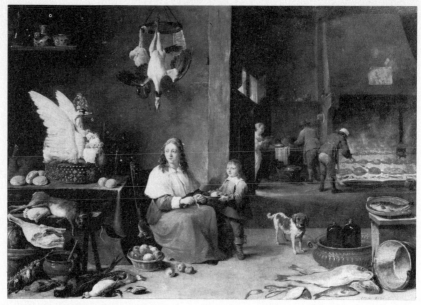

56 *The Kitchen of the Archduke Leopold William*, by David Teniers the Younger, Mauritshuis, The Hague, the best of the so-called '*genre* painters' in Flanders. He produced pictures on a small scale, carried out with fine brushes in silver-grey tones and representing rather conventional scenes of popular life.

All these artists belong to what might be called the Flemish 'grand manner'. But the 'little manner' – that of the traditional small easel paintings – was continued by a large number of painters who specialized in it. Landscape painters were very numerous – many of them, such as Paul Bril (1554–1626), Kerstiaen de Keuninck (*c.* 1560–1632/5), and Joos de Momper (1564–1635), still belonged to the sixteenth century. Roeland Savery (1576–1639) continued the dramatic mode of Mannerism. Jacob d'Arthois (1613–1686) and Lodewijk de Vadder (1605–1655) were more modern, but more superficial. Landscape painting merged naturally into *genre* painting, of which the chief representative was the second David Teniers (1610–1690). He painted a conventional peasantry in pictures bathed in a charming silver-grey light (*Ill. 56*). Adriaen Brouwer (1605/6–1638), who had lived in Holland, introduced into *genre* painting the free style of Frans Hals. Jan Siberechts (1627–1700/3) touches us with a more straightforward realism (*Ill. 57*).

Antwerp was a great centre of flower painters, and exported swarms of specialists in this *genre* – Ambrosius Bosschaert the Elder established himself at Middelburg and at Utrecht, Roelant Savery at Utrecht, and Jacques de Gheyr at Leyden, while Abraham Brueghel went to Naples. The most gifted of these painters was the Jesuit Daniel Seghers (1590–1661), who loved to wreathe his Madonnas with garlands of flowers (*Ill. 58*).

The traditions of the previous century were so tenacious that, side by side with the 'grand manner' decorative style of Snyders and Fyt, certain artists such as Osaias Beert (*c.* 1580–1624), Clara Peeters (1594–1657), and Jacob van Es (1596?–1666) continued to produce still-life paintings of a mixture of objects, in a style derived from the foregrounds of the sixteenth-century pictures.

Of these painters in the 'little manner' one only was gifted with genius – this was Jan Brueghel (1568–1625), known as 'Velvet' Brueghel, who painted with equal felicity landscapes, flowers,

57 *The Sleeping Peasant Girls*, by Jan Siberechts, Alte Pinakothek, Munich. In Flemish *genre* painting the representation of country life remained somewhat conventional. The exceptionally vigorous naturalism with which Jan Siberechts rendered landscapes, peasants and farm beasts makes one think of Courbet.

58 *Madonna and Child in a Garland of Flowers*, by Daniel Seghers, Gemäldegalerie, Dresden. Flower painting was established in the Netherlands by Jan Brueghel, Roelant Savery and Abraham Bosschaert. The best of the Flemish flower painters – after Jan 'Velvet' Brueghel – was a Jesuit father, Daniel Seghers: he specialized in painting garlands to surround Madonnas.

genre, and allegory. He was the only one to assimilate, while reducing it to a miniature scale, Rubens's transparent handling, and some of his 'earthly paradises' or his allegories of the senses teem with intense life (*Ill. 59*).

ARCHITECTURE AND SCULPTURE

Architecture in the Southern Netherlands was confused in style and not very original. Commissions for secular buildings were unimportant, since the capital was only the seat of the governors representing Spain, and the Court had not much influence there. Besides, the ruling class was composed of *bourgeois*, and these were content with houses of modest dimensions, stretching back from narrow fronts placed in line along the streets. These fronts displayed Classical orders arranged in tiers, which fitted in well with the fenestrated system

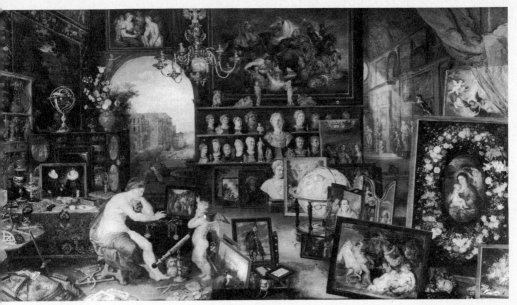

59 *Sight*, by Jan 'Velvet' Brueghel, Prado, Madrid. Jan 'Velvet' Brueghel was the most gifted painter of the Flemish School after Rubens. A painter of small pictures, his curiosity was aroused by a wide variety of natural objects – flowers, fruit, landscapes – and by human activity, ranging from peasants working in the fields to the mania of a collector.

of architecture handed down from the Middle Ages. The chief ornament was the stepped pediment, decorated with volutes.

The greatest building enterprises were religious; in them the Jesuits, who enjoyed strong protection from the Archduke Albert and the Archduchess Isabella, played a very active part without, however, hastening the adoption of the characteristic features of Roman architecture. Although the pilgrimage-church at Scherpen-heuvel, by Wenceslas Cobergher (*c.* 1560–1634), had already, in 1609, a dome crowning a central ground-plan, the basilical ground-plan – sometimes with an ambulatory – remained usual and even retained the Gothic form it had acquired in the fifteenth century. The finest church of the first half of the seventeenth century – that of St Charles Borromeo in Antwerp, built by two Jesuits, François Aguillon (who died in 1617) and Pieter Huyssens (1577–1637) – has

77

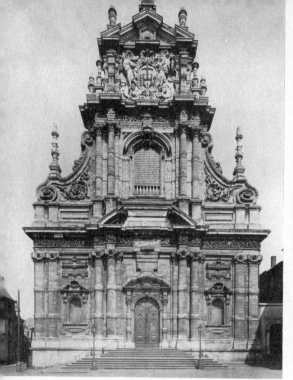
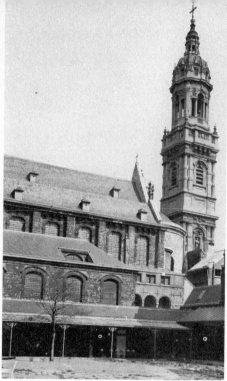

60–61 St Michael, Louvain. St Charles Borromeo, Antwerp. A comparison between St Charles Borromeo in Antwerp and St Michael in Louvain shows the progress of the Baroque. The former still belongs to Mannerism, the successor of the Renaissance – architecture did not become overtly Baroque till the second half of the century.

a nave and side aisles. Its interior, for which Rubens acted as adviser and painted a ceiling, was covered with rich polychrome ornamentation in the manner of the churches in Rome (it was destroyed by fire in 1718). The façade, however, with its dominant vertical lines and its ornamentation distributed in compartments, still belongs, like the belfry (*Ill. 61*), to the Mannerist conception. The real Baroque architecture at this time was created in painting and in the structures put up for the triumphal entry of the Infante Ferdinand (1635) by Rubens, who had published a book on the palaces of Genoa. Rubens also built, next door to his house in the Flemish style, an Italianate palace, which was later in part destroyed, but has been restored.

Romanization took place in the second half of the seventeenth

century. A good example of it is the Jesuit Church of St Michael at Louvain (1650–1671), built by Guillaume Hesius, with a ground-plan and façade (*Ill. 60*) derived from the Gesù and with a fine scheme of ornamentation in white marble. The reconstruction of the Grand Place in Brussels, destroyed by the Maréchal de Villeroi's bombardment in 1695, was begun in 1696 and carried out during the eighteenth century, yet still kept to the old manner. Except on the east side, the square rejects the discipline of a uniform programme as introduced by the architects of Louis XIV. The deliberate variety of its many houses, grouped about two Gothic buildings, is attractive.

The Southern Netherlands produced a whole nursery of carvers in stone and wood, among whom there were whole families of artists, such as the Duquesnoys, the Quellins (*Ill. 62*), and the Verbruggens. There were so many of them that some emigrated to England, Germany, Holland, Italy, and France. François, or Francesco, Duquesnoy joined the Roman School; Jean Warin, Van Obestal, Buyster, and Desjardins (Van den Bogaert) went to France, attracted by the Court at Versailles. Commissions, almost all religious, were plentiful in the Southern Netherlands. They were mostly for funerary monuments and for church furniture – monumental altars, choir screens, *ex votos*, and pulpits. In Belgium the style of Bernini was assimilated more quickly in sculpture than were the Roman fashions in architecture. To this the influence of Rubens certainly

62 *God the Father*, by Artus Quellin II, Bruges Cathedral. The generous plasticity of his work, its stresses on gesture, its opulence and its handling of draperies make Quellin almost a rival – in sculpture – of Rubens.

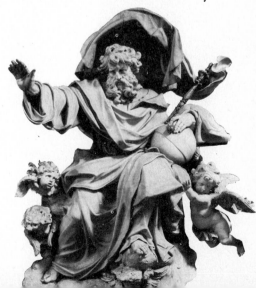

contributed (Luc Faydherbe, 1617–1697, for example, was his pupil), while the Walloon sculptor Jean Delcour (1631–1707), collaborated with Bernini in Rome for ten years.

Often a church's chief ornament was a gigantic pulpit, covered with statues – at times almost a theological encyclopaedia. This kind of furnishing made its appearance round about 1660. Henri-François Verbruggen introduced movement into it, for instance in his pulpit in the Church of St Peter and St Paul at Malines (1699–1702) (*Ill. 63*).

THE MINOR ARTS

The output of the Brussels tapestry factories remained brilliant during the whole of the seventeenth century. The very quality of abundance in the art of Rubens, who supplied these factories with several series of cartoons, suited tapestry well. In the second half of the century the style became lighter, when the influence of the Gobelins output began to make itself felt.

The importance of Antwerp as a centre of publishing gave great encouragement to the art of engraving. Carefully executed book illustrations and separate prints spread Baroque imagery throughout Europe and beyond, aided for a while by encouragement from Rubens.

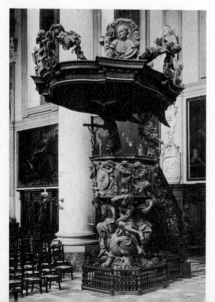

63 The pulpit of St Peter and St Paul, Malines, by Henri-François Verbruggen. In the Germanic lands during the eighteenth century, and in Belgium by the seventeenth, the pulpit had become an iconographic vehicle for expressing the truths of the Faith in figures whose style was borrowed from the eloquence of the preacher. Indeed, the pulpit was called the '*chaire de vérité*'. In France the sermon was cultivated as a literary *genre*.

The Seventeenth Century in the United Provinces

At the beginning of the seventeenth century, with the Truce of 1609, the Northern Netherlands won their national independence. The new nation, known as the 'United Provinces', was distinguished from the rest of Europe by its democratic constitution and Calvinist religion. This had important consequences for the arts. While Calvinism allowed no decoration in the churches, the democratic system was hostile to sumptuous display by the more rich or powerful citizens. Thus the ostentation which led, in most of Europe, to large-scale commissioned works of art was almost absent in Holland. The only grand edifice constructed there in the seventeenth century was the City Hall of Amsterdam, built after the Treaty of Westphalia in honour of the new liberal institutions. The finest dwelling-houses were of modest size, and country palaces kept more or less to the medieval plan. There was therefore little scope for the development of sculpture. Painting, on the contrary, enjoyed the favour of a *bourgeois* society which was susceptible above all to realism.

Holland's liberal institutions, of which Descartes sang the praises, made that country a haven of refuge in a divided Europe – from all parts of Europe the Protestants, Jews, and political exiles found refuge from persecution and contributed to the country's intense scientific and intellectual development. This did not prevent theological disputes within Calvinism from flourishing, and the Dutch Protestants, like the Catholics, were divided over the problem of Grace. These preoccupations with human fate are reflected in the work of Rembrandt.

In the second half of the seventeenth century the United Provinces became a strong nation, in spite of the smallness of their territory and population. This little people proved capable of facing up to the greatest Power of the time, that of France – having already beaten the greatest Power of the sixteenth century, Spain, from which it had won its liberty by force. But the great rise of its arts took place in the first half of the seventeenth century, at a time when the nation still had to consolidate its existence and to build up the wealth it now found in trade and expansion by sea.

ARCHITECTURE AND SCULPTURE

Though insignificant in size, the monuments of Dutch architecture are not, as has sometimes been maintained, negligible. To Holland, in fact, belongs the merit of having laid down the bases of the Classicism which was only later to reach France and England. Its architects were certainly helped towards the conception of Classicism by the sobriety which the democratic system imposed on secular building and by the avoidance of images in the churches. This Classicism began in about 1630 in the province of Holland, which tended to take the lead in the United Provinces. Before this date, the buildings constructed by Hendrick de Keyser (1565–1621) in Amsterdam during the first quarter of the century (Zuidekerk, Westerkerk) (*Ill. 64*) were still dependent on the Mannerist system of proportions, though ornamentation was already more sober. The revolution – the word is not too strong – was accomplished between 1630 and 1640 by two architects, Jacob van Campen (1595–1657) and Pieter Post (1608–1669), at the time when Descartes's friend, Constantin Huygens, Secretary to the Stadtholder Frederick Henry, set the tone of intellectual life at The Hague. Jacob van Campen and Pieter Post replaced the dominance of vertical lines – an inheritance from the Northern tradition that was still in use at the beginning of the seventeenth century – by a tendency to horizontalism, marking the centre of the building by a few colossal stone pilasters of the

82

64 The Westerkerk, Amsterdam, from a plan by Hendrick de Keyser. De Keyser carried out the first stage of the work of purifying the complicated Mannerism elaborated in the northern provinces during the second half of the sixteenth century. In so doing, he prepared the way for Dutch Classicism.

Corinthian order bearing a triangular pediment, and surmounting the cornice with a pavilion roof; the shell of the building was of brick, stone being used only for the columns and quoins – as in the Mauritshuis at The Hague (1633) (*Ill. 65*). This very sober arrangement prevailed throughout the century, being enriched only after 1670 with a little more ornamentation (swags between the two pillars and a decorated pediment). The Amsterdam City Hall, designed by Jacob van Campen, is of this type, but it was built with two tiers.

The Dutch Protestants found plenty of places of worship in the existing Catholic churches, which they stripped of their decorative features. When new churches were required, they hesitated between the basilical ground-plan and the central one (which is more suited to Protestant worship). The only decorative features in the interior were the organ and the wooden amphitheatre of seats. The exterior

was Classical in style. Of the palaces of this period almost the only survivor is the Huis ten Bosch at The Hague, which is laid out like a French château. It contains a *salon d'honneur*, decorated for Amalia de Solms with Baroque paintings by Jordaens and other Flemish artists in memory of her dead husband, the Stadtholder Frederick Henry. This Baroque decoration is the only example in Holland, and it is significant that the artists had to be brought in from Antwerp.

Towards the end of the century the spreading influence of the art of the Court of Louis XIV – arch-enemy of the Netherlands – drew Dutch architecture towards a slightly greater ostentation. Châteaux with great gardens in the French style were built, but all of these have now been destroyed.

The system of architecture introduced by Pieter Post and Jacob van Campen was destined to have wide repercussions all over

65 The Mauritshuis, The Hague. With its large stone pilasters carrying an architrave, the house begun in 1633 by Jacob van Campen is completely Classical in spirit.

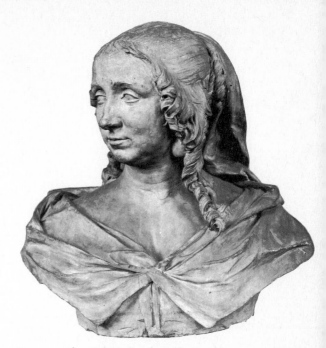

66 The Bust of Maria van Reygersberg, by Verhulst, Rijksmuseum, Amsterdam. There is very little Dutch sculpture. In the portrait busts which he produced, Hendrick de Keyser was still traditional. Rombout Verhulst introduced the lively style, with the accent on movement, practised by the Italians (Bernini) and the French (Coysevox).

Northern Europe. It spread in time to the Rhineland and into Scandinavia, and influenced the English in their search for their own Classicism.

Sculpture was rare in Holland because occasions for commissioning it were few. Moreover, the Dutch had a certain distaste for relief carving and preferred paintings. Sculptors did, however, find work in decorating tombs and wooden pulpits. These had not the allegorical character of the pulpits of the Southern Netherlands. Throughout the century, the Dutch – like the French and the Italians – were fond of having portrait busts made of themselves. The best artist producing these was Rombout Verhulst (1624–1696) (*Ill. 66*).

PAINTING

The conditions in which the Dutch painters worked were somewhat different from those in the other countries: there the artists were much more dependent on commissions, though from about 1630 onwards there arose all over Europe (for instance, in the case of

Poussin, of Velázquez, and even of Rubens) a tendency to treat painting as a personal speculation. This tendency found a favourable soil in the situation prevailing in Holland, which was in other respects materially difficult for artists. Portraits apart, the Dutch painters were, in the greater part of their work, artisans specializing in a somewhat narrowly defined type of picture, which they themselves stocked and sold. They had to wait for a customer, and if their pictures did not please – as was the case with Vermeer's, and with those of Rembrandt when he grew old – they were reduced to a precarious existence. Thus the conditions governing modern creative work in the arts began in Holland. There the artist found himself alone, facing unaided a *bourgeois* society, while in the other European countries he exercised a real social function in a princely and ecclesiastical circle with an enormous demand for the visual arts.

In Holland, as in the Southern Netherlands, it is possible to distinguish a 'grand manner' and a 'little manner'. The 'grand manner' made its appearance in the city of Utrecht, where it was advanced by Abraham Bloemaert (1564–1651), and by those native artists who had spent some period of their lives in Italy: Dirck van Baburen (1590–1624), Hendrick Terbrugghen (1588–1629), and Gerard Honthorst (1590–1656). These painters took from the Caravaggesque style, and brought home with them, its picturesque subjects and, above all, its technique of modelling a figure by means of lighting from the side. While Utrecht tended to be a detached branch of the Roman Caravaggesque, the Dutch style proper was formed at Haarlem, chiefly through Frans Hals (1580–1666), painter of portraits and *genre* scenes. Frans Hals inherited from the sixteenth century the tradition of the portrait of a corporation or fraternity (*doelenstuk*); but what had been merely a juxtaposition of effigies became with him an assembly, a collective being through which there passed a kind of vital communal instinct. Like Rubens, he endowed these compositions with movement, not only through the action of figures but through the impassioned action of his brush.

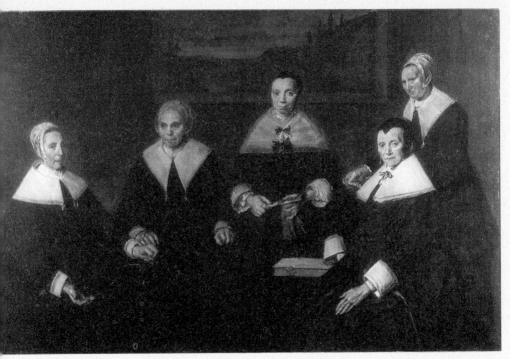

67 *Women Governors of the Haarlem Alms-houses,* by Frans Hals, Frans Hals Museum,
Haarlem. Hals broke up the formal texture of the conventional portraits of his time and
substituted exhibitions of *bravura.* At the end of his life, when he depicted the male and female
governers of the hospital in which he had found refuge, his art had gained an inner quality.

Along with Rubens and Velázquez, Hals was one of the painters who
made touch the painter's chief means of expression. This meant
destroying the impression of calm handling which had become
traditional with the Netherlanders. Formerly, it had been the painter's
point of honour to mask the process of a picture's execution, so as
to attain the closest possible imitation of reality; but, for Frans Hals,
virtuosity consisted in asserting on the canvas his own plastic hand-
writing. From his *Banquet of the Fraternity of Saint George* (1616 and
1627) to his *Governors* and *Women Governors of the Haarlem Alms-
houses* (1664) (*Ill. 67*), Frans Hals followed a line of development
analogous to the one that led Rembrandt from the frank and joyful
sensuality of his youth to the anxious meditation over destiny that
characterized his old age.

87

Rembrandt (1606–1669), more than any other painter, worked at technique with the purpose of forcing it to submit to the impulses that arose from his soul. He began painting in about 1623. From the Utrecht painters he certainly took the methods of the Caravaggesque style, especially its way of bringing the figure right forward and emphasizing it by the harshness of the lateral lighting; but it was perhaps to his master Pieter Lastman, a belated Mannerist, that he owed the more spiritual feeling he began to impart to chiaroscuro. That strange landscape painter Hercules Seghers (who was born round about 1590 and died before 1643) must also have opened his mind to the poetry of the imaginary (*Ill. 68*). Like Rubens – but with perhaps a more personal emphasis, since he was less responsive to commissions than was the Antwerp painter – Rembrandt made painting a means of exploring mythology, history, religious feeling, and the picturesque of life, always with a tendency towards a deepening of the spiritual side.

His career divides into two periods. In 1631, when he went to live in Amsterdam, he at once became highly fashionable as a portrait painter (*Professor Tulp's Anatomy Lesson*, 1632). He made a happy marriage, bought a fine house, and became a collector, so that it might have been thought that his life would be a kind of Amsterdam pendant to that of Rubens in Antwerp. But soon after this he began to make use of commissions to further his own researches (for instance, in *The Night Watch* (*Ill. 70*), 1642), and this estranged his contemporaries. The death of his wife Saskia in 1642 drove him into solitude and confirmed him in his vocation as painter of the inner life. This brought about his decline in favour and his ruin. From 1650 till his death his house in Amsterdam was comparable to an alchemist's study, and in it, all alone, he worked out the magical spells of painting to give his spiritual life free course. Haunted by the figure of Christ, he saw in the Gospels a message of love (*The Supper at Emmaus* (*Ill. 69*), 1648), and this separated him somewhat from the severity of Calvinism, with its belief in the justice rather

68 *The Great Tree*, engraving by Hercules Seghers who led a strange, solitary life, absorbed in his researches, particularly into the technique of engraving. His romantic visions of nature may well have inspired Rembrandt, who owned some of his engravings.

than in the mercy of God. He was also influenced by the Messianic doctrines of the Jewish circles in Amsterdam which he frequented. It may seem paradoxical that, in that century of faith, expressions of the Christian Faith that went deepest of all came, through his brush, from Protestant Holland with its rejection of the use of images in worship – at a time when all Catholic Europe was indulging in a regular orgy of images. But it must be said, against this, that by setting the artist free from all the current

69 *The Supper at Emmaus*, by Rembrandt, Louvre, Paris. Rembrandt stripped his religious subjects of all the iconographic traditions and all the dogmatic rules current in the Catholic world: he went back to the Gospels for the same direct contact which the Protestants sought.

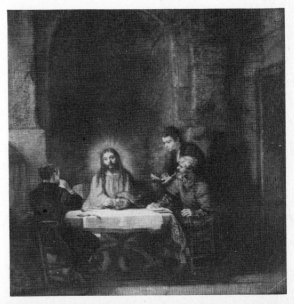

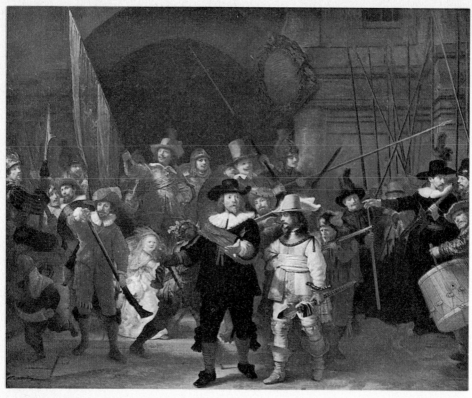

70 *The Night Watch*, by Rembrandt, Rijksmuseum, Amsterdam. A recent cleaning has shown that the painting famous as '*Night Watch*' was nocturnal only because of the dirt that covered it. In fact the company of archers shown in the picture emerges from the shadow, and its leaders, Captain Franz Banning Cocq and Lieutenant Willem van Ruijtenburg, are seen in strong light.

iconographic traditions and from all the priestly directives, which formed a screen between the aspirations of an artist's soul and religion itself, Calvinism set him face to face with the naked truth of the Gospels, and this was a fortunate circumstance for a soul thirsting for God as Rembrandt's was. The works of his last years, in which more and more often he used his own face as model, tirelessly studying in himself the progress of physical decay – messenger of death – are surely the most moving and disturbing intimations of the tragic destiny of man that have ever been transmitted by painting (*Ill. 71*).

71 *Self-Portrait, c.*
1668, by Rem-
brandt, Wallraf-
Richartz Museum,
Cologne. Obsessed
by the life of the
soul, Rembrandt
studied its mysteries
most frequently in
his own features.
He and Van Gogh
are the two artists
who have used the
self-portrait in this
way.

Rembrandt's technique is almost the opposite term to that of Frans Hals and Rubens. Frans Hals, in the intoxication of joyous improvisation, slashes the canvas in all directions with sinewy movements of the brush, and it is similarly the joy of creation that drove Rubens to that constant darting of the brush, never absent from any part of a picture of his. But Rembrandt's brush movement is a kind of kneading of pastes of paint, out of which the picture gradually emerges, a mystery of shade and light.

It is not easy to catch the individuality of the various Schools in Holland, where the cities are so close to one another and exchange

72 *Vice-Admiral Jan de Liefde*, by Bartholomeus van der Helst, Rijksmuseum, Amsterdam. The portraits painted by van der Helst offered the sitter a flattering image, representing him in all the generosity of youth, or in the sufficiency of maturity, or in the wisdom of old age. On each occasion he appears quite content with himself.

between them so easy. Classification by *genres* is easier; it also has the advantage of corresponding to a reality, since most of the artists were specialists.

Portrait painting was the only *genre* that produced pictures in the 'grand manner' – full-length or half-length portraits of an individual, a couple, or an assembly. The portrait painters, whether independent of Frans Hals or derivative from him, confined themselves to a sober, careful, and impersonal craftsmanship which, indeed, was what their clients wanted. Among the more thriving of these excellent artisans of the human effigy mention should be made of Jan Ravesteyn (1572–1657), Bartholomeus van der Helst (1613–1670) (*Ill. 72*), and Thomas de Keyser (1597–1667). But the most sensitive portraits came from some of the painters of the 'little manner', in particular from Gerard Ter Borch (1617–1681); his portraits express a deep

feeling of loneliness – especially those painted after his contact with the style of Velázquez in 1649 (*Ill. 73*).

To speak very generally, Dutch painting derives from the art of the small easel painting, as practised by the Flemish School from the fifteenth century onwards. The Dutch painters of the seventeenth century, jumping a whole century of Mannerism, made a direct link with the conception of painting as the mirror of reality, which had been started by Van Eyck and had had no immediate sequel. In pictures executed very carefully with fine brushes and a surface of light scumbles (which often let the wood panel speak through), the Dutch painters set out to give the most exact image they could of everything that surrounded them – the picturesque details of social life, the secret world of domestic life, familiar objects, and the out-door scenes of both town and country. One of the causes of this attachment to realism may be seen in the mental outlook of a society of merchants, for whom only the positive effects of daily life had meaning. That there was almost no opera in Holland confirms that the Dutch mind was not much tormented by the need for an escape into

73 *Portrait of a Young Man*, by Gerard Ter Borch, National Gallery, London. Ter Borch is the artist in whose work we can discern traces of that anguished view of destiny which tormented the Calvinists – but which the middle-class civilization of Holland tended to minimize. Later, he went to Spain and came under the influence of Velázquez.

the imaginary, then characteristic of other European countries. Another cause may be the Calvinist ethic, which looked on the possession of worldly goods as one of the springs of human dignity. But if we can manage to lay aside the prejudice against figurative art which limits freedom of appreciation in our own time, we cannot help considering as profoundly human a school of painting that directed its whole activities towards expressing the image of a civilization in all its forms. And finally, how can anyone who really loves painting fail to be attracted by those marvellous small worlds realized by a brushwork that, for all its meticulousness, keeps its sensibility from being weakened by repetition and follows out the fine shades of the light with so much love? And how deep a sincerity is implied in that humble attitude towards nature!

An incredible number of artists practised *genre* painting – clear evidence of its success with its public. They reproduced picturesque scenes of military life, family life, the tavern, and the inn. They amused a society which, emerging from the heroic period, was tending to stabilize itself in a *bourgeois* conformism. *Genre* painting, stemming from Frans Hals, was 'miniaturized' by his brother

74 *The Mill a Wijk*, by Jacob van Ruisdael, Rijksmuseum, Amsterdam. A Dutch landscape consists essentially of sky dominating low-lying land, where water (whether it be the sea or some canal) frequently reflects the clouds. In the work of Ruisdael the feeling of infinity, in which man seems lost, attains a Pascalian gravity.

75　*A Young Woman Standing at a Virginal*, by Vermeer, National Gallery, London. In a picture by Vermeer the decorative details often have a symbolic significance: a map or a landscape suggests the outside world, and the cupid holding a letter refers to the absent young man whose memory the girl is evoking as she plays a virginal or lute.

Dirck (1591–1656) and his pupil Hendrick Pot. From Haarlem it spread throughout Holland – in the work, for instance, of Pieter Codde (c. 1599–1678), W.C. Duyster (c. 1599–1635), and Jacob Duck (c. 1600–1667) (*Ill. 76*).

At Haarlem also Dutch landscape painting was developed. Salomon van Ruysdael (1602–1670) took from Jan van Goyen (1596–1656) the amphibious landscape, where nothing seems to exist but sky and water. Jacob van Ruisdael (1628/9–1682), Salomon's nephew, learned to express the grandeur of that flat country dominated by the sky, with its feeling of infinity and the fearfulness of solitude (*Ill. 74*). He gave rise to many imitators at Haarlem and at Amsterdam. In Amsterdam, Meindert Hobbema (1638–1709) crushed the poetry of Jacob van Ruisdael under the heaviness of his realism, while Aert van Neer (1603–1677) specialized in night scenes. Others took the scenery whose lonely grandeur Ruisdael and Hobbema had tried to express, and peopled it with picturesque life

76 *Division of the Spoils*, by Jacob Duck, Louvre, Paris. At the time when Jacob Duck and Pieter Codde were painting, the disturbances caused by the wars of religion were long past, and representations of the excesses of the soldiery had become a picturesque theme that amused middle-class society.

77 *View of the Westerkerk, Amsterdam*, by Jan van der Heyden, Wallace Collection, London. All aspects of Dutch scenery were treated by the painters. Several of them specialized in urban scenes, and the artist who best expressed the atmosphere of the Dutch cities was van der Heyden.

(Philips Wouwerman, 1619–1668; Jan Wynants, 1630/5–1684). Others again – such as Willem van de Velde the Elder and Younger (1610–1693 and 1633–1707) and Johannes van de Capelle (1624/5–1679) – specialized in marine pictures. There were painters who concentrated on city landscapes (Gerrit Berckheijde, 1638–1698; Jan van der Heyden, 1637–1712) (*Ill. 77*), and others who devoted themselves to depicting church interiors (Pieter Saenredam, 1597–1665 (*Ill. 78*); Emmanuel de Witte, 1617–1692).

It is in the still lifes and paintings of home life that the direct descent of seventeenth-century Dutch painting from fifteenth-century Flemish realism is most clearly perceptible. The two *genres* are indeed closely connected. The love for those familiar objects upon which the still-life paintings concentrate made its appearance

97

78 *Interior of the Grote Kerk, Haarlem,* by Pieter Saenredam, National Gallery, London. The painters who depicted churches were for the most part merely accurate illustrators: only one of them, Pieter Saenredam, expressed in his pictures the intimidating nakedness of these Protestant churches, with their complete lack of images and ornamentation.

in the Netherlands in the fifteenth century as an element in the religious pictures of Jan van Eyck, and indeed in the Master of Flémalle. At the end of the sixteenth century, both in the Northern Netherlands and in South Germany, the still life detached itself from secular and religious compositions and became an independent *genre*. In the first part of the seventeenth century, still-life painting was descriptive; the victuals and other objects were laid out or heaped together as though to facilitate an inventory, as, for instance, in the paintings of Floris van Schooten (who was still living in 1665). A second stage followed, in which still-life painting became an art of great refinement, based on a subtle pursuit of composition, colour, and light. The difference between the heaps of David de Heem (1570–1632) and the harmonies of Jan Davidsz de Heem (1608–1684) neatly illustrates this progress. Willem Claesz Heda (1594–*c*. 1680/2) and Pieter Claesz (1596–1661) achieved highly sophisticated compo-

sitions with harmonies that were almost monochrome (*Ill. 79*), while Abraham van Beijeren (1620/1–1675) went in for rather facile effects of abundance, and Willem Kalf (1619–1693) for a sensual treatment of objects.

Flemish painting in the fifteenth century had also been interested in the expression of enclosed space, limited by the walls of a room. The Master of Flémalle and Rogier van der Weyden had treated this theme empirically, but the pursuit of it seems to have been fully conscious in the Van Eycks. The Dutch painters took up these researches at the point where the Flemish artists had left them when Italian influence deflected the Netherlands from their own tradition, and several generations of artists now devoted themselves to exploring the limits of the enclosed space constituted by an interior, and to defining the relative positions of the objects that furnished it and the human beings who lived in it. In the first generation of the Haarlem *genre* painters, this was still only empirical. They still peopled the houses with noisy companies (Pieter Codde, Molenaer, Koedijck, Hendrick Pot); but it became conscious research in the second

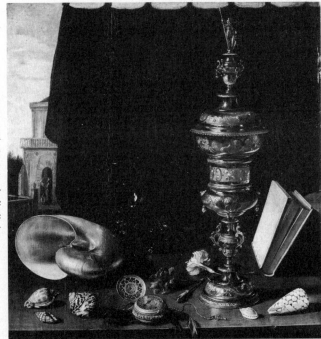

79 *Still life*, by Pieter Claesz, Gemäldegalerie, Dresden. In the seventeenth century, both in France and in Holland, the still life was a favourite *genre* and was given a philosophical significance. The objects grouped together by the painters suggest both the invisible presence of the man whose silent servants they are, and the fragility of the life to which they are linked.

generation – that of Gerard Ter Borch (1617–1681), Gerard Dou (1613–1675), and Gabriel Metsu (1629–1667). In these men's work the space enclosed by the room is felt as a secret place, a refuge of private life, where human beings belonging to a society of considerable refinement indulge in music or in conversation, are seen dressing, or are caught at a moment of silence when, pensive and alone, they seem to be aware of the sadness of the human condition (*Ill. 80*). One needs to be familiar with these pictures to discern, beneath their apparent placidity, the artifices of composition and lighting by which these delicate artists contrive to organize that small space so as to concentrate our interest on the human being who was its soul.

These researches all culminated in Johannes Vermeer (1632–1675), who worked, almost unknown, in the provincial city of Delft

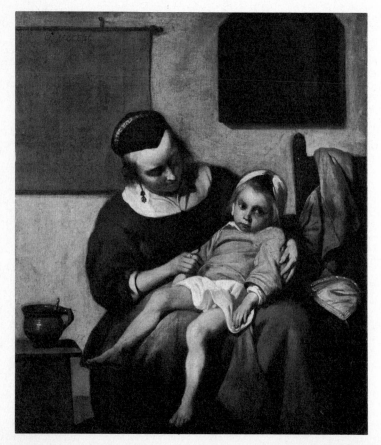

80 *The Sick Child*, by Gabriel Metsu, Rijksmuseum, Amsterdam. Of all the so-called '*genre* painters', Metsu was the one with the most painterly sensibility. Gerard Dou (who was more successful) inclined towards a literal reproduction that rendered human beings and objects lifeless.

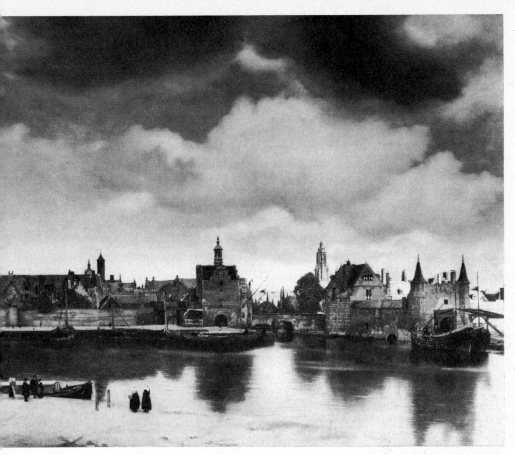

81 *View of Delft*, by Vermeer, Mauritshuis, The Hague. This is one of the two landscapes by Vermeer: the fascination it exerts over the spectator is due to the magic of the light, which seems really to be the soul of the world.

(*Ill. 81*), then inhabited by a highly distinguished society. Strange as it may seem in view of the difference of their subject-matter, Vermeer owed a great deal to the Caravaggesque painters of Utrecht, from whom he took up again the use of lighting from the side; the last pictures of Terbrugghen were, in their colouring, direct forerunners of Vermeer's work (*Ill. 75*). What chiefly distinguished Vermeer from many artisans was the way in which he, like Rembrandt, deepened the human and artistic range of his art. He

died at the age of forty-three, unappreciated and, so it seems, in poverty, leaving only a small number of pictures (about forty now survive), each one of them evidently the result of long meditation. Abandoning the illusionist method, Vermeer formed a kind of *pointilliste* technique of his own, made up of luminous pricks of colour that give intensity and a crystalline purity to the small space of the picture. With him, as with Rembrandt, though the means they used were opposed, light is the instrument for exteriorizing in images the mysterious life of the soul. Pieter de Hooch (1629–c. 1684) tried in vain to assimilate the technique the Delft master had made his own. Out of what had been light he drew only effects of lighting.

Thus, thanks to Rembrandt and Vermeer – one by his emotional power, the other through the virtue of silence – Protestant Holland gave to seventeenth-century Europe, tormented as it was by the mysteries of the soul, its deepest expressions of the inner life.

THE MINOR ARTS

A Dutch house contained few pieces of furniture. The principal one was the huge wardrobe in which the Dutch housewife kept her linen. Through the seventeenth century this furniture retained the monumental squareness inherited from the Renaissance and the Middle Ages.

But Holland excelled in two of the minor arts – silversmiths' work and pottery. Inside those calm houses with their Classical façades the Dutch displayed sumptuous objects of silver from the workshops of Paulus van Vianen (1555–1614) (*Ill. 82*), Adam van Vianen (1565–1627), or Johannes Lutma (1585–1669), executed in a Baroque style (derived straight from German Mannerism) which, by a curious paradox, surpasses in extravagance everything that was made in the rest of Europe at this period. At the same time other silversmiths were working in a more sober manner, which became the rule at the end of the century.

82 Silver dish, by Paulus van Vianen, 1613, Rijksmuseum, Amsterdam. Holland was the European country which produced the best goldsmiths and silversmiths in the first half of the seventeenth century. Strangely enough, they retained the complicated style of Mannerism and moved on towards an exuberant Baroque, just when architecture was developing in the direction of a strict Classicism.

Dutch art went far beyond the frontiers of Holland, thanks to what – though it came from various cities – is known as Delft pottery. At first the aim had been to imitate the pottery imported from China, but at the end of the seventeenth century Delft acquired its own independent style in which the decoration, though sometimes polychrome, is usually confined to blue. Besides dishes and vases, the

Dutch potters produced figurative compositions of tiles used for decorating houses (*Ill. 83*), and orders for these were sometimes received from abroad.

83 Dutch Tile picture of oriental flowers and birds, Victoria and Albert Museum, London. Pottery, chiefly in the form of vases of many shapes, or of tiles assembled into ornamental or figurative compositions, grew to the proportions of an industry in Holland. Its products were imported by all the countries of Northern Europe, by Portugal and even by Brazil.

The Seventeenth Century in the Germanic Countries

At the end of the sixteenth and beginning of the seventeenth century a brilliant Germanic civilization flourished in Prague, at the Court of the Emperor Rudolph II. This city was then one of the important centres of the international Mannerist style. Indeed, German art seemed set to develop towards a direct transition from Mannerism to Rococo, but this movement was interrupted by the disasters of the Thirty Years War, which from 1618 to 1648 devastated all the Germanic lands. It was not till 1660–1670 that artistic activity was resumed with any intensity, for Germany, on emerging from this crisis, had practically to start again from nothing. These events enabled Austria to acquire political dominance and to play the leading role in civilization, aided by the Habsburgs' almost undisputed monopoly of the Imperial title.

The period from 1600 to the beginning of the Thirty Years War saw the continuation of Mannerist art. Architecture remained faithful to Flemish Mannerist principles based on the books on ornamentation. This passion for ornamentation worked out by purely graphic methods preoccupied such artists as Wendel Dietterlin of Strasbourg, who treated the orders as poetic themes and drew from them luxuriant forms (*Ill. 84*); this style can be interpreted as a renewal of the Gothic spirit, but it is a forerunner of the Baroque. The wood-carvers who worked on the decoration of interiors and on church altar-pieces were content to base their art on these elaborations of ornament – the Zürns applied this restless style to statues.

This art spread into the Scandinavian countries, and one of the

finest examples of this flowery Mannerism is the Chapel of Frederiksborg Castle (1602–1620), a treasure-house of goldsmiths' work on a monumental scale.

85 The Wallenstein Palace, Prague, took from 1625 to 1629 to build. Three Milanese architects were responsible for it and it was one of the first Baroque buildings in Central Europe.

The influence of the new style of Italian art was brought in by the Jesuits, who built several churches and colleges in the Germanic lands. The Electors of Bavaria favoured this Ultramontanism, and it spread without restraint, during the Thirty Years War, in those territories which avoided the horrors of the conflict and were dependent on the Habsburgs. From 1623 to 1629 Wallenstein had a great palace in the Italian manner built for him in Prague by Milanese architects (*Ill. 85*), and his example was later imitated both in Prague and in Vienna.

After the Thirty Years War the Germanic countries could not themselves produce the artists they needed for reconstruction quickly enough, so they summoned them from Italy. The first phase of the Baroque (1660–1690), in Austria as well as Bavaria, was directly dependent on artists from Italy – in Austria on the Carnevales and Carlones, in Bavaria on Agostino Barelli and Enrico Zucalli who built the fine Church of the Theatines in Munich (1663–1690) (*Ill. 86*).

86 The Church of the Theatines, Munich, begun in 1663, and carried out by Agostino Barelli and Enrico Zucalli, was practically an import from Rome into Bavaria. In the eighteenth century the Frenchman Cuvilliers built the central part of the façade.

87 *The Flight into Egypt*, by Adam Elsheimer, Alte Pinakothek, Munich. Elsheimer's atmospheric night effects influenced such different artists as Claude Lorraine and Rembrandt.

The original style of German Baroque began its rise in the Habsburg dominance round about 1690.

Frankfurt, a great trading city, was the only one in Germany in which an original school of painting was flourishing in the seventeenth century. It produced the still-life painter, Georg Flegel (1563–1638), and a landscape painter, Adam Elsheimer (1578–1610). Elsheimer, by his taste for atmospheric night scenes (*Ill. 87*), influenced not only Rembrandt but also – since he spent some time in Italy – Claude Lorraine.

The Seventeenth Century in Poland and Russia

As a Catholic country with its back against the Slav world (which remained largely self-enclosed until Peter the Great) Poland naturally faced westwards. It was therefore aware, from the beginning of the seventeenth century, of the rise of Baroque religious art in Rome, and practised the new style not only in the ancient medieval and Renaissance city of Cracow (*Ill. 88*), but also in Warsaw, the new capital. Like St Petersburg, but long before it, Warsaw developed into a kind of laboratory of architecture; a royal palace, palaces for noblemen, and many churches were built there, and were adorned with stucco and painted decoration of a kind fashionable in Rome and in Central Europe. In the second half of the seventeenth century French influence began to penetrate.

From the beginning of the century Poland possessed painters who were well aware of Flemish, Italian, or Dutch art and were capable of meeting the demand for portraits and for historical painting.

Poland was thus, in the seventeenth century, the outpost of Baroque art, one of the points from which Western influence could penetrate into Russia.

At the end of the fifteenth century and during the sixteenth, Russia opened its doors, albeit timidly, to Western influences. The Byzantine style remained all-powerful in religious art, and although the tsars had called on Italians for the building of the Kremlin, this was still only an isolated example of Court initiative.

In the seventeenth century the knowledge of Western art began to reach Russia through Poland and the Ukraine; it even affected

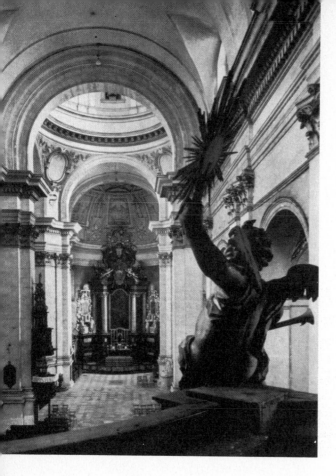

88 Interior of the Jesuit Church of St Peter and St Paul, Cracow. Built by the Italian Giovanni Trevano between 1605 and 1609, this church belonged to a Jesuit college and was one of the earliest in the Roman style in Poland.

religious art. The Orthodox Church attempted resistance by trying to make the traditional church with five cupolas obligatory and to outlaw the pyramidal church – a native invention which, in the preceding century, had resulted in some fine buildings; but this ban remained ineffective, and the pyramidal plan continued to inspire architects, not only at Jaroslavl and Rostov but at Moscow. Western elements crept into the decoration of these churches. Moscow was surrounded by a ring of fortified monasteries, and some of the ancillary buildings now constructed within them were in the Baroque style (as at Novodevitchy and Zagorsk). The Baroque style was grafted on to a pyramidal structure. In this mixed style

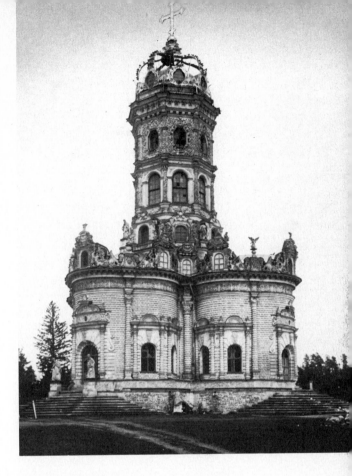

89 The Church of the Virgin of the Sign, Dubrovitzy. This building is characteristic of the first wave of the Baroque in Russia, as it grafted itself on to the traditional plan of an Orthodox church.

hundreds of churches were built round about Moscow at the end of the seventeenth century (for example, the Church of Dubrovitzy (1690–1704) (*Ill. 89*)). It was called the 'Naryshkin style' after the *boyars* who lived in a European manner and who built some of the churches – that at Fili (1693), for instance – on their estates.

Of the secular architecture produced at this period there remains little, for most of the palaces were of wood.

In spite of the stern decrees of the Orthodox Church which forbade any change in the art of the icons and which even ordered, in 1654, the destruction of images not in conformity with the canons, this art also came under Western influence. This process was made easier

because for a century and a half the example of Constantinople had not been there to act as a counterbalance. The 'Greek' style was dying and the Frankish (*Friaz*) style, taking its inspiration from Germany or from Holland, was tending to infiltrate, as the frescoes at Jaroslavl and Rostov show.

On the iconostases ornamental elements began to develop at the expense of icons. This opened the way to Baroque motifs, in particular to the solomonic column with its Eucharistic symbolism – which thus found its way all over the Catholic and Orthodox Christian world, being rejected only by the Calvinists (*Ill. 90*).

90 The iconostasis in the Cathedral at Polotsk, showing the use of the solomonic column and other Baroque motifs.

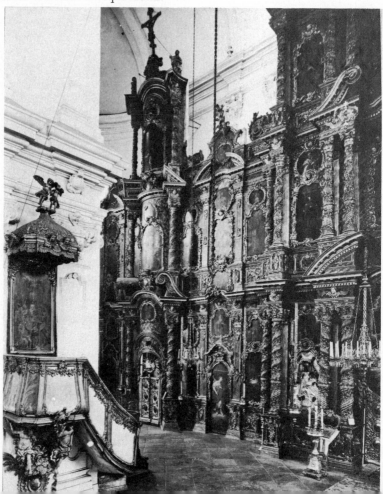

Seventeenth-Century France

France was in the seventeenth century the most powerful country in Europe, having the largest population and being firmly centralized about the king. It took over the political preponderance from Spain, which had dominated Europe in the preceding century.

In the sixteenth century, France had been the country that succeeded best in assimilating the spirit of the Italian Renaissance; but towards 1600, when the wars of religion had exhausted its powers and dried up the creative spirit, French art underwent a grave crisis. Though Henri IV gave a fresh impetus to building, the French School of Painting remained very poor until about 1640. The best French artists, such as Moïse Valentin, Poussin, and Claude Lorraine, left France and enriched the Roman School with their work, depriving their own country of the creative impulse their presence would have supplied.

During the reign of Louis XIII, however, a Court art began to arise; and under Louis XIV the principal forms of French art became concentrated about the Court, which the King removed to Versailles, mobilizing the finest talents to his service. The building and adorning of Versailles, begun in 1661, was carried on actively for some thirty years. By the end of the century the château, with its gardens and its decorations, stood out clearly as the supreme expression of art inspired by a monarchy, and during the eighteenth century all the princes of Europe tried to imitate it, so that the influence of French art spread everywhere.

To obtain this result Colbert, the leading Minister of Louis XIV, organized the artistic production of the country, systematically

creating or encouraging various institutions designed to develop the arts and culture. The Academic movement tended, in France, to govern taste and intellectual progress. In 1661 Colbert gave the decisive encouragement to the Académie de Peinture et de Sculpture, which was founded in 1648. The Petite Académie, known as the Académie des Inscriptions, and set up in 1663, was charged with advising on iconographic problems, inscriptions, and on the design of coinage; the Académie des Sciences was founded in 1666; the Académie d'Architecture, though not created officially until 1671, became a nursery of builders; and it was followed, in 1672, by the Académie de Musique, de Déclamation, and de Danse. In Rome the Académie de France, set up in 1666, began to receive the best students of paintings, sculpture, and architecture that they might learn from the finest examples of the art of antiquity – which, in France even more than in Italy, was considered the unrivalled model. The lectures given at the Académie de Peinture et de Sculpture, which were followed by discussions and controversies, ended in the working-out of a kind of official doctrine, based on the principles of the *beau idéal* but modified by the theories of expression which were then much to the fore in France.

Colbert did all he could to ensure the rise of the industrial arts. He encouraged the manufacture of textiles in several cities, especially Lyons. He lured craftsmen from Venice, in order to import into France the technique of making mirrors – one of the first large-scale applications of this being the Galerie des Glaces at Versailles (*Ill. 98*). He regrouped the various Parisian tapestry workshops at the Hôtel des Gobelins, which in 1662 was made the royal factory under the direction of Charles Le Brun (who was appointed First Painter to the King on 1 July 1662). But the royal factory was not concerned with tapestry only; its mission was also to encourage initiative in various arts and crafts, and to be a school of art for the training of goldsmiths and silversmiths, casters, engravers, carpet-makers, stone-cutters, cabinet-makers, and dyers. The administrative control

of the arts was assumed by Colbert himself, who was Superintendent of Buildings. The artistic direction fell to Charles Le Brun, First Painter, who worked out or approved all projects.

Colbert's artistic initiative formed part of his general policy, which was to render France independent of other countries through the possession of the industries and crafts capable of supplying those manufactured products which it had, until then, been necessary to procure from abroad. The results surpassed all hopes; artistic creation received a decisive impetus, and the France of Louis XIV created a new style of ornamentation, which it could now export to Europe. Down to the end of the eighteenth century France held the lead in the production of furniture and tapestries. The other nations were, indeed, not slow to imitate France by creating academies and officially sponsored factories to stimulate their own artistic production.

ARCHITECTURE

Building in France, as we have said above, after being slowed down at the end of the sixteenth century by the wars of religion, began again very actively under Henri IV. In religious building the style of the Counter-Reformation was brought in by the Jesuits; but in spite of this, France did not altogether renounce its own traditions, and the complete 'Romanization' of religious architecture failed to take place until the reign of Louis XIII. But in France, unlike Italy, it was secular building, not religious, that dominated at the time of Henri IV. He resumed building operations at the royal châteaux and palaces, and the use of brick made possible rapid results. The King also undertook programmes of town planning, endowing Paris with two important squares – the Place des Vosges and the Place Dauphine. The ornamentation of these buildings, when not confined to simple bands of stone blocks across walls of brick, was very heavy, and its proportions and vocabulary made it a continuation of the last phase of French sixteenth-century architecture, which

was Mannerist (the Hôtel de Ville at La Rochelle; the Collège des Jésuites at La Flèche) (*Ill. 91*). In about 1625–1630 the overloading of the exteriors with carved ornamentation, and the rich decoration of the interiors with painted and gilded panelling, were such as to suggest that this Mannerism would develop into Baroque, and that France would move definitely towards the style then prevailing in Italy. In about 1635–1640 there was a reversal of tendency, and France began to work out the principles of the Classical style which was to be pursued there till the end of the eighteenth century.

Jacques Le Mercier (1580/5–1654), who continued the work on the Louvre and built the Chapels of the Sorbonne (*Ill. 92*) and of the Val de Grâce, had already purified the Mannerism of the preceding age and used the orders correctly; but it was François Mansart (1598–1666) who defined the true French Classical style in the

91 The Chapel of the Jesuit College, La Flèche, built by Le Père Martellange in the first years of the seventeenth century, interprets the plan of the Gesù, with its single nave and side chapels, in a spirit still reminiscent of the Renaissance style.

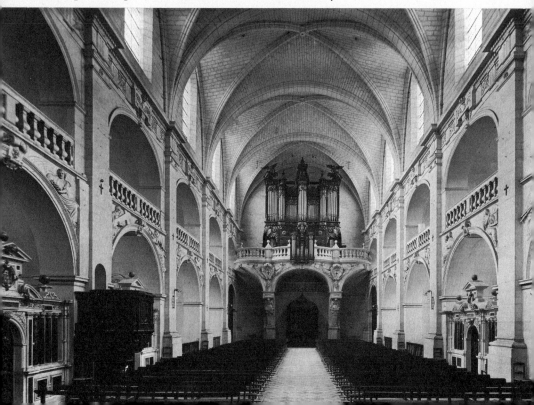

92 Compared with the previous illustration, the Chapel of the Old Sorbonne, Paris, begun in 1629 and built by Le Mercier for Cardinal Richelieu, shows the progress of Romanization in French architecture.

Orléans wing of the Château of Blois (1635). Here the stone façade has three tiers of orders, whose proportions combine harmoniously with the high roofs *à la française*, and the slender chimneys – decorative features that had been traditional in France since the Renaissance. Mansart perfected this type in the Château of Maisons-Laffitte (1642–1650), where he exercised his Classical taste in the interior by substituting an extremely sober scheme of decoration in stone for the usual panelling framed in gold. The type of château he adopted was the open one, with several wings and no inner courtyard, so that all the wings gave on to the gardens or on to the entrance courtyard (*Ill. 93*). There arose in Paris at the same period a type of nobleman's house known as the 'hôtel entre cour et jardin' (a phrase which had a theatrical origin – it came from the position 'between court and garden' occupied by the Opéra built by Mazarin in the Tuileries).

93 The Château of Maisons-Laffitte was built by François Mansart in a noble style, and with the decorations of its interior entirely in stone, this château is one of the earliest examples of French Classicism.

A large doorway leads to a courtyard separating the front from the street, while gardens extend on the other side of the building.

Even before Louis XIV took over the reins of government at the death of his Minister, Cardinal Mazarin, and began to give art the royal impetus it had lacked during the first half of the century, French art had been distinguished by one enterprise worthy of a king, the Château of Vaux-le-Vicomte (1656–1661). This was built with extreme speed by the ambitious Superintendent of Finances, Nicolas Fouquet (who fell into disgrace and was imprisoned for life in 1661). The building, consisting of several pavilions assembled about a dome which roofs a large oval chamber, is by Le Vau (1613–1670) (*Ill. 94*), and Charles Le Brun was responsible for the decoration of the interior with paintings and stucco-work. In front of the château the landscape architect André Le Nostre (1613–1700) created the first of those huge vistas of his, with their wide surfaces of water and green framed by groves of trees, which give the inhabitant of the château a seemingly limitless view, an imposing avenue that continues the architecture into the midst of nature.

Le Vau was at that time the leading figure in French architecture. His rather overloaded style seems evidence of a hesitation between the Classical and the Baroque. The need to create buildings with an impressively monumental quality that would match the power of a monarchy, which in the person of Louis XIV was beginning to impose its will on the arts, might well have produced a new birth of Baroque. The crisis which French architecture was then undergoing came into the open with the competition ordered by Louis XIV for plans for the eastern façade of the Louvre. Unsatisfied with the plans produced for him by his architects, he threw the competition open to Italians, and the prestige of Bernini (then at the height of his career) was such that in 1665 Louis XIV summoned him to France to put an end to the crisis. But by another royal decision this crisis ended in an unexpected way; Bernini's plans did

94 The Oval Room in the Château of Vaux-le-Vicomte has a decorative scheme based on designs by Charles Le Brun, who executed the paintings himself. Its form is one that was much imitated in the eighteenth century, chiefly in the Germanic countries.

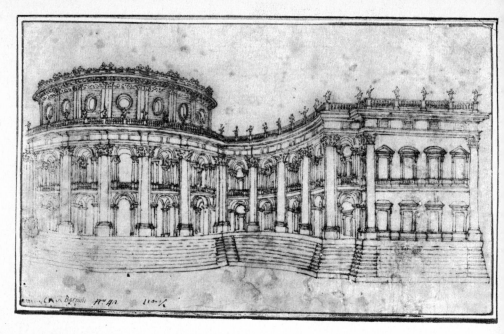

95 Bernini's first project drawing for the East Front of the Louvre, 1664. Dr M. D. Whinney Collection, London.

96 The Colonnade and East Front of the Louvre. When the noble Classicism of the existing colonnade is compared with the Baroque style of Bernini's design, it is easy to understand how the latter failed to please Louis XIV. Nevertheless he showered Bernini with honours and commissioned his portrait bust from him.

97 An aerial view of the Château of Versailles shows how the royal palace is the point of convergence of the three broad avenues about which the town and the perspective of the park were arranged.

not please (*Ill. 95*), and finally a commission set up by the King and consisting of Le Brun, Le Vau, and Claude Perrault worked out the design for the 'colonnade du Louvre', that most Classical of the large-scale examples of French architecture (*Ill. 96*). This design was to dominate the development of style till the end of the eighteenth century. An order of colossal free-standing Corinthian columns in pairs stands high upon a plain stylobate and is completed by a balustraded terrace in the Italian manner.

When the King removed his Court and government from Paris to Versailles, it was to the team that had worked at Vaux-le-Vicomte – to Le Vau, Le Brun, and Le Nostre – that he entrusted

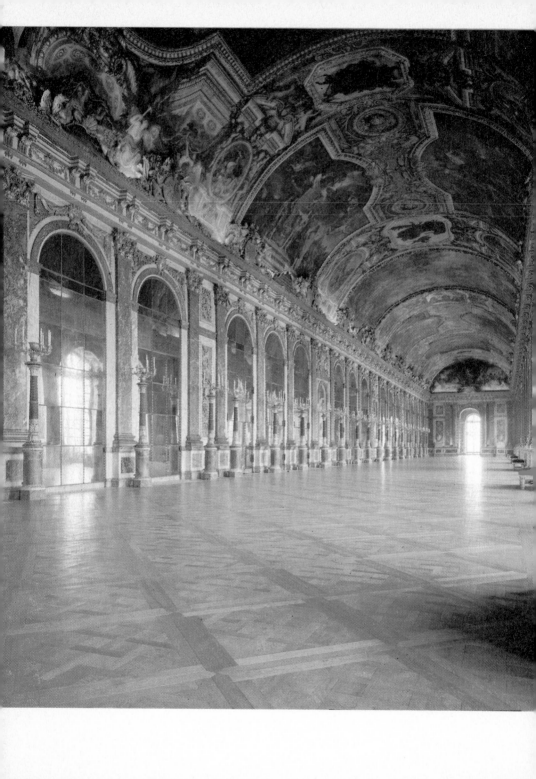

98 The Galerie des Glaces, Versailles, was conceived by Mansart and decorated by Le Brun. The novel use of mirrors for the decoration of the walls facing the windows was to have an enormous influence in the Germanic countries during the eighteenth century.

99 A general view of the gardens at Versailles shows the manner by which Le Nostre draws the eye of the observer to the distant horizon in a leisurely progress in which the natural and artificial elements of trees, statues, grass, and water are skilfully composed.

the realization of a palace which he desired to be the most imposing in Europe (*Ill. 97*). The architecture of the château – which was built in several stages, with enlargements and changes – was not in itself very distinctive. Fortunately Jules Hardouin Mansart (1646–1708) was brought in to correct Le Vau's bad proportions. The purity of his Classicism comes out more clearly in the Grand Trianon (*Ill. 100*) or the Trianon de Marbre (1687), a smaller pleasure château built at some distance from the large one, and in the Dome of the Invalides (1679) in which he harmoniously modifies the horizontal effect of the orders by a use of the traditional vertical emphasis. In the decoration of the interior at Versailles – The Grands Appartements and the Galerie des Glaces (*Ill. 98*) – Jules Hardouin Mansart and Le Brun departed from the panelling with gold edges that had been the rule under Louis XIII, in favour of an Italian-style decoration in marble of many colours, gilt bronze, and paintings; but this rich decoration is ordered in a Classical way – that is to say, subjected to the units of the architecture. For the exterior La Nostre designed a prospect of over two miles which leads the eye right to the horizon. Within the gardens he arranged a whole system of green spaces, trees, and water – both fountains and mirrors of sleeping water – with many forms of architecture (*Ill. 99*). The gardens contain buildings of *rocaille* (the Ballroom) and of marble (the Colonnade) and groups of sculpture, both ancient and new, creating an atmosphere of myth; and the whole became a place dedicated to the glory of the Roi Soleil, a magnificent setting for the fêtes, tournaments, ballets, fireworks, and other amusements that took place there.

French Classicism was now raised, in literature as well as in the visual arts, to the dignity of an institution. Critics and poets sang the praises of *la belle simplicité*, in contrast to the unbridled licence of Roman architecture, which was 'more barbarous and less pleasing than the Gothic'.

In the second half of the reign, from 1690 to 1715, architecture and the monumental arts were dominated by the personality of Jules

Hardouin Mansart, whose work was continued by his nephew, Robert de Cotte (1656–1735). Other châteaux – Marly, Saint-Cloud – were built in the neighbourhood of Versailles. France became dotted with châteaux, and in Paris, which was not abandoned by the nobility, many grand houses were built. Nor did the King, though he had moved from the capital, desert it; he added to it several large-scale groups of buildings, finishing the square courtyard of the Louvre, building the Hôtel des Invalides for men wounded in his wars, and laying out Squares – the Place Vendôme, the Place des Victoires – in which all the façades had to conform to an overall Classical scheme. These Squares, centred on a statue of the King on horseback or standing, became the models for the *place royale*, of which examples appeared throughout Northern Europe in the eighteenth century. Beyond the Tuileries Gardens Le Nostre made one of those vast prospects leading the eye to the horizon, the taste for which he established firmly during this period – this was, of course, the Avenue des Champs-Élysées, the great triumphal way into Paris.

Towards the end of the reign French Classicism was tending towards a more chastened elegance, of which the Royal Chapel at Versailles (1699–1710), designed by Mansart and completed by Robert de Cotte, gives the just measure.

SCULPTURE

The continuity of the Classical tradition in seventeenth-century France is perhaps most striking in its sculpture. This tradition had been created at the time of Henri II, in the full flush of the Mannerist period, by Jean Goujon, who had ornamented the Palace of the Louvre, and it was not repudiated.

Not that the sculptors turned a blind eye to Italy; some of them went there to study, others lived there for such long periods that they became part of the artistic life of some Italian centre – as did Pierre de Francheville, who worked for a long time in Florence and

100 In the château of Versailles itself, Mansart's art was restricted by the earlier work of Le Vau; but he displayed his pure elegant Classicism to the full in the Grand Trianon, which is built of pale limestone and rose-pink marble.

continued the style of Giovanni da Bologna. But they resisted the example of Bernini's style. The only one of them to show its influence in his work was Pierre Puget (1622–1694) (*Ill. 101*) in the time of Louis XIV. He is one of those exceptions that prove a rule, since he came from Provence – a province where, even in architecture, Italian rather than Parisian models were followed. Moreover, he had worked at Genoa. During the reign of Louis XIII and the first part of that of Louis XIV, this Classical tendency was nourished by a kind of realistic honesty, which came out clearly in the many monumental tombs – requiring as they did an element of portraiture – produced by Gilles Guérin (1606–1678), Simon Guillain (1581–1658), and François Anguier (1604–1669), whose younger brother Michel Anguier (born in 1612) continued this tendency till his death

in 1686. Both in his sculptured tombs and in his ornamentation of buildings, Jacques Sarrazin (1588–1660) practised the Classical style with an ease that made him the direct forerunner of the art of Girardon.

Under Louis XIV the ornamentation of Versailles and other royal buildings, the many orders for magnificent tombs and the decoration of the new buildings in the city, involved an enormous amount of work for sculptors. Charles Le Brun took control of this; his untiring imagination produced innumerable designs and plans for them, and these gave to a great number of respectable professions the support of inspiration and the feeling for composition on the grand scale. The outstanding sculptor of Versailles was François Girardon (1628–1715), who was responsible for many statues and groups of statuary in the gardens, in particular for the *Apollo and*

101 *Milo of Crotona*, by Pierre Puget, Louvre, Paris, formerly adorned the gardens of Versailles. Its subject is the legend of Milo, the ageing athlete who, with his hand caught in a tree, was eaten by a lion – a symbol of the agony of helpless strength, well suited to the Baroque style of Puget.

the Nymphs (1668) (*Ill. 102*). His Classicism was so pure that it seems to hark back to Pheidias, and the resemblance is not a purely fortuitous one. The French had, by his time, begun to feel that the true source of Classicism was in Greece, not in Rome – so much so that in 1696 a Director of the Académie de France in Rome suggested the creation of a school in Athens, to enable architects to study there. In his statue for the Place Vendôme, which he finished in 1699, Girardon created the prototype for the royal equestrian statue whose costume and attitude revived those of the typical statues of Roman emperors (*Ill. 103*). Antoine Coysevox (1640–1720) had more imagination than Girardon (who owed a great deal to Le Brun's designs); the serenity of the attitudes and the calm of the facial

102 *Apollo and the Nymphs*, by François Girardon: in the Bosquet d'Apollon, Gardens of Versailles, carved in 1668, is one of the purest expressions of French Classicism. At the end of the eighteenth century Hubert Robert painted a romantic study of it. It was at first conceived as an adornment for a grotto of shells.

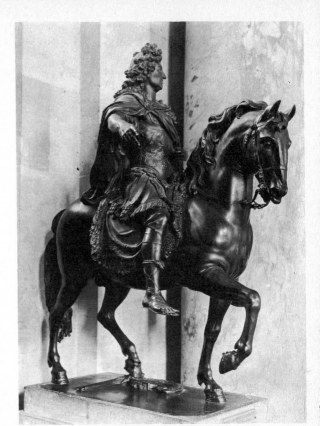

103 Small-scale version of the statue of Louis XIV for the Place des Conquêtes (Place Vendôme), by François Girardon, Louvre, Paris. Mansart and Girardon were together responsible for the Place Vendôme, that masterpiece of the *genre 'place royale'*, soon to be imitated throughout Europe. Girardon's statue, which was finished in 1699, inspired, among others, the statue of the Grand Elector in Berlin by Andreas Schlütter.

expressions (including those of the figures on his tombs) showed that he belonged to the Classical movement, yet in his portrait busts, which are perhaps his most inspired work, there appeared a note of Berninism. Whether it was a king, a general, a financier, a minister, or an artist whose features were being handed down glorified to history, the sitter was always shown in action, with some movement of the head, of clothes, or of wig designed to bring out the noble and inspired quality of his spirit (*Ill. 104*). Bernini was the inventor of this type of *portrait glorieux*, and unquestionably his bust of Louis XIV, commissioned by the King in 1665, had a decisive influence over this kind of work in France.

There was a magnificent development of sculpture in bronze under Louis XIV. The gardens at Versailles required a large number

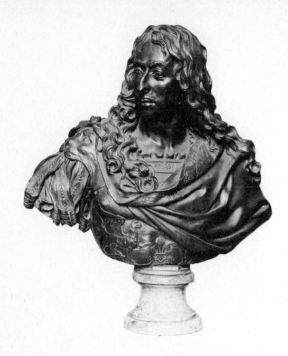

104 Bust of the Grand Condé, by Coysevox, Louvre, Paris. In conformity with the theories of expression expounded by Le Brun, Coysevox shows the hero in the fire of action and the full inspiration of his genius – a Baroque conception, of which Bernini had set the example in Paris with the bust commissioned from him by Louis XIV.

of sculptures in metal. The Keller family executed casts with a superb finish. A type of sculpture in lead, which could be produced more quickly, was also created for the ornamentation of gardens.

PAINTING

The accepted starting-point of the French School is the return to Paris, in 1627, of Simon Vouet, summoned back by the King after a fifteen years' residence in Rome. The efforts of Henri IV to reconstitute a school of art in France had met with success in architecture only, and the country was so poor in painters that Marie de Médicis, when she wished to have the story of her life celebrated in her Palace of the Luxembourg, had been obliged to call in Rubens (*Ill. 49*).

Simon Vouet (1590–1649), when in Rome, had followed the Caravaggesque style; but in Paris he changed his manner for a decorative one, using light and gay colours – a moderated Baroque (*Ill. 105*). He did not, however, succeed in creating a Court art. The consciousness of this failure led Richelieu and the Superintendent of

Buildings, Sublet des Noyers, to lure back to France Poussin, who had become famous in Rome. The Superintendent had a whole programme for the organization of the arts similar to that which Colbert later carried out. Poussin, who came to Paris unwillingly in 1640, found himself overwhelmed with tasks that took him away from his own researches in painting. Since these researches were the only thing that mattered to him, he left in 1642, and the effort made by Richelieu and Sublet des Noyers thus remained fruitless.

Eustache Le Sueur (1617–1655), though he never went to Italy, also painted in a bright style, with an elegant Classicism inspired by Raphael and Correggio; but his series of paintings on the life of St Bruno (*Ill. 106*) differs from the Italian renderings of the lives of

105 *Wealth*, by Simon Vouet, Louvre, Paris. The fleshly opulence and joyful colouring of Simon Vouet made him, to some extent, a French Rubens. On his return from Rome in 1627 he became Court Painter to Louis XIII and was the founder of that tradition of decorative painting which Le Brun developed.

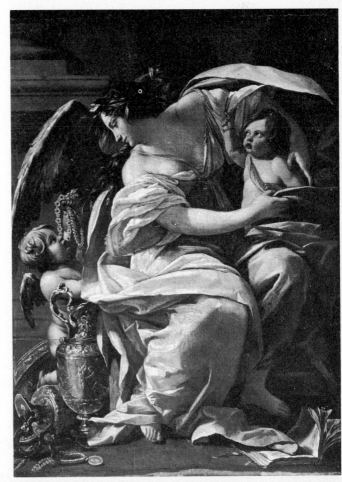

saints and is typical of the sober way in which the French approached the depiction of holiness.

At the end of the reign of Louis XIII and at the beginning of that of Louis XIV, Philippe de Champaigne (1631–1681) brought into portrait painting his search for naturalness and simplicity, giving to his subjects a gravity and austerity in which some have thought they detected the influence of Jansenism (*Ill. 107*). The French painters of this period invested all their figures with a mood of spiritual elevation; in this respect no work is more remarkable than that of the three Le Nain brothers – Antoine (1588–1648), Louis (1593–1648), and Mathieu (1607?–1677). Peasant subjects – to other painters the pretext for picturesque, satirical, or violent scenes – possess in their work a quiet gravity (*Ill. 108*). But indeed all the human figures painted by the French artists at that time, whether of princes, of *bourgeois*, or of poor people, are touched with a certain naturalness and feeling for human dignity (*Ill. 109*).

The Baroque only laid its hand peripherally in the French provinces. At Nancy it inspired the draughtsman and engraver Jacques Callot (1592–1635), who had studied in Florence. Also in Lorraine, Georges de La Tour (1590?–1652), who must have been in Italy, took from the Caravaggists his manner of lighting a scene as though it took place in a vault and his way of choosing models from the poor to play religious roles. Even in the seventeenth century – that century obsessed with the soul – his compositions, limited to one or a few figures, are among those which show the most profound insight into the inner life (*Ill. 110*). At Dijon Jean Tassel (1608?–1667) continued Mannerism. Sébastien Bourdon (1616–1671), who came from Languedoc, was a virtuoso who imitated various painters, always with a very fine technique. At Toulouse Robert Tournier (1590–1667) practised a sombre style of painting derived from the Caravaggists. In Paris Claude Vignon (1593–1670), who had been in Rome, painted as the provincial painters did, in chiaroscuro, at a time when the Parisian School had gone over to painting in light colours.

106 *The Death of St Bruno*, by Eustache Le Sueur, Louvre, Paris. This is the best known out of a cycle of twenty-two paintings which decorated the cloister of the Carthusians in Paris: its noble and Classical representation of death had a considerable influence on French painting and even outside France.

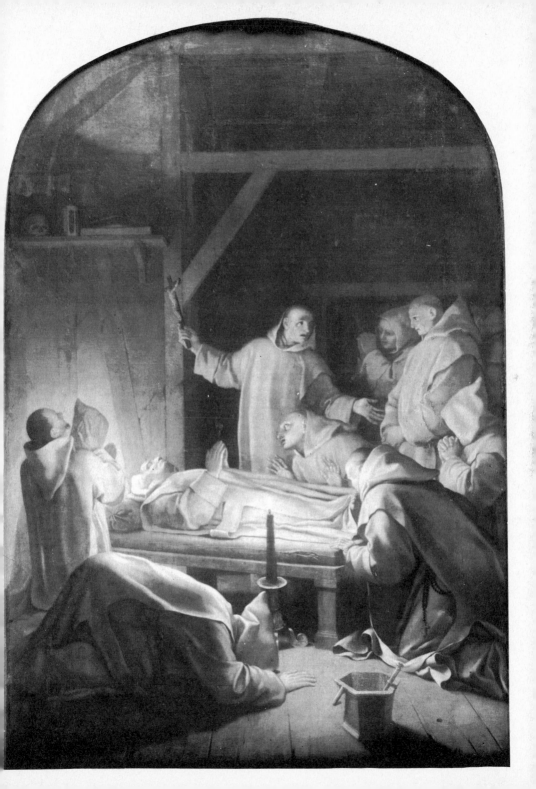

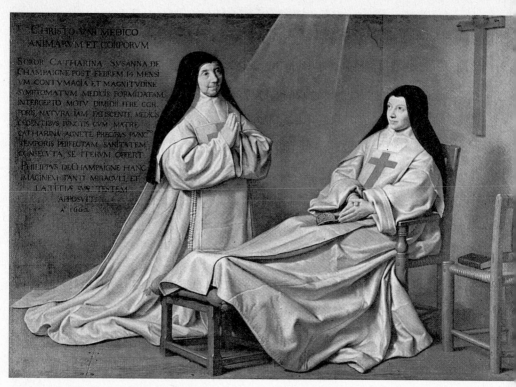

107 *Ex Voto*, 1662, by Philippe de Champaigne, Louvre, Paris. To commemorate a miraculous cure with which his daughter, one of the nuns of Port Royal, was favoured, Philippe de Champaigne depicted her in prayer side by side with La Mère Agnès Arnauld, the Mother Superior of Port Royal.

But it was in Rome, not in Paris, that the French spirit attained its most profound expression in seventeenth-century painting. While Moïse Valentin (1594–1632) enlisted under the flag of Caravaggio (whom he understood better than did many of the Romans), Poussin and Claude Lorraine, having learned what they could from Italian art (including that of their contemporaries), parted company with the conception of art prevalent in Rome at the time of Bernini, and worked out the most accomplished forms of Classicism – to some extent a continuation of the Renaissance conception.

Nicolas Poussin (1594–1665) was able to distil honey from every source that was right for him. In Rome he was careful not to

disregard Domenichino nor to neglect the landscapes of Annibale Carracci; but above all he assimilated every form of Classicism, from Raphael, from the Venetians, from painting (*The Aldobrandini Wedding*), and from the sculpture of antiquity. Nothing in the whole seventeenth century is so far removed from Caravaggio (whom he detested) as the art of Poussin. Even the artists most opposed to the Caravaggesque approach, such as Guido Reni, owed to Caravaggio the technique of slanting the light so as to stress the modelling very strongly; but Poussin's light is distributed evenly as in the paintings

108 *The Guard*, by Le Nain, Private Collection, Paris. This picture, bearing the date 1643 beside the signature *Lenain* (sic), is attributed to Mathieu, the youngest of the three Le Nain brothers.

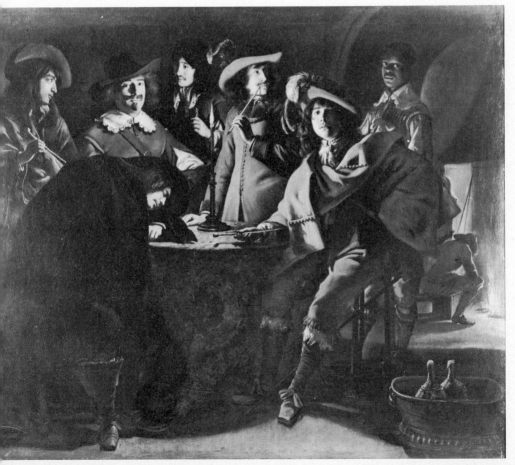

of the Renaissance, so as to define a form integrally – it is a light of genesis. Poussin set out, in fact, to achieve the aim which Alberti, in the fifteenth century, had proposed to the artists of his time – to revive the life of antiquity; and he succeeded through deep meditation on the historical and mythological bases of the ancient world. Ovid's *Metamorphoses* and the great stories of Roman history were the food of his inspiration. During the first part of his working life he composed his pictures as friezes, like Roman reliefs, yet removed from them all coldness by the generosity of his handling, which he worked out for himself and which consists in thick and medium-thick colours felicitously mixed. It was the kind of handling towards which the French artists seemed to have a natural inclination, little drawn as they were to the use of transparent painting; it was the handling adopted by the Le Nain brothers. To give vibrant life to his colour, Poussin commonly used reddish undercoats in the Roman manner, while the Parisian School (Simon Vouet, Le Sueur, Philippe de Champaigne) went in for light undercoatings. Unfortunately the surface layer of colour has thinned, allowing more of the red basis to be seen than the artist wished, so that many of his paintings have darkened. When he reached Rome in 1624, at the age of twenty-nine, he had not (as has sometimes been asserted) formed his own style. For about ten years he painted in a sensuous manner, which is particularly apparent in the *Bacchanals* (*Ill. 111*), a *genre* which he took up from Bellini and Titian, whose paintings for the Camerini d'Oro at Ferrara were at that time to be seen in Rome. The theme is one that enabled painters to express the freedom of the instincts in the innocence of the Golden Age. His *Parnassus* (Prado) and his *Triumph of Flora* (Dresden) render the same feeling in a more intellectual manner which he learned from Raphael. Besides these sources, Poussin's painting in this early phase drew nourishment from the modern romances, especially from Tasso's *Gerusalemme Liberata*, which exerted a strong fascination at that time. Poussin seems usually to have chosen his own subjects; he was one of the

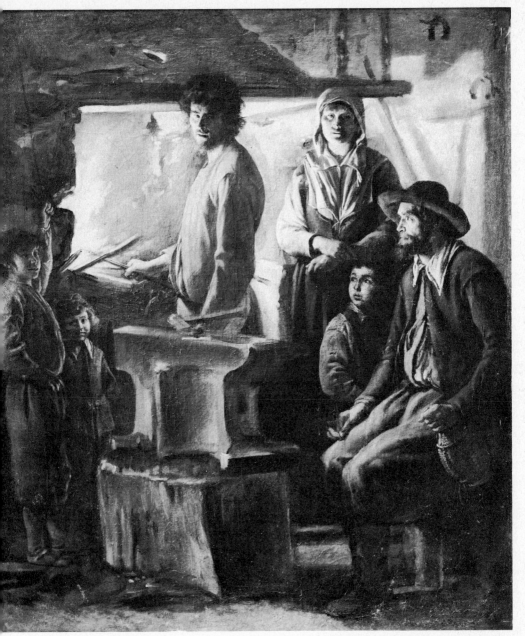

109 *The Forge*, by Le Nain, Louvre, Paris. The three Le Nain brothers formed a studio together and were careful not to distinguish their own personal output by any mark of identification. The most beautiful, most grave and most skilfully painted of their pictures are attributed to Louis.

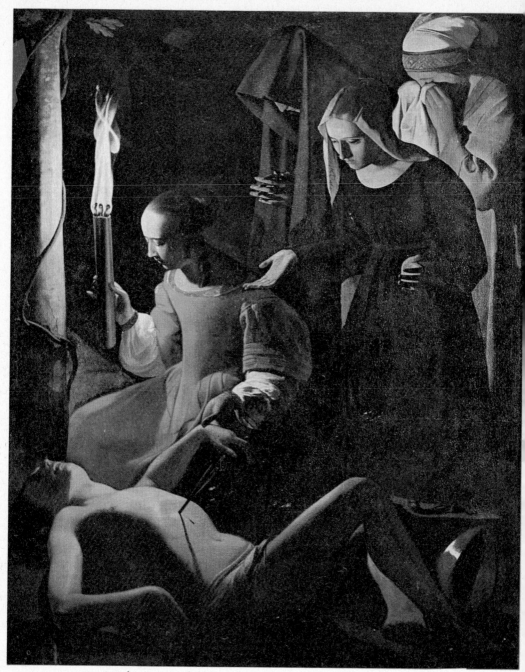

110 *St Sebastian Attended by St Irene*, by Georges de La Tour, Church of Broglie, France. As the author demonstrated over twenty years ago, the composition of this picture, which seems to have been inspired by Correggio's *Descent from the Cross* in the Vatican, suggests that Georges de La Tour was at one time in Rome.

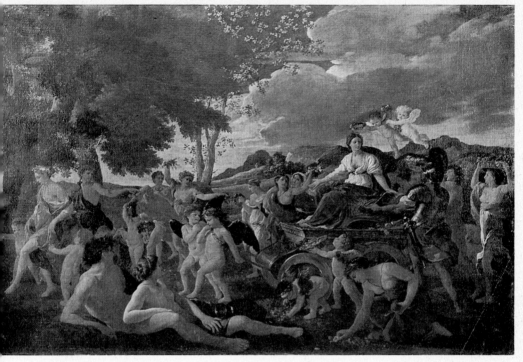

111 *The Triumph of Flora*, by Poussin, Louvre, Paris. Painted in Poussin's first or Roman period, both the composition and the colouring of this picture were clearly inspired by Titian's *Bacchanals*. Its subject is a kind of anthology of themes from Ovid's *Metamorphoses*, which had already provided subjects for the Carracci.

painters of that century who looked on painting as a personal speculation – to him it was both a philosophical and an aesthetic speculation. Whether his religious subjects, most of which were Biblical (*Ill. 112*), were dictated to him is not certain; but clearly, in some cases, there is a feeling of constraint, and his imagination is less at ease. None the less, the series – *The Seven Sacraments* – which he painted for Cassiano del Pozzo is in his best vein; joyful in colouring, it is a kind of reconstruction of the life of the early Christians. All these small pictures exhibit religious feeling as a form of innocence of soul, just as Poussin's treatments of pagan themes made these the expression of a state of primitive innocence.

139

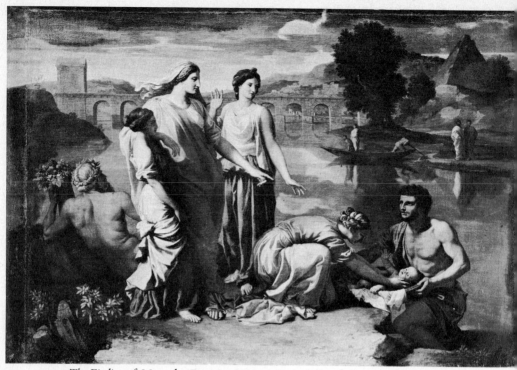

112 *The Finding of Moses*, by Poussin, Louvre, Paris. Painted in 1638, this picture belongs to the beginning of that period in Poussin's work which might be called the period of the severe style. Carried out in finely shaded tones, it is one of the most refined expressions of French Classicism.

Round about 1648 Poussin's sensibility became permeated by a deepening love for natural scenery, and landscape became the dominant element in his work. But he always gave to landscape a humanist significance, in the sense that he made the natural scene a setting for some incident or person taken from mythology (for instance, his *Orion* in the Metropolitan Museum of Art, his *Orpheus* in the Louvre, his *Polyphemus* at Leningrad (*Ill. 113*)), or philosophy (his *Diogenes* in the Louvre), or from Biblical history (*The Four Seasons* in the Louvre). He subjected the planes of his landscape to a harmonious system, but the details were realized with a carefully thought-out yet infinitely sensitive handling which is often a forerunner of Cézanne's.

113 *Landscape with Polyphemus*, by Poussin, Hermitage, Leningrad. Painted in 1649, this picture marks the beginning of Poussin's final period, that in which the poetry rises to an all-embracing feeling for the world – still, however, interpreted through a mythological guise.

Though Poussin lived at Rome he was famous in France, and was thought, by the beginning of the reign of Louis XIV, the greatest French painter. While Claude Lorraine was much admired by the Roman aristocracy, Poussin's work was selling at high prices in Paris – chiefly to the *noblesse de robe* – and he was in continuous correspondence with several Parisian art patrons. Louis XIV acquired a large number of his paintings, and at the Académie de Peinture et de Sculpture, where his Biblical pictures were particularly admired, his work was the subject of pedantic dissertations and erudite discussions. The result of this was a kind of official aesthetic, Poussinism, which passed through several stages and continued into the nineteenth century, helping not a little to steer the French School in the

141

direction of Academicism. For a long time Poussinism obscured Poussin himself, and prevented many people from realizing the sensibility of works which it had become usual to represent as the typical expression of intellectualism.

It remains true that Poussin's art – though highly sensitive in the quality of its execution (in all but a few excessively contrived pictures) – was the result of conscious thought in its working-out. That of Claude Lorraine was quite different. Poussin was intellect or wit, Claude was intuition and instinct. From the start, even more than for Poussin, nature was for Claude the essential source of his art, which was that of a landscape painter. The backgrounds of the two men were very dissimilar. Claude Gellée left Lorraine and went to Rome at an early age, and there at first he vegetated in various humble employments. He went back to Lorraine in 1625, and in 1627 returned to Rome for good. He then modelled himself not so much on Italian painting as on that of certain Nordic artists who were working out, in Rome, an original style of landscape painting from which the Classical conception of landscape sprang – the Flemish painter Paul Bril, who gave him the art of composition, and the German Elsheimer, from whom he seems to have learned the feeling

114 *The Tiber above Rome*, wash drawing by Claude Lorraine, British Museum, London. Although he painted in the open air, the only studies from nature by Claude Lorraine that have survived are his innumerable drawings, most of them in pen and wash. They are incomparable evocations of the Italian light.

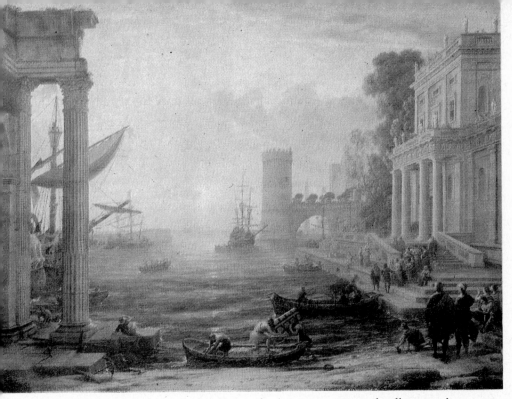

115 *The Embarkation of the Queen of Sheba*, by Claude Lorraine, National Gallery, London. Claude took the theme of the seaport from the Flemish painter Paul Bril, but transformed it from naturalistic illustration to heroic evocation, celebrating the beauty of sunlight, falling on the sea and on the enclosing wings of an imaginary architectural setting.

for atmosphere. Less is known about Claude's life than about Poussin's, since we do not have the letters to go on, which are so valuable for the understanding of the painter of *The Four Seasons*. We do have what amount to the artist's confessions: the many sheets covered with his studies of the Roman Campagna, executed in bistre wash, sometimes heightened with touches of red chalk (*Ill. 114*). What attracted Claude in the landscape of Latium was the beauty of the light, and it was by fine gradations of light that he succeeded in giving the impression of space. He was the first painter to have really looked at the sun in the splendour of dawn, of noon, or of sunset and to have expressed the poetry of the different times of day. Saturated in natural scenery, he returned to the studio to

143

compose his pictures, adding life to them then in the Classical fashion, by means of some action taken from mythology, ancient history, or the Bible. His methods of composition were more varied than Poussin's, some of them being drawn directly from Northern traditions. In all cases the unity of the picture is obtained by means of the enveloping atmosphere, by that luminous fluid filling the objects and haloing them with brilliance. Perhaps the most beautiful of his pictures are those in which he brings in the sea, whose effects he was able to study during the journey he made to Naples. The sea, for Claude, was a poetic element multiplying light; and he edged it with dream palaces, often motivating his pictures by scenes of embarkation or landing taken from history or religion (*Ill. 115*). Sometimes he painted his pictures in pairs or series, which we need to re-establish if we would appreciate the subtle cadences that link one painting to another. It is possible to follow the stages of his work fairly well, thanks to a kind of catalogue – the *Liber veritatis* (in the British Museum) – in which he listed, in the form of drawings, the pictures he had sold, and indicated their owners.

While Poussin's art suggests elevation of thought, the soaring poetry of dream or fantasy seems to have been the source of Claude's inspiration. Unfortunately in his case too the reddish undercoats have darkened his pictures, and their paint, more fragile than that of Poussin, has suffered more from the efforts of restorers.

Claude was less successful in France than Poussin, yet he left a wake behind him among the French landscape painters who studied his work in examples they found in Rome. It was in England that Claude excited the greatest enthusiasm among art lovers in the eighteenth century (his finest pictures and the largest number of drawings by him are still to be found here), and in the nineteenth century Claude's example had a great effect on Turner.

In Paris and at Versailles during the reign of Louis XIV, French painting changed its direction. In the immediately preceding period a number of artists, such as Philippe de Champaigne and the Le Nain

brothers, had been steering it towards a realistic integrity, while in Rome Poussin and Claude were creating each his individual poetry; but now, mobilized for the glory of the prince, painting at Versailles approached what the art had been in the hands of the Roman painters of the early seventeenth century. Its aims were decorative, and thanks to Charles Le Brun French art achieved the mastery of the technique of giving life to the figures in large-scale compositions, which it had hitherto lacked. This shortcoming had been particularly marked in the case of Vouet, who had never been capable of painting more than a few figures on a restricted surface; but now, on the ceiling of the Hôtel Lambert in Paris, on that of the Great Room in the Château of Vaux-le-Vicomte, and in that of the Galerie des Glaces at Versailles (with its series of huge pictures of the story of Alexander) Charles Le Brun rivalled the Italian decorative artists. During his residence in Rome, between 1642 and 1646, he had managed to assimilate that art of composition which the Carracci had mastered – notably in the Galleria Farnese of the Palazzo Farnese, which Le Brun studied assiduously.

In Paris he did not fail to study Rubens's Medici Gallery, though this was then looked upon as an example of bad taste by pundits of the official doctrine, whose established ideal was Raphael. At the same time, the theory of expression, which Le Brun elaborated at the Académie in his lectures illustrated by drawings, would have made him a real Baroque artist, had not this doctrine been to some extent contradicted by the influence of Poussin. This influence comes out in his easel pictures on religious subjects, where the small surface enabled him to bring out the quality of his handling and the gaiety of his light colouring, which he took up again from the tradition of the Parisian School (*Ill. 116*). These were the best of his pictures, along with the portraits, in which he achieves an objective sincerity – for instance, in his *Jabach Family* (Berlin, now destroyed) and his *Chancellor Séguier* (Louvre). On 6 September 1683 Colbert died; his successor Louvois, who hated everything to do with him, deprived

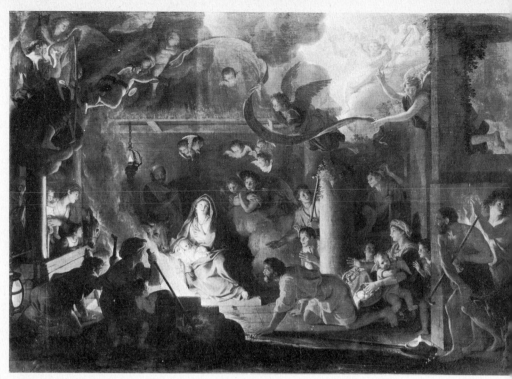

116 *Adoration of the Shepherds*, by Charles Le Brun, Louvre, Paris. This picture shows how clever Le Brun was at composition, at mingling the world beyond with earthly life and at controlling the fantastic effects of the light produced by a screened fire.

Le Brun of his prerogatives and favoured Pierre Mignard (1612–1695). Mignard was no more than a rather boring craftsman, very poor in imagination, as his painting of the Dome of the Val-de-Grâce proves; but he had a great success because of the amiable and conventional character he gave to his portraits of women and children.

Le Brun started a whole school of decorative painters in France, including families who handed on their methods of several generations, such as the Coypels and the Boulognes. To illustrate the King's campaigns, Le Brun called in a talented Flemish painter, van der Meulen, who showed great sensibility in his watercolour landscapes. Lesser painters, who were no more than good artisans, were also

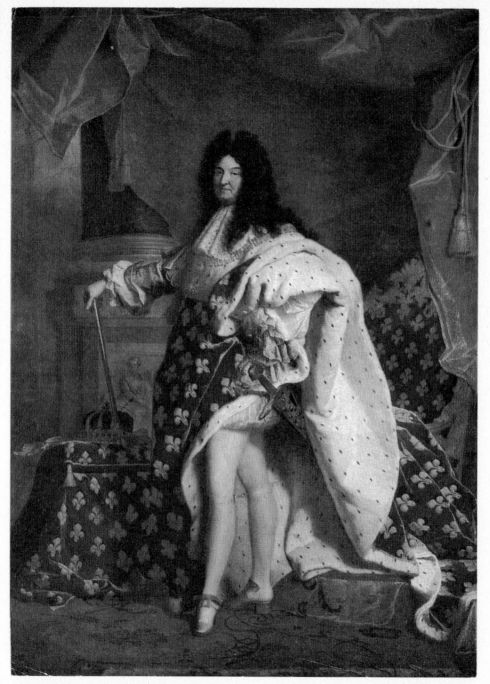

117 *Louis XIV*, by Hyacinthe Rigaud, Louvre, Paris. Louis XIV had such an admiration for this portrait of himself, in which he is shown invested with the attributes of royalty, that he kept it although he had intended to present it to Philip V of Spain. Rigaud, as was his usual practice in portrait painting, has turned his sitter into a type; and yet the face of the old king has an intense quality of truth.

needed to take part in the depiction of the King's pastimes. At the end of the reign the outstanding painter was Hyacinthe Rigaud (1659–1740). Although his activity continued well into the next century, the ethical quality of his figures and the aesthetic quality of his style are part of the spirit of the Louis XIV period.

Guided by Le Brun, Rigaud created in painting, as Coysevox had done in sculpture, the portrait of the 'man of quality', whose value he conveyed by the nobility of the attitude, expressiveness of the gesture, and movement of the draperies – in short, by the passion of which he showed his generous temperament to be capable. The aim was less to depict an individual and a character, as Philippe de Champaigne had done in the preceding period, than to affirm the social rank and 'condition' of the sitter, who might be the King, a minister, a financier, or a soldier, but who was always of the Court. Rigaud thus started the Court portrait, which was to have a considerable importance in Europe during the next century. In 1701, in his portrait of Louis XIV, he created the image of royal majesty, vested in all his attributes (*Ill. 117*).

THE MINOR ARTS

In the reign of Louis XIII the industrial arts, especially the making of furniture and tapestry, still followed the principles of the sixteenth century – as indeed was the case in Europe as a whole. Yet already the new vigour, which the applied arts were soon to display under Louis XIV, was to be found in the vitality of that essentially French art, tapestry. This was produced in various privately owned workshops in Paris; and the best compositions of Simon Vouet were those of the cartoons he made for the tapestry-workers.

Colbert's concentration of tapestry-making at the Hôtel des Gobelins in 1662, under the direction of Charles Le Brun, gave the art an added impulse which soon brought many orders for tapestry from all over Europe. The tapestries were based, for the most part, on cartoons by the First Painter, whose indefatigable invention met

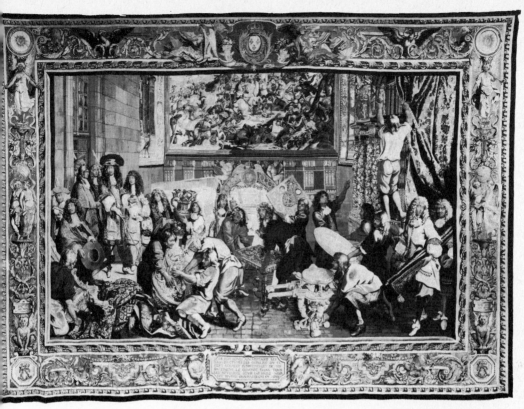

118 The most famous series of tapestries for which Charles Le Brun supplied cartoons is the *Histoire du Roi*. The episode of *Louis XIV Visiting the Gobelins Factory* recalls the impetus given by the King to the arts through his patronage.

all demands with ease. Some of them helped to form the image of the monarchy (*Ill. 118*) – for instance, the series known as *L'Histoire du Roi* and as *Maisons Royales*, also the *Histoire d'Alexandre* (which was an allusion to the glory of Louis XIV); but the one in most demand in Europe had an exotic subject, *The Indies*, and the cartoons for it, made at the Gobelins in 1687, were based on pictures brought back from Brazil by the Dutchmen Franz Post and Van Eckhout, which were sent to the King by Prince John Maurice of Nassau. At the end of the reign Berain and Claude Audran I invented a new style, less illustrative and more strictly decorative, borrowed from the *grotteschi* – a type of theme which, started by the Italian Renaissance,

119 Jean Berain was one of the pioneers of the new style. He infused a new vigour into the poetic and decorative Renaissance theme of the *grotteschi*.

now took on fresh life (*Ill. 119*). The Manufacture de la Savonnerie also produced rich carpets whose design was divided up like that of a ceiling.

At the end of the seventeenth century the pottery workshops abandoned the designs in imitation of the Chinese and those based on the Italian Renaissance, to which Nevers had remained faithful. The Rouen potteries began to use very fine designs in blue or in several colours, consisting of figurative motifs dominated by the *lambrequin* (*Ill. 120*). The Moustiers potteries took their inspiration from Berain's designs of *grotteschi*.

120 The Rouen pottery dishes, with their *lambrequin* decoration, continued the nobility of the Louis XIV style into the first half of the eighteenth century.

Few examples of the goldsmiths' and silversmiths' work of this time have survived, since almost the whole output was melted down. A sumptuous set of furniture in massive silver was made for the Galerie des Glaces after designs by Le Brun. But this only lasted for a few years before it, too, fell victim to finance the King's wars.

Encouraged by Colbert, the textile factories, especially at Lyons, created fabrics with designs of great splendour – brocades and silks based on Italian models. Lace-work and glassware imitated the products of Venice.

The development of furniture-making may perhaps be truly called a revolution. It was accomplished by cabinet-makers working on designs supplied by the masters of ornamentation. The new style put

an end to the furniture of cubic form which had been in use since the Middle Ages, unchanged except in decoration during the Renaissance. The actual forms of pieces were now twisted and fretted in a Baroque style; the wood was carved and gilded, often with the addition of admirable bronze fittings. The Boulle family, though it did not invent, perfected a type of furniture decoration to which it gave its name – marquetry in copper and tortoiseshell. And, finally, the quite new idea of comfort was introduced into furniture; its forms became better adapted to human requirements, and the types of piece that were made grew more varied and specialized for particular uses (one of the outstanding creations of the Louis XIV period was the chest-of-drawers, significantly called the *commode* (*Ill. 121*)). This development towards a more and more close adaptation to the needs of life and towards a more purified style of ornament, which was to be the glory of French furniture in the eighteenth century, was begun by the refinement of social life at the Court of Louis XIV.

121 The Boulle family became famous for its method of decorating furniture with inlay in tortoiseshell and copper. This piece, made for the King's Room in the Trianon, is an example of a type of furniture that was to have a great success in the eighteenth century – the commode.

Seventeenth-Century England

For much of the seventeenth century, England suffered from great political insecurity. In the visual arts, during the reign of Charles I, the main contributions came from abroad. Conscious of his royal dignity, and loving display, Charles I summoned artists such as Rubens to his Court, and acquired a collection of pictures that was even finer than the one later brought together by Louis XIV. After his defeat in the Civil War and death on the block, important parts of his collection were sold abroad, though much remained and, after the Restoration, more was recovered. Production in the arts came almost to a standstill under Cromwell. With the Restoration it was resumed – not, at first, with the same intensity, since Charles II was not a Maecenas like his predecessor, but the Great Fire of London in 1666 greatly stimulated creative work, especially in architecture. At the end of the seventeenth century, the artistic relationship between the two countries was reinforced when Princess Mary was called to the throne with her husband William of Orange.

ARCHITECTURE

It was in the field of architecture, unquestionably, that England's greatest contribution was made to the world stock of forms created by what is called the Baroque period. The general line of development there was definitely towards Classicism, but by no means as exclusively as is often suggested, for the English architects frequently turned aside towards richer forms that were sometimes frankly Baroque.

The principles of Classic form, towards which England tended, were clearly laid down by Inigo Jones (1573–1652). Yet he had begun his career with a kind of work that might easily have turned him towards the Baroque; he was a theatrical designer for the masques, which were then the rage at the English Court. He seems to have made his first journey to Italy in 1601, but it was a later visit – in 1613–1614, during a tour of Europe – that confirmed him in his vocation as a Classicist. This journey took him, in fact, not only to Rome but also to the Veneto, where he was able to admire the works of Palladio; the Library at Worcester College, Oxford, still has the copy of Palladio's *Quattro Libri* which he brought back from Italy, full of his annotations.

The Queen's House at Greenwich, begun by him on his return (1615–1616), is a strict application of the principles of Palladian architecture (*Ill. 122*). Inigo Jones was the real founder of the modern English School of Architecture; in 1615 he was made Surveyor of the King's Works, and in 1618 a member of the Commission on Buildings set up to recommend plans for the development of the City of London. The principal building left by him, the Banqueting House in Whitehall (1620–1621), is in a style based on that of Vicenza.

Thus the doctrine of Palladianism, which England was to adopt fully in the eighteenth century, was clearly defined by Inigo Jones; and yet he himself sometimes strayed from it, as in the case of the double cube room at Wilton House (*c.* 1649) of which the elaborate ornamentation resembles the kind usual at that time in the French châteaux and town-houses. In about 1638 Inigo Jones worked on an imposing plan for the Palace of Whitehall, which was never carried out.

The architects of the next generation, John Webb (1611–1672) and Sir Roger Pratt (1620–1685), also worked within the sober principles of Classicism, while Sir Balthazar Gerbier (1591?–1667) was more Baroque. But parallel to this official art a more workaday

122 The Queen's House at Greenwich, by Inigo Jones, begun in 1615, is the earliest example of the application of the Palladian style in England.

style was in use in England, including London – a continuation in brick of forms surviving from the previous century, but with an occasional introduction of the new Classical forms. In the second half of the century, building in brick took an opposite turn, imitating the extremely sober Classicism which had been started thirty years earlier in Holland by Jacob van Campen and Pieter Post. The originator of this change was Hugh May (1622–1684), who had taken refuge in the United Provinces during the Civil War, in company with Buckingham. This chastened style in brick, relieved only by a few stone mouldings and bands of masonry, gives many of the English towns their characteristic look. It was used throughout

England for building town-houses until stone came in again with the Victorian Age (*Ill. 123*).

The Great Fire of London, which from the 2nd to the 5th of September 1666 destroyed thirteen thousand two hundred houses and eighty-seven churches, created in the English capital a vast building yard, comparable to the one that was being formed at Versailles at the same time. The art of France, where an absolute monarch ruled, centred on a royal château; that of England, where the monarchy had become Parliamentary, on a city.

This sizeable new School of Architecture was presided over by Sir Christopher Wren (1632–1723). That he began with a university career as Professor of Astronomy is not unimportant; it meant that his mind was broken in to the mathematical disciplines. As with Inigo Jones, a journey had a decisive influence on his development, but this one was to Paris, in 1665. There he met Bernini and examined with passionate interest the châteaux already in existence or in course of construction. He came back with an inclination towards an ornate style, which altered the course set for English architecture by Inigo Jones and may truly be called – having regard to London's northerly latitude and to English Puritanism – Baroque.

The rebuilding of London was organized with remarkable method. A Commission for Rebuilding the City of London was set up, comprising three representatives of the King – Sir Christopher Wren, Sir Roger Pratt, and Hugh May – and three representatives of the City. The Commission's work led to the Act for Rebuilding the City of London (1667), which was followed by other Acts. An overall plan was made (but not executed), made up of wide streets radiating from squares or circuses, and was a survival of the radial plans that had been dear to the Renaissance. Public buildings – the Guildhall, the Royal Exchange, the Customs House – were built afresh. As regards dwelling-houses, the need for rapid and economical rebuilding imposed the use of brick, the result being a sober style of architecture and the adoption of a few standard types of house.

156

123 Compared with the Mauritshuis in The Hague (*Ill. 65*), Eltham Lodge, Kent, by Hugh May, shows clearly the impetus derived by the Classical trend in England from Dutch examples.

One thing that helped to give the City of London the general appearance it retained until the Second World War, when so many of these buildings were destroyed, was the rebuilding in stone of the parish churches; of eighty-seven destroyed, fifty-two were built afresh. It is here that the importance of Wren is seen most clearly, for these churches were designed by him and constructed under his supervision. Being meant for Anglican worship, they were essentially assembly halls, not on a very large scale, but spacious in order to be well adapted for preaching. Sir Christopher Wren, though he usually adopted the basilical plan, did not exclude the central (St Stephen's Walbrook, St Antholin's), but the supports of

the roof were widely spaced-out Corinthian columns, leaving the interior unencumbered (*Ill. 124*). The vitality of his space composition, and a certain richness of ornamentation taken from the vocabulary then prevailing in Italy and in France, set Wren's style apart from the Palladianism of Inigo Jones. Wren provided all his churches with belfries, surmounted by slender spires. Some of these are even in the Gothic style, which had never altogether ceased to be used in England, chiefly for university buildings – it was used by Wren himself for Tom Tower, Christ Church, Oxford (1681–1682).

The element of Romanticism comes out still more strongly in St Paul's Cathedral (1675–1712). This was conceived on a grand scale. Wren's first designs, for a central ground-plan of the type favoured by Bramante and Michelangelo for St Peter's, were opposed by the Commission set up to approve the designs, and the architect was ordered to produce a Latin cross plan. Wren succeeded gradually, however, in making his views prevail, by centring the basilica on a vast dome, the outside of which has a colonnade of the

124 Wren's churches are spacious, light, and relatively unencumbered, to allow the whole congregation to worship together as the Anglican religion requires – St Bride's, Fleet Street, London (photographed before 1940).

125 St Paul's Cathedral was intended to rival St Peter's in Rome, and its Roman style contrasts with many of the highly original churches also built by Wren in London.

kind Bramante had invented for St Peter's (*Ill. 125*). The use of Corinthian columns, with their effect of richness, is definitely Roman. And indeed, in his colonnade for Greenwich Hospital (after 1716) (*Ill. 126*), Wren imitated Bernini's colonnade before St Peter's. He designed the Great Hall of the same Hospital (1698–1707) with a sumptuous scheme of ornamentation – which Sir James Thornhill later completed with *trompe-l'œil* paintings that are the most perfect examples of this *genre* produced in England. Wren's Baroque tendencies were further emphasized at St Paul's in his design for the heavily decorated choir stalls carved by Grinling Gibbons.

Our survey of English art of the seventeenth century needs to include the first quarter of the eighteenth. Not only is this scope indicated by the date of Wren's death, but at that moment the Baroque style – which seemed to be spreading freely under the influence of two architects, Nicholas Hawksmoor (1661–1736), a follower of Wren, and John Vanbrugh (1664–1726) – came to be opposed by the Neo-Palladian reaction. The styles of Hawksmoor and Vanbrugh were closely related, and indeed the two men sometimes worked together. They were responsible for the design and construction of the two most Baroque of the great English country-houses, namely Castle Howard (*Ill. 127*) and Blenheim Palace (where Vanbrugh adopted a Versailles-like ground-plan with several courtyards). In each of them the aim of the whole conception was to create an overwhelming impression of magnificence, and to surprise the onlooker by the richness of the effects and the imposing distribution of the masses. Yet, in spite of everything, one feels that this architectural language is opposed to the English temperament; there is a lack of that imaginative impetus which creates the poetic quality of Baroque in the countries where this style is spontaneous. This lack rendered legitimate the Palladian reaction which, after three-quarters of a century of essays in the Baroque, brought English architecture back to its native tendencies.

5 The Eastern Dome and Colonnade of Greenwich Hospital shows another example Wren's Roman style: it was inspired by Bernini's colonnades in front of St Peter's.

7 The use of a colossal order and the richness of the ornamentation make Sir John nbrugh's Castle Howard one of the most Baroque buildings in England.

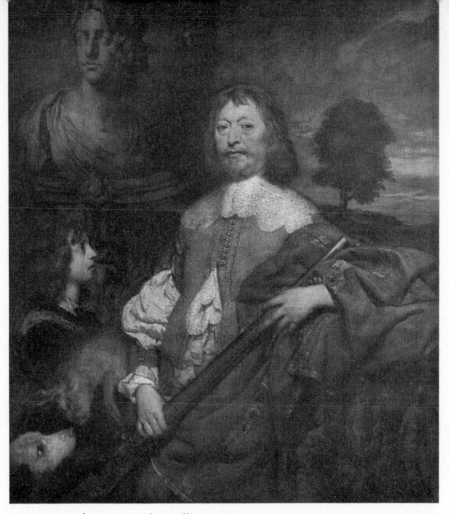

128 *Endymion Porter*, by William Dobson, National Gallery, London. The rude strength Dobson gives to people he paints contrasts with the aristocratic air of Van Dyck's figures.

SCULPTURE AND PAINTING

England produced so few painters and sculptors in the seventeenth century that recourse had to be had to artists from abroad. Most of these came from the United Provinces, but some from the Southern Netherlands. The best sculptor of English origin, Nicolas Stone of

129 *James Stuart, Duke of Richmond and Lennox*, by Sir Antony van Dyck, Metropolitan Museum, New York. When he was required to paint Charles I and his Court, Van Dyck found scope for the aristocratic tendency of his own temperament.

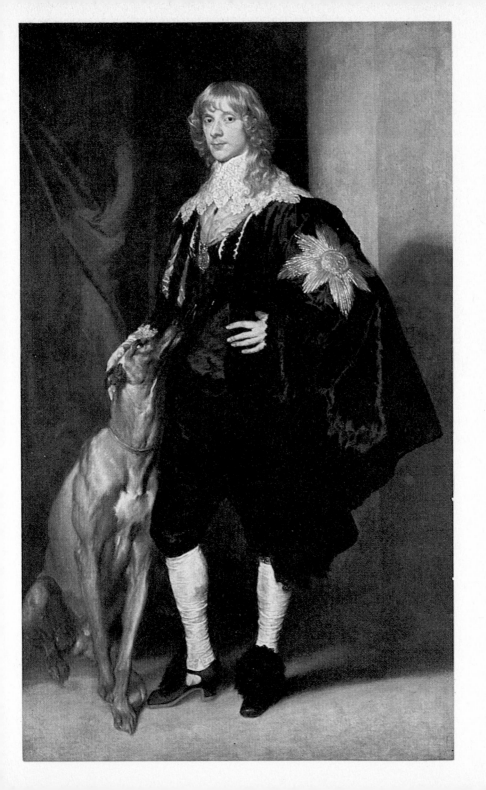

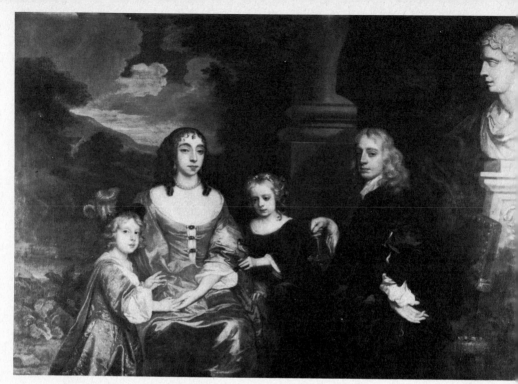

130 *The Family of Charles Dormer, Earl of Carnarvon*, by Sir Peter Lely, Collection of Sir John Coote, Bt. The pictures of the Dutchman Lely lack the aristocratic grace of Van Dyck. Instead, they reflect the superficial character of the Court of Charles II.

Exeter (1583–1647), brought into his country the style of Hendrick de Keyser of Amsterdam, whose son-in-law he was.

The ban on images in churches did away almost entirely with commissions for religious art; and since the English had little taste for mythology, this inexhaustible source of inspiration for the Baroque imagination was also lacking. The only set of mythological paintings on a large scale, the ceiling of the Banqueting Hall in Whitehall, was painted by Rubens in 1629–1630. The painters were thus limited to portraits. Even to meet this need, appeal had to be made to foreign artists, to Daniel Mytens from Holland and Van Dyck from Antwerp. Van Dyck, who had already visited London in 1620, returned in 1632 and settled there in 1635. He created the lasting image of Charles I, his Queen, and the nobles of his Court

(*Ill. 129*); and his elegant, thoroughbred style had a great influence on the next century. In the last part of his career he may be regarded as an English painter, for he learned to render the peculiar aristocratic grace of the society of the Cavaliers, soon to be threatened by the Civil War. The style of his contemporary, William Dobson (1611–1646), who was English, had in it more of a Baroque turbulence (*Ill. 128*).

The English School of Portrait Painting, which was to become so brilliant in the next century, may be said to have been really begun by Sir Peter Lely (1618–1680), who was born in Germany of Dutch parents, studied at Haarlem, and settled in London in 1643. Under the Restoration he became the official Court Painter; an admirer of Van Dyck, he 'mannerized' the style of that artist in a somewhat decadent way, which suited his sitters (*Ill. 130*).

THE MINOR ARTS

England remained attached to Renaissance forms during almost the whole of the seventeenth century. It was at the beginning of the eighteenth that the curvilinear forms of the Baroque style began to appear in English furniture. But the sweeping rhythm of acanthus volutes already gave life to the woodwork decorations in Wren's time, especially to those of Grinling Gibbons (1648–1720), who was the best wood-carver of the Baroque period and worked with Wren. The English were among the first in Europe to use lacquer. This was introduced from Japan and China, and it had been imitated in England before 1688 when John Stalker and George Parker published a *Treatise of Japanning and Varnishing*.

Pottery kept for a long time to Renaissance shapes and decoration; at the end of the century these yielded to Chinese and Japanese influence.

The silversmiths' art began in the seventeenth century that great advance which enabled it to create so many masterpieces in the next century. The decoration of the pieces remained Mannerist in

style during most of the seventeenth century, its place being taken, at the beginning of the eighteenth, by the French style of Jean Le Pautre and by the *lambrequin* motifs brought in by the Huguenot *émigrés* (notably Pierre Harache, David Willaume (*Ill. 131*), and Pierre Platel).

131 The style of this silver ewer by David Willaume, a French Huguenot in exile, shows the continuation of the Louis XIV *lambrequin* decoration, which has now become baroquized to some extent.

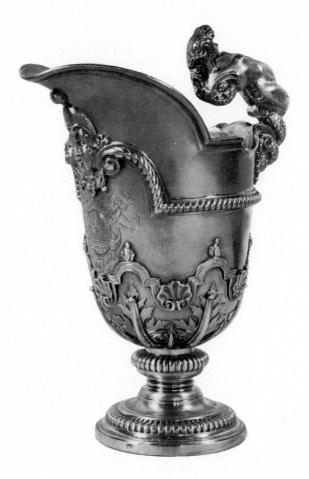

Eighteenth-Century Italy

In spite of some political realignments, Italy in the eighteenth century was moderately peaceful. The territory was still divided into several States, of which the most important were the Kingdom of the Two Sicilies, the Grand Duchy of Tuscany, the Republic of Venice, and the Papal States. Venice, Rome, and Naples were the main centres of art, for different reasons. People went to Venice to see the masterpieces of the Renaissance, but contemporary works also had considerable success, especially with visitors from Central Europe (with which Venice had been in close relations continuously since the Middle Ages) and from England. In Rome new attractions were added to those the Eternal City had presented in the previous century – the organization of museums had made collections more accessible to the public; and archaeology, of which Rome was the great centre, had become intensely active since the discoveries in the Campagna. Winckelmann, who settled in Rome in 1755, laid down rational and scientific bases for archaeology in his great *Geschichte der Kunst des Altertums*. Rome thus became an ideal place for the crystallization of Neo-Classicism.

ARCHITECTURE

For all the importance of the buildings raised during the previous century, the impetus of architecture in eighteenth-century Italy did not slacken. Rome remained fixed in a kind of Berninesque formalism. Carlo Fontana (1634–1714), who had worked with Pietro da Cortona, Rainaldi, and Bernini himself, transmitted this tradition to the eighteenth century. The creation of grandiose urban stage-settings

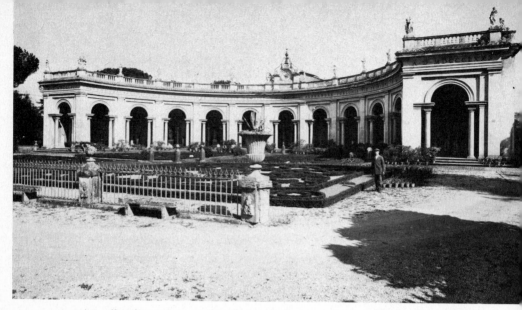

132 The Villa Albani, Rome, still contains the famous collection of Classical antiquities, of which Winckelmann was the keeper. The Caffè Haus of the Villa by Carlo Marchioni reflects this taste and led directly to the Neo-Classical style in architecture.

continued; they include the stairway of Santa Trinita dei Monti by Francisco de Sanctis, the Trevi Fountain by Nicola Salvi (which is so Berninesque that it was long thought to be based on a design by the master), and the façade of the Lateran by Alessandro Galilei. In the middle of the century Neo-Classicism laid its finger on Roman architecture (the Caffè Haus of the Villa Albani, by Carlo Marchioni (*Ill. 132*)). But in general, after the death of Bernini, Rome ceased to be a place of innovation; the chief centres for original work were on the periphery, in Southern Italy and Piedmont.

Venice continued on the course set by Baldassare Longhena. Giorgio Massari (*c.* 1686–1766), at the Gesuati, achieved a Baroque variation on the theme of the Palladian façade.

In 1734 the Crown of the Kingdom of the Two Sicilies went to a son of Philip V of Spain, who reigned as Charles VII. Here then this megalomaniac prince (who in 1754 succeeded to the throne of Spain) began to erect colossal buildings – the Palaces of Capodimonte and Caserta, and in Naples itself the Albergo dei Poveri and

the San Carlo Theatre. In addition, many new palaces and churches were built. The most original architect in Naples was Ferdinando Sanfelice (1675–1750), who composed his palaces about staircases, to which his imagination gave a variety of capricious forms and unexpected features. But Charles VII also called upon artists from outside to meet the enormous demands he had created – Ferdinando Fuga came from Rome in 1752 to design the Albergo dei Poveri; and Luigi Vanvitelli (1700–1773) was from the same city. Son of the Dutch painter Gaspar van Wittel (a specialist in views of Rome), Vanvitelli was summoned in 1751 by Charles VII to produce the plans for the palace he intended to raise at Caserta, some way outside Naples. Wishing to imitate Versailles, he had in mind a vast royal residence which would be the seat of political power. Though reduced in scale, the plan included no less than twelve hundred rooms, distributed in a quadrilateral enclosing four courtyards, a huge chapel in close imitation of the one at Versailles (*Ill. 133*), and a theatre. Vanvitelli stuck to the Italian type of compact ground-plan, but this one was original in its way of leading the visitor right up to the centre, with its entrance giving on to a vast stairway.

133 The Chapel of the Palace of Caserta is obviously inspired by the Chapel of Versailles, but the architect, Luigi Vanvitelli, has enriched his model with coloured marbles.

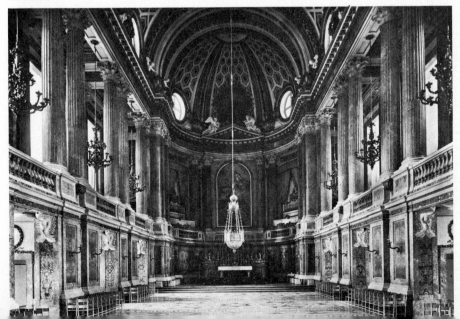

Beyond the château, again in imitation of Versailles, there is a colossal vista, and this was a novelty in Italy, where gardens were still laid out in terraces. Caserta is still Baroque by virtue of its enormous scale, but it is Neo-Classical in its sparing use of curves and in the employment, for the outside elevations, of nobly proportioned tiers of colossal columns – a scheme then becoming general throughout Europe.

In Sicily, meanwhile – at Palermo, Catania, Syracuse, Messina – an over-ornamented Baroque was being given full liberty. At Catania Giovanni Battista Vaccarini (1702–1768), who had learned his trade from Carlo Fontana in Rome, tried to bring some discipline into this extravagance. To the south-west of Syracuse the 1693 earthquake made it possible to rebuild a whole string of towns – Noto, Comiso, Grammichele, Ragusa, Modica. Of each of these the architects made an admirable Baroque stage-set, taking full advantage of the opportunity to treat the whole town, with its squares and stairways, churches and palaces, as a single work of art.

The height of ornamental folly was reached in the extreme South of Italy, at Lecce, where Giuseppe Zimbalo and his pupil, Giuseppe Cino, mingled reminiscences of Gothic and the Renaissance with Baroque, and built a kind of dream city, a concept of an imagination unrestrained by conformism of any kind.

While the South indulged in an independent Baroque, the North put a brake on it. Filippo Juvara (1678–1736), another pupil of Carlo Fontana, was summoned to Turin in 1714 by Vittorio Amedeo II of Savoy, and there he began to curb the tendency to Rococo which Guarino Guarini had started. Sometimes – as in his Palazzo Madama (1718–1721) and his Chiesa del Carmine (1732–1735) – he brought architecture right back to the Bernini norm. At Stupinigi he built a palace whose ground-plan in the form of an X was dictated by the requirements of a hunting-lodge. Its façades are Classical, but the rooms inside are in a temperate Baroque style. In his Basilica della Superga near Turin (1717–1731) the Berninesque

134 The Basilica of La Superga near Turin, by Filippo Juvara, is one of the first buildings in Italy in which Roman sumptuousness was purified in a Neo-Classical spirit.

forms are purified to an elegance that is already entirely Neo-Classical (*Ill. 134*). Juvara's output was considerable, both in Turin and in other Italian cities. His reputation was such that he was called to Lisbon, London, and Paris for consultation; and he died in Madrid, having been invited there to design the Royal Palace.

In Turin itself the spirit of Guarini was not entirely extinguished, in spite of Juvara's reaction against it. It still inspired Bernardo Vittone (1704/5–1770), who loved intersecting planes and vaults with interlaced groins, yet moderated Guarini's dynamism with a certain elegance of proportion borrowed from Juvara.

SCULPTURE AND PAINTING

The process of populating the churches of Rome with statues and carved tombs continued, and the sculptors' workshops were extremely active. They even produced for export (statues were ordered from Rome for the Palace-Monastery of Mafra near Lisbon). Sculpture, even more than architecture, was now firmly fixed in the style

171

135 *Il Disinganno*, by Francesco Queirolo, Capella Sansevero, Naples. This group, in which Queirolo has deployed his full virtuosity, symbolizes the Christian sinner extricating himself from the nets of error with the help of the Faith.

of Bernini. In this it contrasted to some extent with painting, which in Rome soon began to incline towards Neo-Classicism. Camillo Rusconi (1658–1728), the Frenchman Pierre Legros (1666–1719), and Michelangelo Slodtz (1726–1746) are among the sculptors most typical of this continuation of the Baroque.

In Naples and in Sicily sculpture was more original. In Naples Antonio Corradini (1668–1752), Francisco Queirolo (1704–1762), and Giuseppe Sammartino (1720?–1793?) gave free access to a kind of folly of illusionism. They were fond of trying to reproduce in marble the transparent and fluid effects of painting – a type of virtuosity that contains a confession of impotence (*Ill. 135*). More creative were the forms worked out by Giacomo Serpotta (1656–1732) in his decorations in stucco for various oratories in Palermo (*Ill. 136*). Right at the start of the eighteenth century his work began to explore the possibilities of those asymmetrical arrangements in which the rhythm is balanced through quasi-contrapuntal

136 The Oratory of S. Lorenzo, Palermo, by Giacomo Serpotta. Stucco was very widely used in Italy and in Central Europe: it made possible the rapid execution of an extremely rich ornamentation, with a great virtuosity in varied expression.

compensation – a system which the German artists of the Rococo period made into the basic principle of their schemes of ornamentation.

Painting in Italy during the eighteenth century presents a complex situation. In it the past, present, and future coincide. It is best studied from this point of view, rather than under the various Schools.

In Bologna, more than elsewhere, many painters continued in a *Seicento* formalism that became fossilized. Giuseppe Maria Crespi (1664–1747) reacted, in Bologna itself, against this Academicism, but in a direction that was still more *Seicento* – that is, by applying both to his religious and his battle pictures a chiaroscuro atmosphere and a spirit of realism (*Ill. 137*). It was the Romantic side of the *Seicento* that was carried on by Alessandro Magnasco (1667–1749), known as Lissandrino, who worked in Milan, Florence, and Bologna; his satirical spirit makes him a successor to Callot, his love of night scenes to Morazzone and Francesco del Cairo, and his Romanticism to Salvator Rosa, while he took also from the Venetians the magic of his colour. His strange compositions, with their nervous brush-work, express a deep melancholy (*Ill. 138*).

In Naples there flourished a whole school of decorative painters. Of these, Francesco Solimena (1657–1747), with his crowds of figures

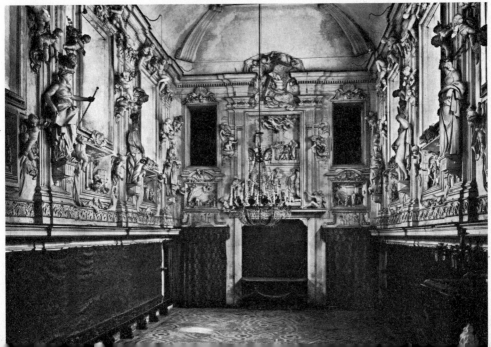

137 *The Extreme Unction*, by Giuseppe Maria Crespi, Gemäldegalerie, Dresden. In his series of the Seven Sacraments, Crespi, following the tradition of Caravaggio, humanized the acts of religion by representing them in their everyday simplicity.

swirling through eddies of light and shade (*Ill. 139*), still belongs to the line of the *tenebrosi*, while Francesco de Mura (1696–1784), of the next generation, abandons this chiaroscuro for a gaiety of colouring that makes him the Neapolitan Tiepolo. The love of realism, which had already emerged in the preceding century, made the Neapolitan painters continue very actively with still-life painting.

In the North of Italy, in Lombardy, this realism turned some painters towards war pictures, based on observation of the life of peasants or of beggars, who were depicted with a certain satirical astringency (for instance, Giacomo Ceruti, who was active in the middle of the century). This *genre* was represented in Naples by

Gaspare Traversi (active between 1732? and 1769), who amused himself with the oddities of small tradesmen and their servants. In Venice Pietro Longhi (1702–1785) represented scenes of varied life, not satirically but with a feeling for the picturesque. The most astringent realism was that of a Lombard portrait painter, Giuseppe Ghislandi (1655–1743) of Bergamo, who was known as Fra Galgario. The effigies of the decadent aristocracy of his time, produced by his brush, make one think of Goya's portraits of the Spanish royal family (*Ill. 141*).

It was in Venice that Rococo painting came into its own. The name can, in fact, be rightly applied to the jagged compositions of Piazzetta, the choppy handling of the Guardis, and to Tiepolo's flights into space. The way was prepared for Venetian *Settecento* painting by Sebastiano Ricci (1659–1734), who painted in light colours, and by Giovanni Battista Piazzetta (1683–1754), who retained something of the *tenebrosi* style of the *Seicento*. Venice, in love with her own beauty, gave birth to a number of landscape

138 *Reception on a Terrace*, by Alessandro Magnasco, Palazzo Bianco, Genoa. Even in this small detail of a large decoration, Magnasco's technique, his flurry of coloured brush-strokes evoking a half-realized Romantic atmosphere, can be seen.

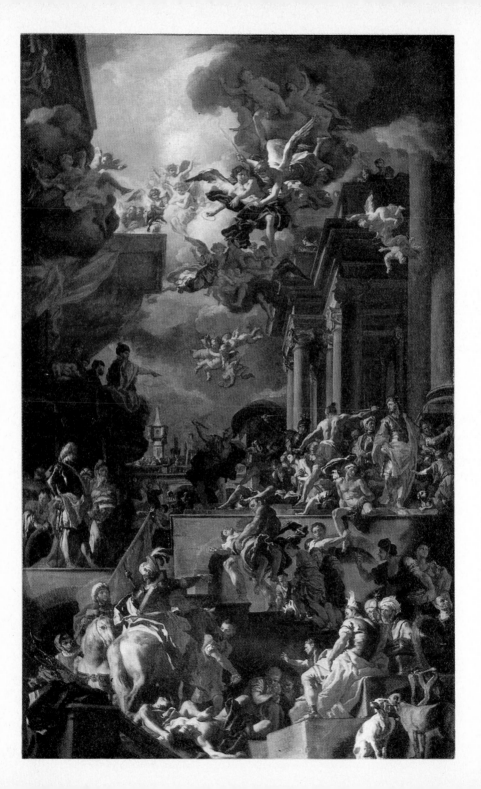

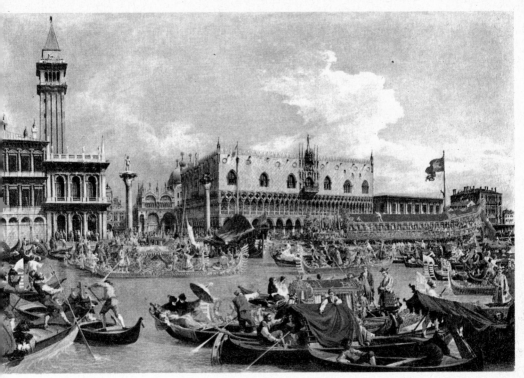

140 *The Feast of the Ascension, Venice*, by Canaletto, Aldo Crespi Collection, Milan. Canaletto was a kind of chronicler of the life of Venice, its festivals, ceremonies, and monuments.

painters, who depicted her palaces, open spaces, and canals, with the picturesque life that filled them; and these *vedute* soon had a great success throughout Europe. Antonio Canale (1697–1768), known as Canaletto, laid out his compositions in a geometrical spirit that was almost a return to the *Quattrocento*, in his desire to obtain the most faithful image possible (*Ill. 140*). In contrast Francesco Guardi (1712–1793), whose style already suggests Impressionism, never tired of evoking the mirage of the Venetian atmosphere, with its colour that reflects and is reflected (*Ill. 144*). When his association with his brother Gianantonio (1699–1760) was ended by death he devoted himself entirely to landscape painting. But within landscape painting the essentially Rococo *genre* is that of the *capriccio*. This pastoral or

◀ 139 *The Massacre of the Giustiniani at Chios*, by Francesco Solimena, Capodimonte Museum, Naples, is the sketch for one of the large-scale compositions for the Senate Chamber in Genoa. The space follows the same laws of perspective as those used by Padre Pozzo.

idyllic *genre*, with its compositions full of fantasy and its decorative aim, was created by Marco Ricci (1676–1720) and continued till nearly the end of the century by Francesco Zuccarelli (1702–1788).

Ceiling painting, to which Padre Pozzo had given such brilliance in the last years of the seventeenth century, continued vigorously in Naples (Solimena, Sebastiano Conca, Francesco de Mura). Its developments of perspective inspired the members of the Galli-Bibiena family, who came from Bologna, to produce theatrical designs for various Courts in Italy and Central Europe. The Venetian painter, Gian Battista Tiepolo (1696–1770), brought spatial painting to its climax, by leaving aside the artificial devices of his predecessors' architectural perspectives and setting his flying figures in the midst of clouds, with vertiginous foreshortenings. Both in his frescoes and in his easel paintings in oils, Tiepolo used an extremely light colour and a brushwork that was sensitive, rapid, and almost transparent (*Ill. 142*). His masterpiece was the ceiling of the staircase of the Prince-Bishop's Residenz at Würzburg in Franconia (1750–1753).

The reputation of the Venetian painters was such that they were summoned to a number of foreign Courts. Sebastiano and Marco

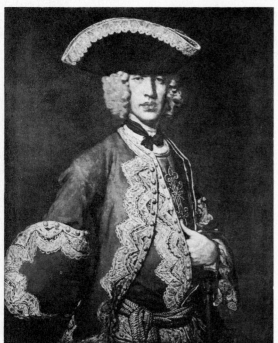

141 *Nobleman with the Three-Cornered Hat*, by Vittore Ghislandi, Poldi-Pezzoli Museum, Milan. Ghislandi was a monk, and he is also known as Fra Galgario. His portraits, with their mixture of satirical and romanticized elements in depicting a society moving towards its decline, make one think of Goya (*Ill. 176*).

142 *The Institution of the Rosary*, by Gian Battista Tiepolo, the Gesùati, Venice, shows ceiling painting which is still arranged in the manner of Padre Pozzo. A staircase in the picture enables the eye quite literally to climb to the important figures and the open sky beyond them.

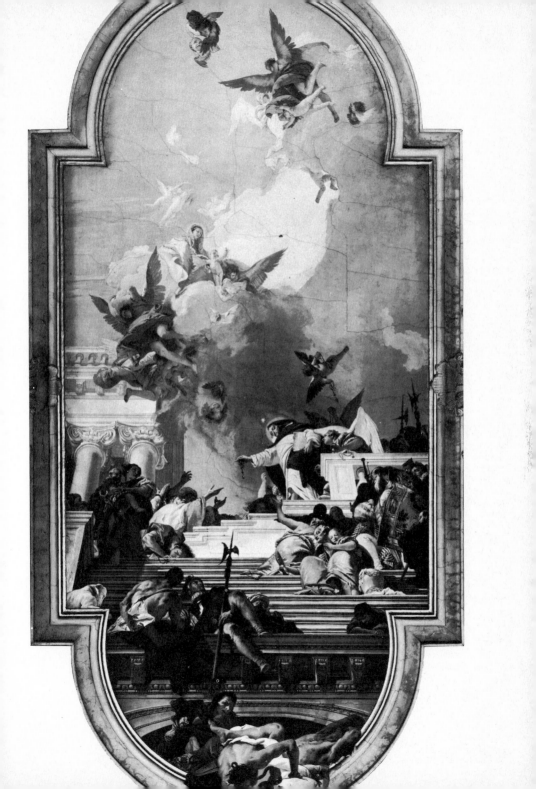

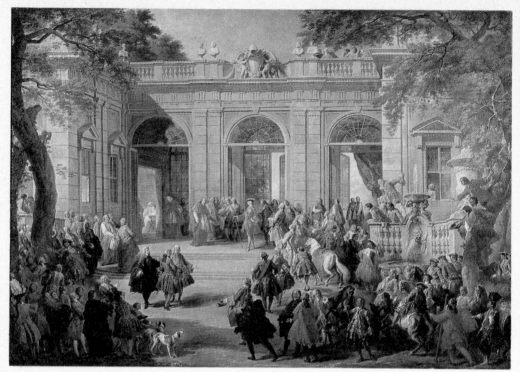

143 *Charles III visits Benedict XIV at the Quirinale*, by Gian Paolo Pannini, Capodimonte Museum, Naples. Pannini's lively chronicles of Roman life have more sincerity than those rather conventional views of ruins which initially made him famous.

Ricci, Pellegrini and Canaletto went to London (Canaletto through the agency of Joseph Smith, the English Consul in Venice, who was an enthusiast for Venetian painting); Tiepolo painted in Madrid and Würzburg; Bernardo Bellotto, who was Canaletto's nephew and borrowed his name, worked in Dresden, Warsaw, and Vienna; and the pastel artist Rosalba Carriera went to Paris and Dresden.

It was in Rome, shortly before the middle of the century, that Italian painting took a definitely Neo-Classical course, opposed both to the *Seicento* Baroque and to Venetian Rococo. The artists now renounced the seductions of the imaginary. The sole exception was the engraver Giovanni Battista Piranesi (1720–1778), whose views of Rome have an aura of fantasy. The other *vedutisti* – such as Gaspar

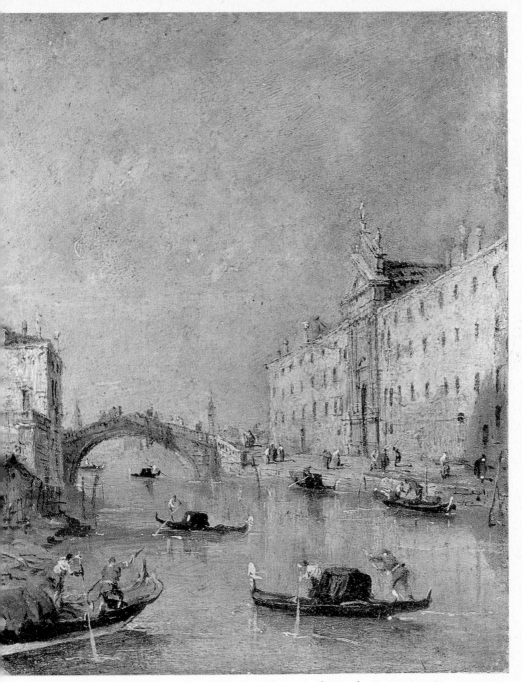

144 *The Rio dei Mendicanti, Venice*, by Francesco Guardi, Academia Carrara, Bergamo. Guardi was a forerunner of the Impressionists in the way he painted his forms melting into the watery atmosphere of the Lagoon.

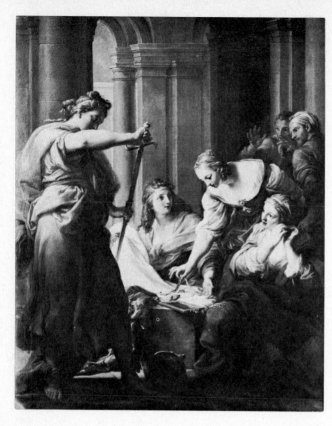

145 *Achilles on Scyros*, by Pompeo Batoni, Uffizi, Florence. The Neo-Classical brush of Pompeo Batoni freezes the mythological inspiration whose fantasy gave life to Baroque painting.

van Wittel (1653–1736), known as Vanvitelli, and Gian Paolo Pannini (1691/2–1778) – who were now having a great success both with Roman patrons and with the many foreigners passing through Rome, made it their object to represent the picturesque sights and amusements of the city with topographical exactitude. Pannini, however, also produced pictures of ruins entitled *Vedute Ideate*, but these came from an architect's vision rather than a poet's (*Ill. 143*). Pierre Subleyras (1699–1749), a Frenchman who settled in Rome, painted religious compositions that were sober and disciplined in accordance with the French tradition; they suggest the work of Eustache Le Sueur in the preceding century. Marco Benefil (1684–1764) went so far as to plagiarize Raphael (*The Transfiguration*, San Andrea de Vetralla). Pompeo Batoni (1708–1787), alike in his

mythological (*Ill. 145*) and his religious pictures, adopted simple compositions, which he carried out in very light colouring with a certain sentimentality; he painted portraits of the aristocratic society of Rome, including many English visitors. Anton Raphael Mengs (1728–1779), who came from Bohemia, was a passionate adept of Winckelmann's theories of an ideal beauty revived from antiquity; but his mediocre talent was only capable of producing lifeless portraits and cold compositions with an archaeological flavour.

THE MINOR ARTS

The overloaded Baroque style of furniture-making came to an end in the 1730s. There took place then, in Genoa and Venice, a simplification which has been given the name *Barocchetto*. New types of furniture were produced, in particular the *ribalta* (an elaborate secretaire) and the pier-glass (an elegant piece in two parts). The transition from Baroque to *Barocchetto* is especially clear in the change from the *cassone* into the *cassettone* and then into the *ribalta*. Venice produced elegant *rocaille* furniture with painted decoration.

The eighteenth century saw a revival of marquetry, which had been in high demand in the sixteenth century. The most gifted of the cabinet-makers specializing in the encrustation of precious woods with ivory was Pietro Piffetti (1700–1777), who worked for the Court of Savoy. And indeed it was Piedmont that produced the best designs and most carefully finished pieces of furniture, profiting from both French and German influences. The Palazzo Reale and the Palazzo dell'Accademia Filarmonica in Turin still contain admirable rooms decorated in gilded wood, which were originally filled with very fine furniture.

The English style known as Chippendale began to influence Venetian and Genoese furniture-making from 1760 onwards.

Pottery did not flourish in Italy as much as in France and the Germanic lands at this time. But the enthusiasm for porcelain now reached Italy, and some of this was produced by factories at Vinovo

in Piedmont and at Capodimonte near Naples. The Capodimonte factory made the decorations of a whole room in porcelain in the Chinese style for the Palace of Portici, and this is now in the Capodimonte Museum (*Ill. 146*). In Naples, from the end of the seventeenth century onwards, cribs with a great many figures became common in churches – and still more common in the palaces. At first they were carved in wood. In the eighteenth century, they were more often moulded in terracotta. The realist taste for representing sacred scenes in terms of people from the poorer classes, which had emerged in the beginning of the *Seicento*, ended up in the small figures of these Neapolitan cribs.

146 The Porcelain Room from the Palace of Portici is now installed in the Capodimonte Museum, Naples. The decoration in the '*chinoiserie*' style was carried out in porcelain between 1754 and 1759 by the Capodimonte factory.

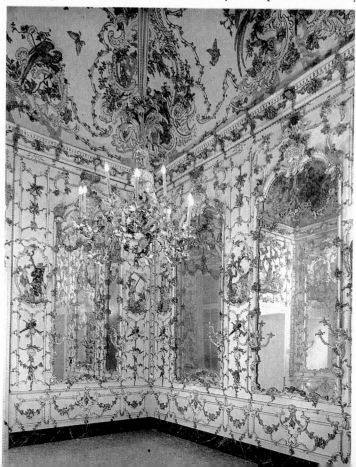

Eighteenth-Century France

The seventeenth had been a royal century; the next was an aristocratic one. At the death of Louis XIV the Court at Versailles was dissolved, and Louis XV, still a child, was brought to the Tuileries. There was a hasty flight from the Court where, during the last years of Louis XIV, the gloom produced by political miscarriages and by the austerity of Madame de Maintenon had caused a general feeling of depression. Many town-houses were now built in Paris, and many châteaux in the provinces. Society changed and grew larger – in it financiers now mingled with the old *noblesse d'épée* and *noblesse de robe*; intellectuals also were admitted, and they helped to bring advanced ideas into vogue in a milieu where women were developing refinement of taste, good manners, and the art of living. After the severity of the second half of Louis XIV's reign, morals relaxed. The Duke of Orléans, who exercised the Regency for eight years (1715–1723), set an example of pleasure-seeking life.

In this refined society there was a great demand for works of art, both new and old. Connoisseurship spread. Louis XIV had set an example as a royal patron, and in the eighteenth century, although the kings did little to add to the royal collections, art collectors grew more and more numerous, and an organized art trade arose in answer to the increased demand, which produced high prices.

This did not change when the young King re-established the Court at Versailles. The new Queen, with her lack of ostentation, had no effect on the arts. Later the royal mistresses, especially Madame de Pompadour, were to contribute to the refinement of taste, but it

185

was now the city that set the tone to the Court. The King did not hesitate to destroy some of the finest parts of the Versailles of Louis XIV, such as the Escalier des Ambassadeurs, in order to live there comfortably in the now fashionable *petits appartements*.

Louis XVI, who was interested only in hunting and in the lock-smith's craft, proved totally indifferent to the arts, and the taste of Queen Marie-Antoinette was applied chiefly to fashion and to frills and furbelows – but also to furniture. The important position which Parisian society was acquiring completed, in due course, the decline of the royal influence. In the *salons*, where politics, literature, and philosophy were discussed, intelligence was now a better intro-duction than wealth. Style was developing towards Neo-Classicism, but the applied arts, being the expression of the art of living, exhibited an increasing refinement. None the less, during the last years of the *ancien régime*, a certain official activity due to the initiative of the Comte d'Angiviller, the highly intelligent Director of Buildings, once more began to exert an influence on the arts. D'Angiviller encouraged the figurative arts in their tendency towards Classicism by commissioning works on historical subjects from living artists – a policy which helped to produce a new Academicism. More fortunate was his programme for developing the museums. In view of the public exhibition of the King's pictures in the Great Gallery of the Louvre, the Director of Buildings revived the policy of buying works of art, making some happy additions to royal collections.

It has become customary to call the three main stages of French eighteenth-century style by the names of the political periods – Régence, Louis XV, and Louis XVI. There is no disadvantage in retaining these names, consecrated by usage, provided we realize that the changes of style did not correspond exactly with the dates of the reigns. The Régence style, which accomplished the transition from the seventeenth to the eighteenth century, extended from 1705 to about 1730. The Louis XV style flourished between 1735 and 1750. But the Louis XVI style began in about 1760 – that is to say,

long before that King came to the throne. From that moment Classicism became dominant – at least in architecture. For in many cases the decoration of the interiors lagged behind; it is not uncommon to find a 'Louis XV' scheme of decoration inside a town-house with 'Louis XVI' façades.

ARCHITECTURE

It must be recognized that the change in the decoration of interiors had already begun in the time of Louis XIV. In the rooms made for that King at Versailles after 1684 – alongside the grand chambers reserved for official life – the architectural decoration in polychrome marble and gilt bronze was given up in favour of gold-edged and painted panelling, and these rooms were on a small scale. In the town-houses that were built in Paris from the beginning of the eighteenth century this development was accelerated; gold-edged panelling and mirrors, leaving little room for pictorial compositions, replaced the grand columns and large-scale paintings of the preceding century.

In about 1720 this decoration began to acquire sinuous forms and to find place for *rocaille*. Such designers of ornamentation as Oppenordt, Nicolas Pineau and, later, Meissonnier caused this sensuous style to prevail in place of the more noble style of Le Pautre. The second Claude Audran (1658–1734) endowed the *grotteschi*, which had been reintroduced by Bérain and were now known as *arabesques*, with a quality of imaginative fantasy and winged grace. The architect Germain Boffrand (1667–1754) contributed more than anyone to the rise of this Rococo style in French interiors, and it was he who designed the best example of it in Paris – the rooms of the Hôtel Soubise (1738–1739) (*Ill. 147*).

The importance acquired by the arrangement of interiors at this period makes it legitimate for us to approach its architecture from this point of view. It was the moment when people turned away from Louis XIV's solemn vistas of rooms and sought to specialize the places where people lived in accordance with their uses – a bedroom,

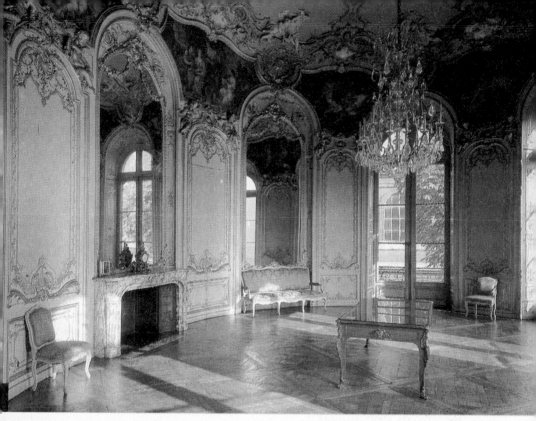

147 Germain Boffrand decorated the Salon Ovale and other rooms of the Hôtel Soubise in Paris, 1738–1739. This is the best example of the full Rococo style in French interiors.

an antechamber, a dining-room, a reception room replacing the gallery, a study, a boudoir for leisure, a library; and it became usual to distinguish between reception rooms on the ground floor and more intimate rooms upstairs. Moreover, the planning of the new town-houses was given more suppleness to accommodate this division of function. The façades were made less severe, with many windows and with the different storeys clearly stated. Their forms too became more elegant – though there was no renunciation of an external Classicism, which contrasted with the Rococo style of the interior. In the architecture itself, examples of true Rococo were rare. They were to be found mostly in the east of France, where various artists – notably Germain Boffrand and Héré – indulged in

greater fantasy, in response to the taste of the Queen's father, the dethroned King of Poland, Stanislas Leczinski, who had been granted the Duchy of Lorraine. The châteaux built by this prince have been destroyed, or deprived of their decoration and gardens; but the planned centre of Nancy (*Ill. 148*) remains.

Apart from Nancy, programmes of town planning continued the Classical style which came in during the reign of Louis XIV. Paris, Rennes, and Bordeaux built *places royales* dedicated to Louis XV, modelled on those of the previous reign. After Robert de Cotte and Germain Boffrand, who made the transition between the Louis XIV and Louis XV periods, the dominant architect towards the middle of the century was Jacques-Ange Gabriel (1698–1782). In the Place de la Concorde (*Ill. 150*), the former Place Royale, he took up again the idea of the Louvre colonnade, using orders of giant Corinthian columns and long balustrades (1753–1765). Twenty years earlier he had given the Place de la Bourse in Bordeaux (*Ill. 149*), also formerly the Place Royale, a less solemn and more elegant character by using Ionic columns (1731–1755), and a comparison between these two squares enables us to measure the change that had taken place in the

148 The architect Héré carried out the Place de la Carriére, Nancy, for the Duke of Lorraine, Stanislas Leczinski, sometime King of Poland, in 1753–1755. One of the finest pieces of town planning in France, it is entirely in the Rococo style.

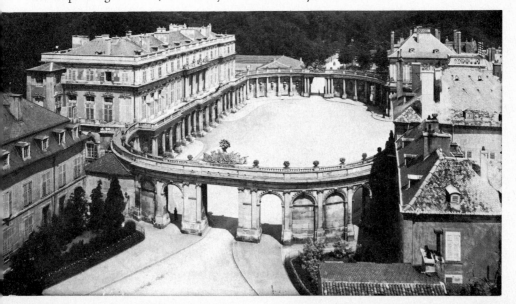

149–150 Place de la Bourse, Bordeaux. Place de la Concorde, Paris, with the Hôtel de la Marine and Hôtel de Crillon. In both of these 'places royales' Jacques-Ange Gabriel used the arrangement already tried in the Louvre colonnade (Ill. 96), but the one in Bordeaux, with its high French roofs, is the less Classical.

meaning of Classicism in the case of a single architect. The 'folly' designed for Madame de Pompadour in the Trianon gardens and built from 1762 to 1764 is the purest example of the Classicism of Jacques-Ange Gabriel; and he applied the same style, whose essential characteristic is return to the Classical orders, to the Versailles Opera House (1770), recently restored. He also planned to remodel the Château of Versailles in this style, and we must count ourselves fortunate that the royal finances did not allow him to go ahead.

During the reign of Louis XVI orders of colossal columns became the dominant architectural feature, with a tendency to approximate more and more to the proportions of those of antiquity. Jacques Germain Soufflot (1713–1780) made this the motif of both the interior and the portico of his Église Sainte-Geneviève (now the

Panthéon), which he surmounted with a cupola in imitation of that of St Paul's in London (*Ill. 151*). But the discovery of the antiquities of Southern Italy soon influenced architects to imitate the Greek orders rather than the Roman. The Greek proportions inspired the art of Chalgrin (1739–1811), Gondoin (1737–1818) and, above all, Claude-Nicolas Ledoux (1736–1806), who used for the Salt Mines at Arc-et-Senans near Besançon (1773–1775) a Doric order based on the temples at Paestum (*Ill. 152*). He built the gates of the new Paris fortifications in a severe style. The colonnade became the motif which architects repeated endlessly, for example in the Grand Théâtre at Bordeaux (1773–1780) by Victor Louis.

Interiors were still decorated with ornamental woodwork, but *rocaille* went out of fashion and was replaced by compositions of garlands, ribbons, and panniers. Sometimes they were even inspired by the architectural features of the exterior, and the return to the orders, which occurred in the first part of the reign of Louis XIV, was carried out in wood. This ornamentation was not uniformly gilded. It was now painted in light colours, often relieved by touches of stronger colour or by a little gilding. After 1770 under the influence of the architect-designer Clérisseau, who made several journeys to Italy, some of the town-houses were decorated in the Pompeian

151 The Panthéon, Paris, by Soufflot, was originally intended as a church, Sainte-Geneviève, and was inspired by St Paul's Cathedral, London (*Ill. 125*).

152 The Directors' Pavilion, Salt Mines at Arc-et-Senans, 1773–1775, by Ledoux, was one of the earliest examples of industrial architecture, modelled on Classical antiquity.

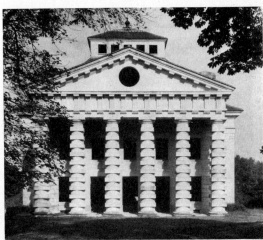

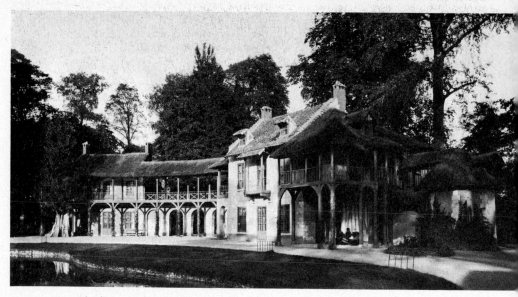

153 The 'Hameau', or artificial village, in the grounds of the Petit Trianon, Versailles, was laid out by the architect Mique in imitation of an 'English garden': it was the final caprice of Queen Marie-Antoinette.

style, or in 'the Etruscan manner' which was then very much in fashion in England.

The layout of the gardens remained, during the reign of Louis XV, more or less in conformity with the style of Le Nostre, though on a less imposing scale. In the second half of the century the picturesque 'Anglo-Chinese' type of garden, with its winding walks, was introduced into France – it was embellished with numerous pavilions in the Classical style, temples to the ideals of sentiment (to love, to friendship, to faithfulness), Chinese kiosks, artificial Gothic ruins, rustic dwellings, peasant villages. Of all these picturesque gardens there is hardly anything left in France, except that of the Petit Trianon at Versailles, laid out in 1780 by Richard Mique (1728–1794) in response to a caprice of Queen Marie-Antoinette (*Ill. 153*).

SCULPTURE

Sculpture was more Baroque than architecture in eighteenth-century France. It stemmed from Coysevox rather than Girardon. Most

of the artists made long visits to Rome, bringing back with them the taste for dramatic attitudes, eloquent gestures, and drapery in movement. The evolution of baroquism can easily be traced through the families of artists which went back to the period of Louis XIV – the Coustous (nephews of Coysevox), the Lemoynes, the Adams, and the Slodtz family. The second Jean-Baptiste Lemoyne (1704–1731) was the portraitist most in favour under Louis XV; he revived the tradition of Coysevox's busts by a more thorough study of the character of the faces (*Ill. 154*). Busts of women, which had been unusual under the Roi Soleil, became fashionable and acquired smiling and coquettish attitudes. On the other hand, Edme Bouchardon (1698–1762), during his nine years in Rome, paid much closer attention to the statues of antiquity than to Baroque ones. Recalled to Paris in 1732, he protested unceasingly, both in words and by example, against the baroquism of the sculpture of his period, and produced works which harked back to those of Girardon yet appear Classical before their time (*Ill. 155*).

Small rooms required small statues, and various artists met this

154 The Bust of the Regent, by Jean-Baptiste Lemoyne II, Versailles. Lemoyne continued the noble style of Coysevox (*Ill. 104*), in such busts as this, but his work lacked that sharpness of expression and psychological penetration which distinguished the busts by his predecessor.

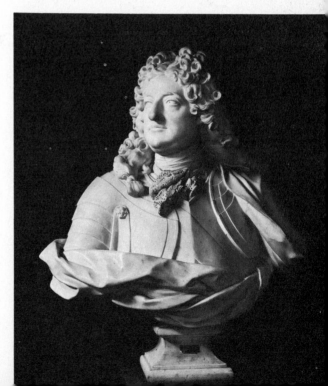

demand, especially Jean-Baptiste Falconet (1716–1791), who was the favourite sculptor of Madame de Pompadour. His affected grace was somewhat weak, and the statue of Peter the Great which he set up in St Petersburg at the request of Catherine II was a sharp break with his usual work (*Ill. 199*).

In the second half of the eighteenth century official commissions became rare, and the artists worked more and more for the interiors of houses. None the less, Jean-Baptiste Pigalle (1714–1785) maintained the 'grand style', and in his Monument of the Comte d'Harcourt in Notre-Dame, 1776 (*Ill. 157*), and his Tomb of Marshal Saxe in St Thomas's Church at Strasbourg he harmonized Baroque movement with the Classical cadence. Jean-Jacques Caffieri (1725–1792) still endowed with nobility the art of the portrait bust, which Jean-Antoine Houdon (1741–1828) reduced, more often than not,

155 *Cupid Making a Bow out of the Club of Hercules*, by Bouchardon, Louvre, Paris.

156 *Diana*, by Houdon, Gulbenkian Collection, Lisbon. These two statues illustrate the French conception of the smooth and elegant nude, which derives from the School of Fontainebleau.

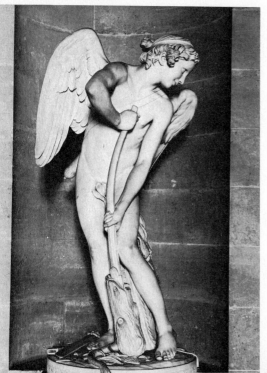

157 In the Funerary Monument to the Comte D'Harcourt, by Pigalle, Notre-Dame, Paris, the praying widow and the mourning spirit with a lowered torch seem to cry out against the figure of Death who carries off the body of the Count.

merely to the face, caught in one of its fugitive expressions. Claude-Michel Clodion (1738–1814) satisfied the taste of society for the bibelot-sculpture inspired by Fragonard's paintings on themes of gallantry. Under Louis XVI modelling became more and more smooth, feminine nudes more and more numerous. Houdon's *Diana*, with its smooth and slender limbs wholly integrated, reminds us of the forms characteristic of the Fontainebleau School (especially those of Primaticcio) in the sixteenth century (*Ill. 156*).

PAINTING

Whether the name of Antoine Watteau – who was born in 1684 and died in 1721 – should be associated with the seventeenth or with the eighteenth century is a controversial question. The poetic gravity of his art, contrasting as it does with the frivolity of the eighteenth century, has made some historians consider him as belonging to the seventeenth century, but this argument would force us to say the

same of Chardin. The truth is that by his technique Watteau belongs firmly to the eighteenth century; he brings out, in fact, the altered balance between the tendencies that had been in conflict at the end of the seventeenth century and had nourished the opposition between the Poussinists and the followers of Rubens, between the partisans of design and those of colour. Watteau had studied Rubens in the Medici Gallery in the Luxembourg Palace and he had combined this influence with that of two other great masters of colour – of Titian and Veronese. His art was a poetical escape into an enchanted world, which he created by means of characters from the Italian *Commedia dell'Arte* and from the Comédie-Française, and of landscapes from the great gardens in autumn. His work is laden with a deep melancholy and a kind of anguished sensibility. Two pictures stand out from the rest – the *Embarquement pour Cythère* (Louvre) (*Ill. 159*), 1717, and the *Enseigne de Gersaint* (Berlin) (*Ill. 158*), which he executed rapidly, less than a year before his death, for use as a sign for a picture dealer's shop.

Watteau's painting, like Chardin's, was still – as Poussin's had been in the seventeenth century – a personal speculation. In the eighteenth century, when painting was an art of society, not a Court art, conditions changed. There was an abundance of commissions, which enabled many painters to gain a living. But to some extent these painters returned to the condition of artisans, and there was nothing comparable, in the eighteenth century, to the half-princely situation enjoyed by Le Brun under Louis XIV. Families handed down the tricks of the trade; 'dynasties' with almost countless members – the Coypels, the de Troys, the Van Loos – spanned the century.

This quality of the artisan left its mark on the manner of painting. Artists sought not so much to find a style of their own as to paint correctly in an impersonal manner – which indeed was best suited to the illustrative quality demanded of them. Painting, which in the seventeenth century had tended towards formal research, became mere depiction.

158 *L'Enseigne de Gersaint,* by Antoine Watteau, Staatliche Schlösser und Gärten, Berlin. Painted in a few days for use as a sign for the shop of Gersaint, the dealer, this picture is one of the most poetic evocations of the elegant life of eighteenth-century France.

When, in 1717, the *Embarquement pour Cythère* was registered at the Académie, where it was the picture submitted by Watteau for his reception as a member, it was officially described as a *fête galante.* This *genre* was chiefly graced, after Watteau, by two followers of his – Jean-Baptiste Pater (1695–1736), who came from Valenciennes as Watteau did and who followed him closely, transposing his atmosphere to a more silvery one, and by Nicolas Lancret (1690–1743). Lancret, who was more varied, more of a real painter, frequently turned to *genre* scenes (*Ill. 160*).

The painting of historical subjects turned into *mythologie galante,* abounding in nudes. François Lemoine (1688–1737), who in 1733–1736 painted the ceiling of the Salon d'Hercule at Versailles, still kept something of Le Brun's nobility of style; but this style became effeminate in the work of his two pupils, Charles Natoire (1700–1777) and François Boucher (1703–1770). Boucher was the favourite painter of Madame de Pompadour, Louis XV's mistress; his mannered grace fitted in well with the Rococo style, and adapted itself perfectly to the requirements of *trumeaux* – those spaces framed in

197

159 *L'Embarquement pour Cythère*, by Watteau, Louvre, Paris. This was the picture presented by Watteau on his reception into the Académie; it is a kind of summing up of his art, inspired by Giorgione, Leonardo, Titian and Rubens.

sinuous forms above doorways, which were now the only places left for paintings in the rooms panelled with gilded wood (*Ill. 161*).

Some painters concentrated almost exclusively on the illustration of that royal and princely pastime *par excellence*, the chase. François Desportes (1661–1743) began to excel in this *genre* under Louis XIV (*Ill. 162*), and Jean-Baptiste Oudry (1686–1755) distinguished himself in it under Louis XV. Both these artists showed a great interest in landscape: the *Chasses de Louis XV* in the Château of Fontainebleau, painted by Oudry for translation into tapestry, are among the finest evocations of natural scenery in eighteenth-century France.

In a society that delighted in itself, portrait painting was in great demand – on condition that it adapted itself to the tastes of that society and supplied its sitters with seductive effigies. Nicolas de

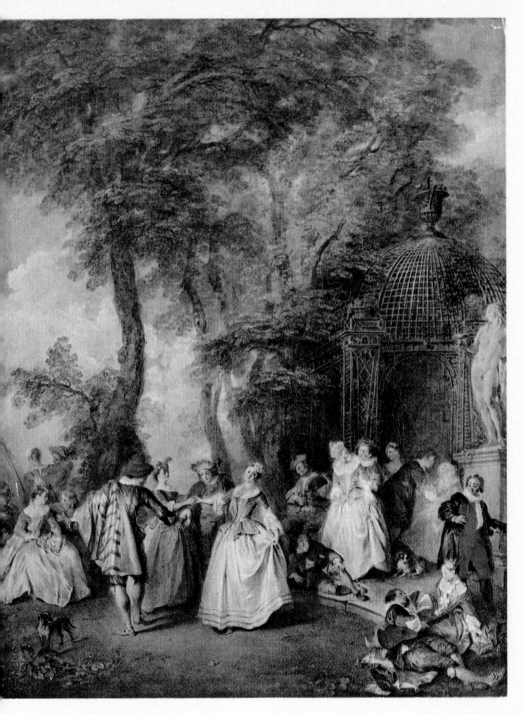

160 *Le Moulinet devant la charmille* ('The Quadrille in front of the Beech Grove'), by Nicolas Lancret, Staatliche Schlösser und Gärten, Berlin. Watteau's profound poetic feeling becomes in Lancret no more than a picturesque and amiable evocation of the life of society.

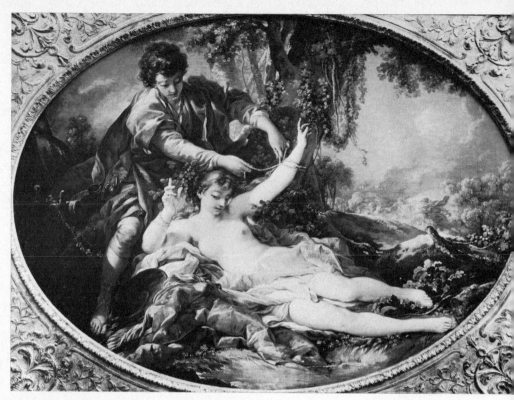

161 *Sylvia Freed by Amyntas*, by François Boucher, Banque de France, Paris. The mythological themes which had already inspired so many of the Baroque and Classical painters are transformed by Boucher into the gallant style, which he adapted to the new decorative requirements.

Largilierre (1656–1746), straddling the two centuries, continued to produce allegorical portraits, with his subjects dressed up as mythological characters in tumultuously flowing draperies; his manner had considerable success with women. The women became decidedly undressed in the portraits painted by Jean-Marc Nattier (1685–1766), who was clever at transforming the weightiest matrons into goddesses (*Ill. 163*). There was a tendency to embellish portraits with many accessories whose purpose was to define the sitter's status. The most fashionable practitioners of this type of society portrait were Louis Tocqué (1696–1772), Nattier's son-in-law, and Carle Van Loo (1705–1765), also a painter of goddesses.

But a reaction towards simplicity was not long in coming. Jacques Aved (1702–1776), who owed a great deal to Chardin, was the best representative of this tendency, depicting men and women in private life, in the clothes they wore when at home – the women reading or doing needlework. The fashion for portraits in pastel is sometimes dated from La Rosalba's coming to Paris (1720), but in fact this *genre* was already being produced in France, where Joseph Vivien (1657–1735) had made himself a specialist in it. In the eighteenth century two artists exploited its resources to the full – Jean-Baptiste Perroneau (1715–1783) and Maurice Quentin de La Tour (1704–1788). Their temperaments were opposed. Perroneau, a restless man, wandered all over Europe, and delighted in researches into colour which made him somewhat forgetful of fidelity to the model. La Tour, on the contrary, stuck as close as possible to literalness at the expense of

162 *Dog Guarding Game*, by François Desportes, Louvre, Paris. This is an example of that iconography of the nobleman's life, often used in the sort of decoration in which French eighteenth-century painting specialized.

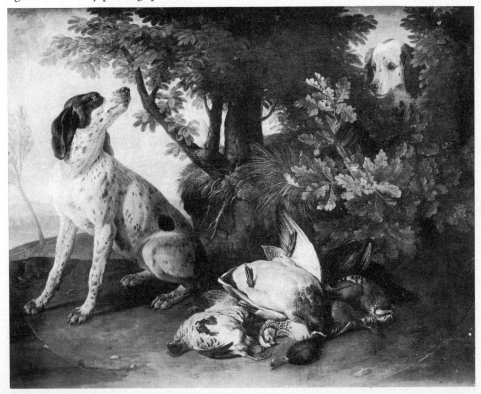

painterly effects; he aimed at rendering character with an analytical precision, and his trenchant drawing makes one think of Voltaire's style (*Ill. 164*).

The naturalism which in the seventeenth century had inspired the Le Nain brothers was not extinct; it emerged again in the eighteenth century under the influence of Dutch painting, which was having a great commercial success. Jean-Baptiste Siméon Chardin (1699–1779) painted still life and *genre* pictures that show, in its intimacy, the life of the *petite bourgeoisie* of Paris to which he himself belonged. With him, as with Vermeer, woman is the soul of these modest homes. In contrast with the monotony of the illustrative painting of his time, Chardin created for himself an extremely fine, highly sensitive handling, achieved by successive applications of the loaded brush and confirming his emotion before the real object (*Ill. 165*). He had several imitators, but none of them approached his talent.

163 *Madame Victoire as an Allegory of Water*, by Jean-Marc Nattier, São Paulo Museum, Brazil. Nattier specialized in portraying his sitters in mythological or allegorical fancy dress, and achieved great success with these portraits.

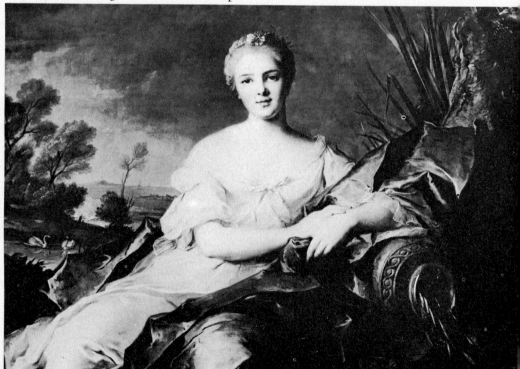

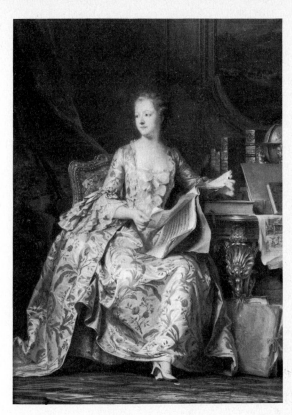

164 *Madame de Pompadour*, by Maurice Quentin de La Tour, Louvre, Paris. The meticulous care which La Tour has given to every detail in this picture in pastels is typical of his analytical realism.

The most Rococo painter of the French School belongs not to the reign of Louis XV but to that of Louis XVI, even though the tendencies to Neo-Classicism were then coming into the open. Jean-Honoré Fragonard (1732–1806) was a pupil of Chardin and of Boucher. He made a journey to Italy, and his career began on his return to Paris in 1762; but it was the painters of the Northern Schools – Franz Hals, Rembrandt, Ruisdael and, above all, Rubens – who had the most effect on him. Like the seventeenth-century Flemish and Dutch painters who were his inspiration, he attached the highest importance to the handling of the brush; his pictures convey a feeling of improvisation and are always 'carried off' in masterly fashion. He employed different techniques, but the best was the one inspired by Rubens, whose secrets of transparent painting he rediscovered. He began as a practitioner of the *genre galant*, and

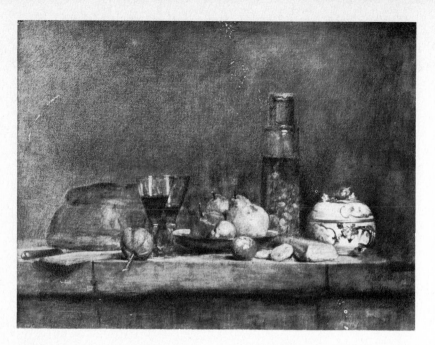

produced the most daring pictures of the century. At the end of
the reign of Louis XVI, moved by the spirit of the time and by
events in his own life, he turned to the idyllic and sentimental
(*Ill. 167*).

This sentimental type of painting dominated the work of Greuze
(1725–1805) (*Ill. 166*), whom the philosopher Diderot praised for his
moralizing aims – which were, in fact, somewhat ambivalent. When
he followed the impulses of his talent, forgetting 'illustration', Greuze
was a fine painter, a forerunner of David and even of Géricault.

Portrait painting remained fashionable, becoming more simple
but no less ingratiating. Greuze produced his best pictures in this
field. The official Court Painter was now Joseph-Siffrein Duplessis
(1725–1802). The most gracious portraits at this time were of
women, and the most distinguished painters of these were François
Hubert Drouais (1727–1775), who painted Madame de Pompadour
and Madame du Barry, and the two women painters, Madame
Labille-Guiard (1748–1803) and Madame Vigée-Lebrun (1755–1842),
of whom the latter was favoured by Queen Marie-Antoinette.

165 *Still Life with a Jar of Pickled Onions*, by Jean-Baptiste Chardin, Louvre, Paris (*opposite*). Chardin was the painter who rendered the silent life of the humblest objects of everyday life like food and drink with the greatest degree of intensity.

166 *The Broken Pitcher*, by Jean-Baptiste Greuze, Louvre, Paris (*right*). The technique of this 'gallant' picture, with its erotic allusion, is already completely Neo-Classical in style.

167 *The New Model*, by Jean-Honoré Fragonard, Musée Jacquemart André, Paris (*bottom*). A magnificent example of Fragonard's Baroque brio, the whole is carried off with the lightest of touches.

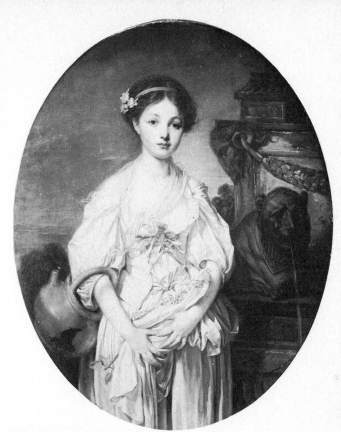

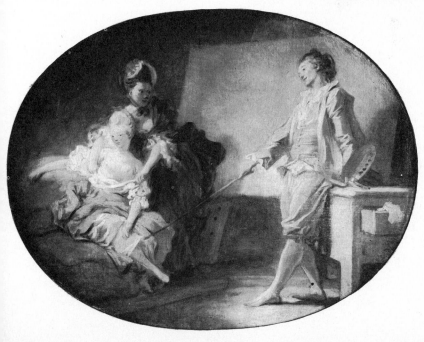

Landscape painting developed in eighteenth-century France, but remained conventional. Joseph Vernet (1714–1789), during a visit to Rome, acquired from Claude Lorraine – through Manglard – the taste for sea scenes and coastal scenes, which he treated romantically (in his storm pictures) or topographically; the best are his topographical pictures – his series the *Harbours of France*. Hubert Robert (1733–1808), who learned his trade during a long journey through Italy, was a very productive artist. He took over from Pannini the theme of ruins, but in his hands it became less dry and more picturesque; he became the illustrator of Italian and French gardens – and was himself a landscape gardener. Later on, at the end of the *ancien régime* and under the Revolution, he developed into the chronicler of the city life of Paris. In his large-scale decorative works, known as *tableaux de place*, he was often conventional, but in his works on a small scale he was a very fine painter, with a sensitive and spontaneous technique. Moreau the Elder (1729–1805), who depicted the gardens and outskirts of Paris, took a step further towards sincerity in looking at and rendering outdoor scenes.

History painting remained cold and conventional, in spite of all the efforts of d'Angiviller. Joseph Vien (1716–1809) was the first to put into practice the reaction towards Neo-Classicism. He was followed by François Vincent (1746–1816). But the manifesto of Neo-Classical painting was Louis David's *Serment des Horaces*. This picture, which was painted in Rome in 1784 and exhibited in Paris at the 1785 Salon, was based on a meticulous study of antiquity in accordance with the theories of Winckelmann. Composed with a noble simplicity, like a carving in relief, and executed in an admirable painterly technique, it brought about the revolution from which the art of the nineteenth century was to be born.

MINOR ARTS

Made for the life of society, French eighteenth-century art produced a prodigious development of the industrial arts. The art lovers of this

period had a passion for furniture and objects of many kinds. The inventory of Madame de Pompadour's possessions, in her various town-houses and châteaux, filled no less than two hundred quarto pages and took two notaries a year to make after her death. Versailles and the other royal buildings were packed with furniture and objects, most of which were sold by auction under the Revolution.

A new tapestry factory was opened and placed under the direction of Oudry. It specialized in *petit point* and used a remarkable number of different shades – as many as twelve hundred – in order to imitate painting as closely as possible, with the result that many of the colours were apt to fade. The best efforts in history painting, by the de Troys, Coypels, and Van Loos, in particular, were produced for tapestry.

The outstanding achievements of the French goldsmiths and silversmiths of this time can hardly be appreciated unless they are studied abroad, preferably in Lisbon and Leningrad, since most of the pieces owned by the French aristocrats were melted down. There were some five hundred of these craftsmen in Paris in 1750, the best of whom were Thomas Germain (*c.* 1673–1748) and François-Thomas Germain (*c.* 1726–1791) (*Ill. 168*). It was an art that took kindly to the Rococo forms. Equally, the workers in wrought iron were much sought after for staircase banisters, balconies, and ornamental gates and railings – those by Jean Lamour at Nancy are outstanding.

The edict issued by Louis XV in 1759 for the melting down of services of gold and silver plate brought into favour services of pottery, and then of porcelain, which became a luxury product.

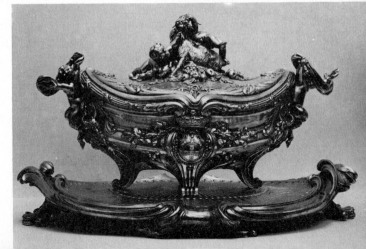

168 In France the Baroque style was subjected to many restraints in the major arts. In the minor ones it expressed itself with more freedom and fantasy, as in this silver soup tureen made for Don José of Portugal by François-Thomas Germain.

Pottery, which easily took over the Rococo forms from the gold-smiths' and silversmiths' work, flourished throughout France. Its finest shapes and polychrome decorations were produced at Marseilles (in the workshops of the widow Perrin) and in the east of France – at Niederwiller, Strasbourg, and Lunéville. Encouraged by the nobility, the manufacture of porcelain received the favour of Madame de Pompadour who, in 1753, extended her protection to the Vincennes factory. This had been started in 1738, and was in 1753 transferred to Sèvres.

The refinement of social life found expression in the rise of cabinet-making, both in Paris and throughout the provinces. The cabinet-makers had full scope for fantasy; they responded to the taste of their customers by inventing all kinds of new forms adapted to this or that requirement of living, especially pieces of furniture used by women. This incomplete list may give some idea of the incredible variety.

Tables, for instance, ramified to include bedside tables, bed tables, trolley tables, tray tables, coffee tables, serving tables, card tables, draught-board tables, backgammon tables (*à trictrac*), flower stands, boudoir tables, tables with drawers (*en chiffonnière*), work tables, *tricoteuses*, dressing tables, combined work and dressing tables (*toilette à transformations*), pin-tray tables, breakfast tables, dining tables, side tables, console tables (consoles *en demi-lune, d'ébénisterie, d'applique* etc.), *guéridon* tables, occasional tables, tables *à l'anglaise* or *à la Bourgogne* – and, of course, writing tables. The writing table – it might be of the *bureau plat* type or kneehole with drawers on either side – developed through the *secrétaire à dos d'âne* (table supporting a *serre-papiers* which could be closed in by a lean-to lid) into the full secretaire; this might be *en pente, en tombeau, à abattant* (drop-fronted), *à cylindre* (with a cylinder lid), *de voyage*, or the *secrétaire-armoire*, and there were *bureaux Mazarin, bureaux à cartonniers*, desks at which to write standing, the *bonheur du jour*, and other varieties. Again, there were wardrobes, corner cupboards, corner shelves,

book cabinets, display cases, jewel cabinets, caskets, coffers, chests, and pedestal cabinets. Chests-of-drawers (*commodes*) could be frankly such or could have drawers concealed by ornamentation flowing over bellying fronts, and they could be *à vantaux* (with leaves), *à tablettes d'angles, mazarines, à perruques, à la Régence, à console, commodes tombeaux*. There were candlesticks, wall-lights, candelabra, and *athéniennes* (candelabra whose branches emerged from an urn borne on a tripod, in imitation of the tripod in Joseph Vien's painting, *La Belle Athénienne*). Mirrors were of many shapes and sizes. There were screens, fire-screens and the *prie-Dieu*. There were barometers, thermometers, and a wide variety of clocks – bracket, cartel, mantel, pedestal, *régulateur*, musical, a clock combined with a cabinet or chest-of-drawers, etc. Beds were *en bateau* (with tapered ends), *en tombeau* (box), *à l'ange* (partly canopied by a starry sky, without posts), *à la française, à l'italienne, à la romaine, à la polonaise* (an elaborate four-poster), *à la turque, à la chinoise, à la d'Astorg*. Seats were the most varied of all. Stools (*tabourets*) were of many forms, heights, and styles. Chairs could be : *en gerbe, en lyre, en éventail, à l'anglaise, en montgolfière, caquetoires, chaises voyeuses* (for sitting astride at the card table), *voyeuses à genoux, chaises d'affaires*, or *bidets* ; armchairs *en cabriolet, à la Reine, de cabinet* or *de bureau, de commodité, bergères, bergères à confessional, à oreiller, à gondole, à la turque* ; and there were chairs *à coiffer* and children's chairs. Sofas (*canapés*), day beds (*lits de repos*), and short settees (*causeuses*) also took many forms and names, such as *paphoses, veilleuses, turquoises, duchesses, duchesses brisées, canapés en gondole, sultanes, ottomanes*, and *marquises* (which were also called *confidents* or *tête-à-tête*).

These pieces of furniture were executed with a care that has never been surpassed. The chests-of-drawers, desks, and tables were often covered with marquetry or with Chinese lacquer-work imitated in *vernis Martin*. Charles Cressent (1685–1768) extended the use of gilt bronze ornamentation on furniture of various kinds, especially writing desks and chests. Gaudreaux (*Ill. 169*), Jean-François Oeben (who

died in 1763), and Jean-Henri Riesener (1734–1806) were the most celebrated cabinet-makers of the Louis XV period, and the two latter worked on the famous Secrétaire-Cylindre du Roi, which took nine years (from 1760 to 1769) to make. Georges Jacob (1739–1814) was the principal supplier of furniture to the Court under Louis XVI.

Furniture in the time of Louis XV, especially chests and wall-bracket consoles, took particularly well to the sinuous and resilient forms and *rocaille* ornamentation of the Rococo style. Under Louis XVI straight lines replaced the curved ones, and the ornamental motifs were borrowed from the repertory of Classical antiquity: *rais de cœur*, ovolos, droplets, fluting, acanthus leaves, palmettes, and fantastic beasts – to which Egyptian sphinxes would soon be added. At this time furniture was further enriched by the use of exotic woods.

Under the Revolution all this richness of ornamentation disappeared, yielding to a simplification of the Louis XVI style known as the Directoire style. Napoleon restored sumptuousness to the furniture-making art.

169 Executed by Gaudreaux, with ornaments in bronze, by Caffieri, this commode was made for the *Chambre du Roi*, Versailles, in 1739.

Eighteenth-Century Spain and Portugal

Spain emerged from the War of the Spanish Succession considerably diminished, having lost the Low Countries, which were awarded to Austria by the Treaty of Utrecht. The country now tended to withdraw into itself, resentful of the attitude of the Court, which became much more open to influences from abroad – that is to say, from France and Italy. The head of the new Bourbon dynasty, Philip V, was the grandson of Louis XIV. He married Elizabeth, the last of the Farnese. They brought with them a luxury hitherto unknown in Spain, and created a Court art there. Italian influence was reinforced in 1759, when Charles VII of the Kingdom of the Two Sicilies, the son of Philip and Elizabeth, became King of Spain under the name of Charles III.

This Court art was largely independent of the native Spanish art, which at that time, especially in the religious field, was attaining a splendid climax. The Court art, formed by foreign influences, was localized in the royal palaces of Madrid and the near-by country, while the rest of Castile, Andalusia, and Galicia were creating highly original forms of their own, which were to be the last expression of the Hispanic School. This situation was to some extent comparable to that which prevailed in the sixteenth century, when in the midst of the flowering of the native Plateresque style the Habsburgs had sought to Europeanize Spanish art.

THE MONUMENTAL ARTS

Architecture in this period was so closely bound up with the other monumental arts, especially with that of wood-carving as shown in

the altar-pieces, that it is difficult to dissociate it from them. The name 'Churrigueresque' has often been applied misleadingly to Spanish eighteenth-century architecture. It comes from José Churriguera (1665–1725), the first of a dynasty of architects, whose work represents only one of the tendencies of Spanish Baroque in the eighteenth century, which varied very greatly from province to province. The truth is that the eighteenth-century Baroque of Spain was the creation of two families, that of the Figueroas in Seville and that of the Churrigueras in Madrid and Salamanca. It is significant that the first large-scale work by José Churriguera was not a building but a piece of decoration for a church interior – the vast altar-piece of San Esteban at Salamanca (*Ill. 170*), for which he supplied the design in 1693. This fulfilled a development which had begun in about 1660 among the designers of altar-pieces, especially at Compostella – in the enormous cliff of gilded wood, the dominant elements of which were the solomonic columns with vine-leaf embellishments and acanthus foliage – while the whole was made subject to a monumental unity. José's brothers Joaquín (1674–1724) and Alberto (1676–1740), also worked at Salamanca. The style of the

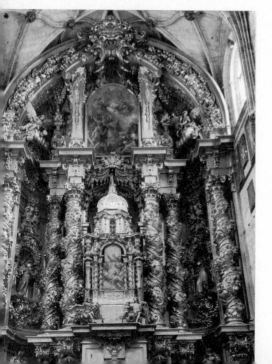

170 The High Altar of the Church of San Esteban, Salamanca, was designed by José de Churriguera in 1693. It is over ninety feet high and is of gilded wood. The gigantic twisted columns called 'solomonic' are used. This altar-piece was often imitated in other parts of Spain and in Portugal.

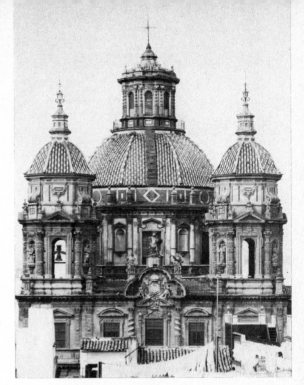

171 San Luis, Seville, built by Leonardo, Matías and José de Figueroa, 1699–1731. The Figueroa family designed their churches to produce astonishment by the accumulation of ornamental motifs and by the creation of new forms in which the Classical orders were purposely transgressed.

Churrigueras is distinguished by the care they took to retain in their monumental works an overriding cadence – in which, unquestionably, there is to be felt the influence of the Plateresque style of Salamanca. In that city Alberto designed, in a noble style, the finest city square in Spain, the Plaza Mayor. He produced the plans for it in 1728, and it was completed by the *ayuntamiento* (City Hall), whose architect was Andrés García de Quiñones.

We must go elsewhere – Toledo, Valencia, Madrid, Seville – to find examples of that unbridled freedom which has been unfortunately given the name 'Churrigueresque'. The Figueroa family, in their churches in Seville, introduced a multiplicity of columns and mouldings of all sorts, mixing Classical motifs with those of *mudéjar* origin. Leonardo de Figueroa (*c.* 1650–1730) invented this style, which was quite different from the noble cadences of the Churrigueras; it was the one that spread to the overseas colonies (*Ill. 171*).

An engineer, Ignacio Sala, gave to a factory – the Tobacco Factory

of Seville, whose building took from 1728 to 1750 – the air of a palace; but here, already, some restraint is applied to the disorder of Figueroa's monuments. Pedro de Ribera (1683–1742) adorned Madrid with buildings (the Puente de Toledo (1729–1732) and the San Fernando Hospital (1722–1726)) whose overloaded ornamentation even borrows motifs from drapery, lace, and braiding. At Valencia the Palace of the Marquis of Dos Aguas, built by Ignacio Vergara between 1740 and 1744, suggests Art Nouveau (*Ill. 172*). At Compostella the employment of granite imposed on the architects an almost exclusive use of mouldings, but they were able to draw from these some sumptuous effects. The whole town was adorned with churches, squares, and palaces, and the old Romanesque Cathedral was enrobed in a kind of Baroque reliquary. Work on this was begun at the end of the seventeenth century, on the initiative of a humanist canon, Don Jusepe de Vega y Verdura, and was carried on during many years of the eighteenth century. The façade with the two bell-towers – the *obradorio* – was built between 1738 and 1750 by Fernando de Casas y Novoa. Only Catalonia was almost innocent of Baroque art. The most extravagant monument erected in eighteenth-century Spain is the Transparente at Toledo (1721–1732), a kind of chapel of many-coloured marble, stucco-work, and painting in the ambulatory of the Cathedral behind the high altar (*Ill. 173*). It is by Narciso Tomé (who was active in 1715 and died in 1742), and was celebrated by versifiers as the eighth wonder of the world. It belongs to a specifically Spanish type of work, which is exemplified in the *camarín*, or chapel behind the choir, and consists in creating a transparent stage-set of gilded wood, stucco-work, or marble, to which a magic grace is imparted by the light that passes through it.

All over Spain the altar-pieces were enriched with decoration which was more and more thickly applied, and mirrors were included at times. The most resplendent creations of this type are the altar-pieces (1770) by a Portuguese, Cayetano da Costa, in the Church of San Salvador in Seville.

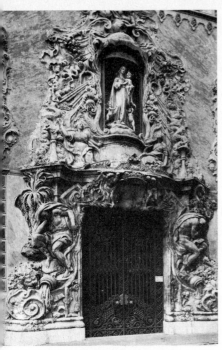

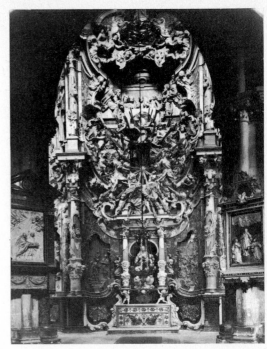

172 The Doorway of the Palace of the Marquis of Dos Aguas, Valencia, built by Ignacio Vergara, 1740–1744.

173 The Transparente of Toledo Cathedral, by Narciso Tomé, 1721–1732. With the Palace of Dos Aguas, one of the most extravagant examples of Spanish Baroque art.

It is worthy of remark that all these buildings and schemes of decoration remained Baroque in spirit, the decoration being achieved by an accumulation of ornamental motifs disposed symmetrically. Spain would have remained innocent of the asymmetrical rhythms of the Rococo, had not these been used in the royal palaces under foreign influence.

In fact, as we have said, there did develop, parallel with this native art flourishing in the provinces, a Court art closely related to the Italian and the French and imported by Philip V after the Treaty of Utrecht in 1713. To escape from the Escorial, he had built for him a more modern palace at La Granja, near Madrid. The German Ardemans and the Italian Sacchetti worked on this, but its gardens in the French style were laid out by René Carlier and Etienne

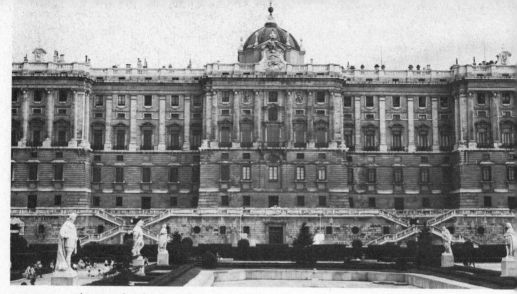

174 The Royal Palace, Madrid, was carried out, 1736–1764, by Sacchetti on designs by Juvara, which he simplified. This palace was the first example in Spain of a new Classical spirit, which in time led to the abandonment of the Baroque.

Boutelau from France, and other Frenchmen worked as sculptors on the decoration of the Palace and its gardens.

The Palace built in Madrid to replace the Alcázar (burned down in 1734) is on a closed ground-plan of Italian type that also embodies something of the austerity of the Spanish *alcázar*. The designs supplied by the Italian Juvara, who died in Madrid in 1735, were carried out by his pupil Sacchetti (*Ill. 174*). The decoration of the interior, in a frankly Rococo style, dates from the time of Charles III.

Buildings by Italian and French architects introduced into Spain the Neo-Classical movement which, in the second half of the eighteenth century, gradually sterilized the Baroque art that had shown such vitality in the provinces. The Neo-Classical, as it spread, acquired a definitely official stamp, for supervision of the buildings put up in Spain was now vested in the Academia de San Fernando, founded in 1752 by Ferdinand VI. The best practitioner of this Italian Classicism was Ventura Rodríguez (1717–1785), who created a considerable number of designs, while the art of Juan de Villanueva (1739–1811) was more elegant and purist.

Monumental sculpture – of which little was produced – was chiefly used to adorn gardens, and was usually done by Frenchmen.

Baroque polychrome sculpture had a final moment of life at Granada, at Seville, and in Murcia. At Granada José Risueno and at Seville Duque Cornejo adapted the images of the Faith to the graces of the eighteenth century, while in Murcia the Salzillo family, of Italian origin, practised an effeminate and mannered art which stemmed from that of the Neapolitan cribs.

PAINTING

During the reign of Philip V Spanish painting was entirely decadent. It became an art of the Court, supplied by Frenchmen, such as Michel-Ange Houasse and Louis Michel Van Loo, or Italians, such as Amigoni and Corrado Giaquinto. At the end of the century there was more originality; Luis Meléndez (1716–1780) continued the mood of the still-life painters of the preceding century, and Luis Paret (1747–1799) was a society painter who might be compared with Jean-François de Troy or with Lancret. At length Francisco

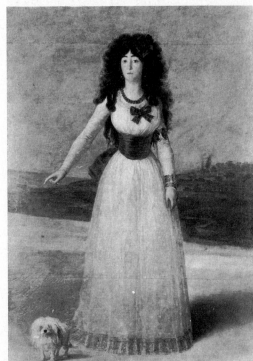

175 *The Duchess of Alba*, by Francisco Goya, Alba Palace, Madrid. This picture, which dates from 1795, is painted with the lightness and delicacy characteristic of Goya's first manner, which was still in the spirit of the eighteenth century.

Goya (1746–1828) came on the scene, and asserted once and for all the Spanish genius in painting. Goya's art divides into two periods. From 1776 to 1793 he depicted the contemporary scene and the life of society in an elegant style, sensuous and with gay colours – a style that gradually acquired a Neo-Classical form. His portraits at this time, especially those of women (*Ill. 175*), remind us of the refinement of Velázquez. But his deafness, which became total in 1794, helped to produce in Goya a bitterness which came out in the satirical manner he adopted in painting the family of Charles IV (*Ill. 176*). His frescoes for San Antonio de la Florida (1793) mark a turning-point. The French invasion cut Goya off from the aristocratic society which had supported him, and from that point onwards his art is characterized by Romantic expressiveness and belongs to the nineteenth century.

176 *The Family of Charles IV*, by Goya, Prado, Madrid. When he painted the Royal Family in 1800, Goya gave free rein to the Romantic style in which he had begun to work in San Antonio de la Florida in 1798.

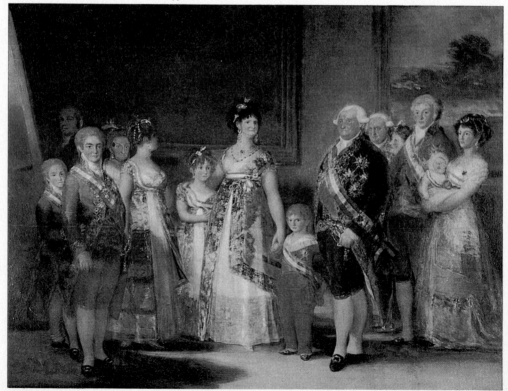

Pottery flourished in Spain, the more so since the mother country was called on to supply the colonies. The old factory at Talavera kept up an enormous output. In the seventeenth century the designs had been based on Italian models, but in the eighteenth the influence of the East filtered through. The factory at Manises, near Valencia, revived the production of pottery with metallic lustre. In 1727 the Conde de Aranda organized, at Alcora near Valencia, the mass production of pottery, recruiting three hundred workers, who included Frenchmen, Italians, and Dutchmen. Potters from Moustiers, called in by him, brought into Spain designs in the manner of Berain. The Talavera and Manises factories, and other factories in Catalonia, produced polychrome pictures that were used to adorn the lower parts of the walls in churches and palaces.

One of the most flourishing arts in Spain was that of metal-work; in the eighteenth century it recovered the splendour it had possessed in the sixteenth. In the half-light of the churches, the chapels are shut off by tall grilles with magnificent Baroque swirls.

In the work of the silversmiths, repoussé technique was continued along with the production of massive pieces.

The Bourbon dynasty in Spain, following the example of what had been done in France, encouraged output in the arts of interior decoration. Before the Treaty of Utrecht Spain had imported tapestries from the Brussels workshops. Deprived of the Low Countries, Spain became dependent on the Gobelins factories, which were supplying the whole of Europe. In 1720, Philip V's Minister, Alberoni, summoned Jacob Vandergoten, an Antwerp weaver, to found the Spanish Tapestry Factory of Santa Bárbara in Madrid.

Charles III, who had started a royal porcelain factory at Capodimonte in 1743 when he was King of the Two Sicilies, transported this with him to Madrid when he became King of Spain in 1759. The factory decorated two rooms entirely in porcelain for the Palaces of Aranjuez and Madrid.

Furniture-making, which in Spain during the seventeenth century had remained set in the Renaissance style, developed during the eighteenth century in the same direction as the rest of Europe, owing to the impetus given to the luxury arts by the Bourbon dynasty. The English and French styles were imitated. The decorative scheme of the interior of the Palace in Madrid was almost alone in admitting Rococo features, and the rest of Spain remained faithful to the Baroque throughout the eighteenth century.

PORTUGAL

It is an error – shared by the majority of historians – to treat Portugal as a kind of annexe of Spain. Portuguese art is radically different from that of neighbouring Spain – as different, roughly, as French art is from German.

Another error is the tendency to exaggerate the importance of the Palace-Monastery of Mafra. The initiative for this building came from the Court, and it is as different from the native art as the Palace of La Granja is from the art of Seville or Salamanca. João V ordered it to be built in pursuance of a vow and in imitation of the Escorial. Its architect was an Italianized German, Ludovice (1670–1752), and the sculpture, which was all imported from Italy, forms a note-worthy museum of the Berninesque. It is true that Mafra became a building yard where other architects learned the new forms, but its influence was confined to Lisbon and the Alentejo. The real native art of Portugal is to be found in the North – at Oporto, where another Italian, Nicola Nazzoni (who died in 1773), became rapidly assimilated to Portuguese ways, and at Braga, where a fresh upsurge of naturalism, comparable to that of the Manueline style, may be seen. Eighteenth-century art in Portugal differed essentially from that of Spain in being Rococo and using asymmetrical ornamentation – in the second half of the century, with the exception of the art of Braga, its tendency was towards elegance, and it was not unlike the art of Swabia or Franconia. The best examples, however, are in

177 The Church of São Pedro dos Clerigos, Oporto, Portugal, built by Nicola Nazzoni, 1732–1748.

Brazil. The churches are very simple outside, with hardly any ornamentation except the façade; but their interiors are clothed in gilded woodwork, which often covers the whole of the walls and the ceiling. This kind of ornamentation acquired an extraordinary exuberance, especially at Oporto (*Ill. 177*), between 1715 and 1740, and then, between 1740 and 1760, moved towards unity and harmony under the influence of the Rococo.

The art of the Court created few important buildings. The outstanding one is the Palace of Queluz, near Lisbon. This was built by Mateus Vicente (1710–1786), but the decoration of its rooms and gardens was by a Frenchman, Jean-Baptiste Robillion.

The Lisbon earthquake in 1755, which made it necessary to rebuild the city quickly, hastened the coming of Neo-Classicism, and this radiated from the capital into the provinces, the North proving the most resistant. It was in about 1780 that the architect Cruz Amarante introduced the new style at Braga. At Oporto the English influence was its carrier.

Sculpture consisted almost entirely of religious images displaying a great elegance of form. In them the Rococo style did not destroy the discretion characteristic of Portuguese art. Under Don José, Machado de Castro (1732–1822) attempted an equestrian statue of his King for the Praça do Comercio in Lisbon. The result was heavy. He was more successful in designing cribs, after those of Naples.

Painting is represented by Francisco Vieira de Matos (1699–1783), who produced Baroque compositions in the Roman taste; by the Frenchman Quillard, who brought with him Rigaud's type of portrait painting; and – in the Neo-Classical period – by Domingos Antonio de Séqueira (1768–1837), who was known, rather pretentiously, as the Portuguese Goya.

The minor arts were chiefly remarkable for a product that is specifically Portuguese, the decorations in tiles (*azulejos*) with designs in blue. These, in the eighteenth century, reproduced compositions filled with figures, and considerable use was made of them, both in religious and in secular art (*Ill. 178*).

178 The art of covering surfaces with majolica began in Seville: it was taken up in Portugal, and there in the eighteenth century it assumed great importance, at a time when Spain was giving it up. In Portugal whole pictures were created with painted tiles called *azulejos*, like this scene, from the Cloister of São Vicente de Flora, Lisbon, now in the Museu Nacional, Lisbon.

The overseas territories under Spanish and Portuguese domination were not content to repeat the formulae imported from the mother countries and to interpret them more or less skilfully. Independent artistic centres formed themselves in the colonies, inventing original forms that were sometimes ahead of the mother country in their working out of the possibilities of Baroque. Thus the Portuguese colony of Goa, being in contact with the art of India, produced in the seventeenth century monuments whose style may be regarded as a precocious Baroque. The Puebla School in Mexico had the idea of covering the whole of a church with a scheme of decoration in stucco, some little time before this was done in Spain at Cordova and Valencia. In Peru the closely ornamented façades of the churches at Cuzco and Lima, dating from about 1660 to 1670, were fore-runners of those built in Spain at the beginning of the next century.

The seventeenth century saw a continuation of the building of large cathedrals modelled on those of Granada, Valladolid, and Jaén (in Mexico, at Mexico City, Puebla, Mérida, Guadalajara, and Oaxaca; in Peru, at Cuzco and Lima; and in Colombia, at Bogotá). In the eighteenth century the colonial art was still mainly religious, and the Baroque style produced a great proliferation of forms, both in the gilded woodwork of the interiors and on the stone façades (where artists imitated the carvings of the altar-pieces). Sometimes, in Mexico and in Bolivia, a style of carving in well-marked planes appeared, marking a return to the plastic conceptions of pre-Columbian art (*Ill. 179*).

In Brazil, where there had been no artistic civilization before the arrival of the colonizers, the art is closer to that of the mother country, although the various provinces of the colony are distinguished from one another and from the Portuguese Schools by certain formulae of their own. In the province of Minas Gerais, indeed, Brazil carried Rococo refinement further than did the mother country, thanks to the genius of Antonio Francisco Lisboa (1738–

1814), known as Aleijadinho. A cripple and a half-breed (his father a Portuguese and his mother a Negress), he worked as architect, decorator, and sculptor and, in his *Prophets* at Congonhas do Campo, breathed into the Baroque, which was by then failing, a primitive power worthy of the Middle Ages (*Ill. 180*).

The minor arts enjoyed great prosperity in Mexico, where they were stimulated by influences from the Far East.

In painting on the whole in most of the Spanish and Portuguese territories, European models were interpreted in a popular manner. Sometimes they show a medieval flavour, as at Quito and at Cuzco. Mexico alone imported large numbers of pictures painted by the School of Seville and it possessed, in the seventeenth century, certain painters comparable to those of the mother country. In the eighteenth century these schools declined, as in Spain.

179 The portal of the Church of San Lorenzo, Potosí, Bolivia, is a remarkable example of a type of sculpture that recalls pre-Columbian art. It is the work of native craftsmen.

180 *The Prophet Isaiah*, from the terrace of the Church of Bom Jesus, Sanctuary of Congonhas do Campo, Brazil, is an example of the archaizing spirit of the great Brazilian sculptor, Aleijadinho, the last genius of the Baroque anywhere in the world.

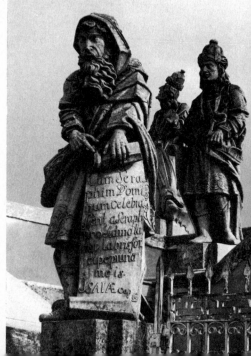

The Eighteenth Century in Central Europe and the Germanic Countries

Artistic activity in Central Europe and Germany, after being seriously slowed down in the seventeenth century by the Thirty Years War, revived between 1660 and 1680, and continued to the end of the eighteenth century with extraordinary intensity.

Political circumstances favoured this upsurge. The Austrian monarchy emerged with reinforced prestige from its decisive victories over the Turks, and the feeling of triumph radiated throughout the Principalities of Germany which had shared in the struggle. This atmosphere of glory also contained a religious element, since the victory over the Turks was that of the Cross over the Crescent. Throughout Austria and Germany monastic Orders rebuilt their churches and monasteries on a vast scale and with a prodigious luxury of ornamentation, making of them symbolical glorifications of the Christian religion, with which they associated the Imperial idea. Many pilgrimage-churches also were rebuilt in the Baroque style.

Austrian and Bohemian princes, grouped about the Emperor, had palaces and castles built for them from the end of the seventeenth century onwards. Prague became as full of churches and palaces as Vienna.

Before the Prussian hegemony, the vocation of Germany appeared to be to avoid unity. In the eighteenth century it was more disunited than ever, because France, in search of security, had succeeded through the Treaties of Westphalia, Utrecht, and Rastadt in increasing the political fragmentation of Germany. This was done by according sovereignty to a great many lay or ecclesiastical

Principalities, which were now bound to the Emperor by no more than a purely symbolical bond of obedience. All the bishops or princes ruling these States – some of which were tiny – hastened to express their accession to the monarchical status by a royal ostentation. The result was a multiplication of the centres of artistic activity, and a keen competition in building and in the luxury arts. Each ruler strove at first to equal that incomparable paragon of the monarchical idea, Louis XIV. Later they modelled themselves on the Imperial Court of Vienna. The situation in Germany was thus the opposite of that in France, where centralization continued and where, in the eighteenth century, art was governed by the life of Parisian society rather than by the influence of the king, so that it tended to acquire a 'private' character. Ostentation was as important to the Protestant princes as to the Catholic, except that in a Protestant State the art of the Court had no rival, since the arrangement of the Lutheran churches offered few chances for art. An exception was the Frauen-kirche in Dresden: this building, which was built by Georg Bähr on a central ground-plan, had all the external characteristics of a Catholic church, though the interior was adapted to Lutheran worship.

Since Germany did not suffer the devastation caused by the French Revolution – and in spite of the ravages of the Second World War – it is in this part of Europe that one must look for princely palaces and gardens that are still whole and intact, while France offers no more than a shadow – a magnificent one, it is true – of what the art inspired by its kings once was.

The peculiar achievements of Austrian and German Baroque art were the result of an original interpretation of the forms invented in Italy and in France. Austria, having received possessions in Italy under the Treaty of Utrecht, welcomed a flood of Italian artists of all kinds, from the end of the seventeenth century to the end of the eighteenth – architects, painters, sculptors, masters of decoration, and designers for the stage came in, chiefly from Lombardy, which had been exporting craftsmen in the building arts from the Middle

Ages onwards and was now under Austrian rule. Germany also welcomed Italians, chiefly for church-building, in which France had not shone and had few fine models to offer; but for the art of the German Courts the new-comers were chiefly from France. Yet these artists, whether French or Italian, assimilated themselves so perfectly to the spirit of the societies for which they were working that it is hard to distinguish them from the native artists. The French architects who had the greatest influence in Germany were those closest to the Rococo, Robert de Cotte and Germain Boffrand, who were often consulted by German princes about their residences. The French influence is reflected in the names of many of the German pleasure-palaces – Sans Souci, Sanspareil, Solitude, La Favorite, Monplaisir, Monaise, Monrepos, Bellevue, La Fantaisie, Monbrillant, etc.

ARCHITECTURE

In Austria the Imperial Baroque style was fully formed by the end of the seventeenth century. Italian artists such as the Carlones and Giovanni Zucalli contributed largely to it, but its excellence was mainly the work of two great native artists – Johann Fischer (1656–1723), ennobled in 1697 with the title von Erlach, and Lucas von Hildebrandt (1668–1745). Owing to various circumstances, both these artists were trained in Italy; what they brought back from there was not only the feeling for the 'grand manner' of Bernini and his followers, but also the style of Borromini and of Guarino Guarini with its stress on movement. Already in 1688, at the Palace of Frain (Vranov) in Moravia, and in 1694, at the Church of the Jesuits in Salzburg (Ill. 181), Fischer von Erlach had achieved his own style – of which he was to produce other examples in Vienna, in the Karlskirche (1716) (Ill. 182) and in the Library of the Hofburg (designed by him and executed by his son). It is an eclectic style, which works by an accumulation of masses and a multiplication of effects towards an expansion of the spaces – an aim which is shown by the artist's love for the elliptical ground-plan; a style whose richness

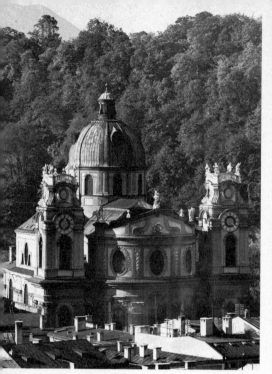
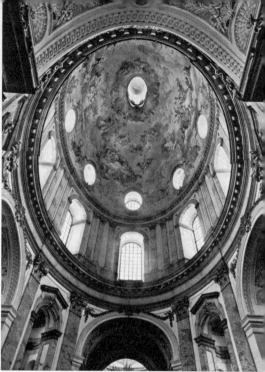

181–182 The Church of the Jesuit College, Salzburg, and the interior of the dome of the Karlskirche, Vienna, both by Johann Fischer von Erlach. In the Karlskirche von Erlach made a rather too literal application of the models he borrowed from Rome, while in the Church of the Jesuits he allows himself greater creative freedom.

was meant to express the Imperial majesty. Hildebrandt's style was a little less heavily charged, and more responsive to rhythmical cadences; at the Mirabell Palace in Salzburg, and the Kinsky Palace in Vienna he created the type of the princely palace, in which the main theme is a grandiose staircase. Prince Eugène of Savoy commissioned him to build his Summer Palace at the Belvedere, a Baroque version of certain French forms. The garden separating the two palaces, the upper and the lower, was designed by Claude Girard, a pupil of Le Nostre. In his religious buildings Hildebrandt also makes clear his preference for elliptical forms. One of the principal decorative themes in the Palaces of Vienna and Prague is that of the colossal *atlantes*, who support the balconies on the façades (*Ill. 184*), and, in the interiors (*Ill. 183*), the stairways.

228

The impetus to the rebuilding of the monasteries was given at the beginning of the eighteenth century by the Abbots of St Florian and of Melk. Jakob Prandtauer (1660–1726) worked on both these abbeys. While at St Florian he continued an enterprise begun by others (*Ill. 185*), Melk, dominating the Danube, is entirely his work. In Upper and Lower Austria and the Tyrol the monasteries were rebuilt with enthusiasm. Often they include (centred about the church) an array of sumptuous apartments – a richly adorned library that is a temple of knowledge, a great festal chamber, a theatre, perhaps a museum, a prelacy or princely lodging for the Abbot, and Imperial apartments – whose utility was more symbolic than real, signifying the alliance between the spiritual power and the temporal power within a monarchy existing by Divine Right.

From the monumental emphasis and grandeur of Johann Fischer von Erlach and of Lucas von Hildebrandt, Jakob Prandtauer diverged to evolve a more chastened style, more responsive to a harmonious ordering of the masses and to rhythmical cadences. This refining of the style was still more firmly established in the work of his cousin Josef Mungennast (d. 1741), whose masterpieces are the Church

183–184 The Upper Belvedere, Vienna, by Lucas von Hildebrandt, and a section of the South Front of the Palace of Sans Souci, Potsdam, by Georg Wenzeslaus von Knobeldorff, two examples of the use of one of the principal motifs of German and Austrian Baroque— the atlas-caryatid, symbolizing strength.

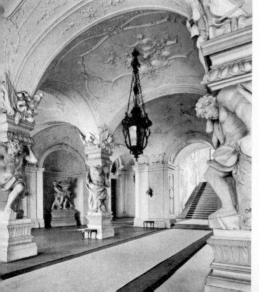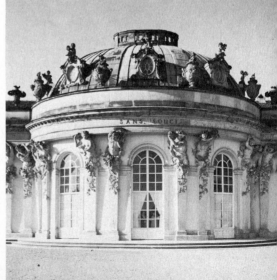

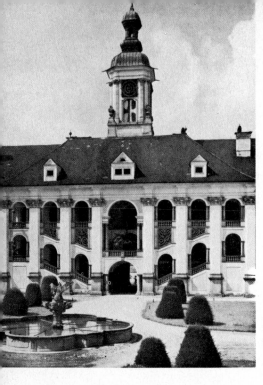

185 The Staircase of the Monastery of St Florian, Austria, by Jakob Prandtauer, 1706–1714, seen from the exterior. Even in the monasteries the staircase was treated as a monumental entry: in this case it leads to the Imperial apartments.

and Library of the Monarchy of Altenburg. But it is still not Rococo, for Austria did not adopt the system of balanced asymmetrical motifs. The decoration of the churches was richer than that of the palaces, and was carried out in various kinds of marble or, more often, in delicately painted stucco imitating marble, to which were added white marble statues and painted ceilings. By way of exception the rooms inside the Palace of Schönbrunn are decorated, in imitation of Versailles and what was being done in Germany, with some rooms whose decoration derives from the Far East.

The Zwinger at Dresden (*Ill. 187*) may be considered as part of Austrian Baroque by the quality of its inspiration; it was a kind of open-air festal chamber surrounded by a border of large and small rooms, and it was built between 1709 and 1738 on plans by the architect Daniel Pöppelmann (1662–1736) for Augustus the Strong, Elector of Saxony and King of Poland. But Germany very soon moved towards an elaboration of the Rococo style; this consisted in

186 The interior of the Residenz Theatre, Munich, decorated by François Cuvilliès in woodwork and stucco.

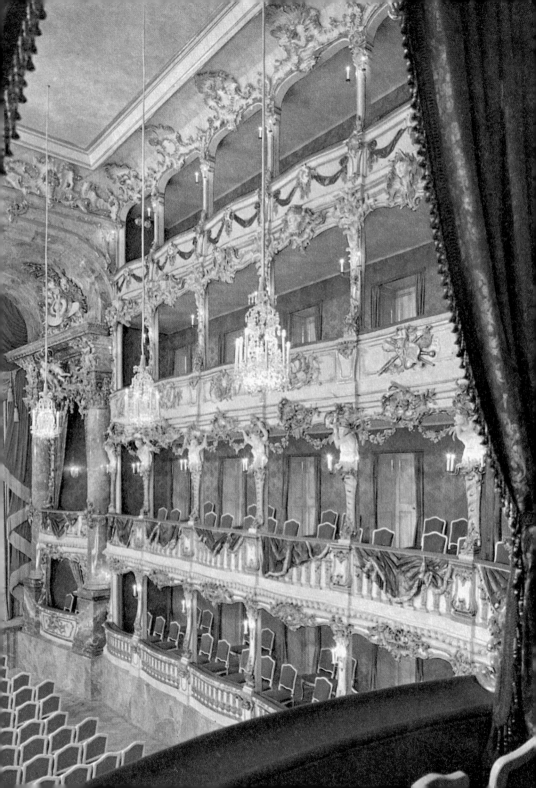

drawing from an increasing abundance of varied forms and ornamentation an essential unity, achieved by bringing all the elements together symphonically through rhythmical principles comparable to those of music – which at that time was enjoying a wonderful flowering in the same part of the world. The characteristic of Rococo rhythm in ornamentation is its counterpointing of asymmetrical elements, ordered within an architectural framework where the many curves and counter-curves and re-echoing planes render the whole space vibrant. The decoration of the churches was carried out in stucco and lively colours, that of the princely apartments in gilded woodwork and stucco often incorporating mirrors.

The creative wealth of German Rococo in the eighteenth century is so great that it is almost impossible to give even a glimpse of it in a book of this size. Several of the German-speaking regions became laboratories of forms, which contributed to the working-out of the possibilities of Rococo. The Austrian province of Vorarlberg was a nursery of architects and of the building craftsmen, who produced little work in their own district but swarmed out through Switzerland, Austria, and Swabia. In their religious work they were remarkably constant to the simple type of church inspired by the design of the Gesù in Rome. In Bohemia, on the contrary, Christoph

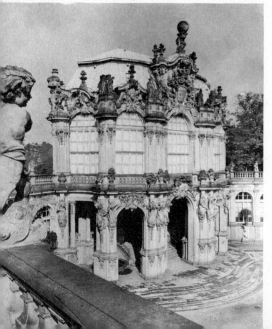

187 Central Section of the Zwinger, Dresden, by Daniel Pöppelmann, 1709–1718. The Zwinger was conceived as a vast open-air festal hall, surrounded by rooms used as art galleries, etc. This explains its prodigious wealth of ornamentation.

Dientzenhofer (1655–1722), an architect from Bavaria, took Guarini as his inspiration and explored the possibilities of complex ground-plans, oblique lines, elliptical forms, and springing curves. Wesso-brunn produced stucco-workers who went all over Germany.

The King of Poland, the principal electors and the princes and prince-bishops had imposing residences built for them, to which were added gardens that, even today, still have all their ornaments – their statues, their temples, their systems of fountains, their open-air theatres, their exotic pavilions, their orangeries, and their 'wetting-sports'. The most complete is the garden at Schwetzingen, laid out for the Elector of Mayence. Frederick II had pleasure-palaces built for him near Berlin – at Potsdam (Sans Souci) and at Charlottenburg.

The finest interiors were those of the Prince-Bishop of Würzburg. These, unfortunately, were for the most part destroyed in the Second World War, but the frescoes painted by Tiepolo on the ceiling of the Grand Staircase and in the Festsaal have miraculously escaped. The Residenz at Munich was burned down during the war, but the decorations of its ceremonial apartments (*Reichenzimmern*) had for-tunately in part been removed and have been reconstituted. They are the work of François Cuvilliès (1695–1768), who was a Frenchman who became entirely Germanized. His masterpiece, without ques-tion, is the elegant and poetic decoration of the Amalienburg (1734–1739), a hunting-pavilion in the gardens of the Palace at Nymphen-burg. In both cases the decoration is carried out in stucco and woodwork, and in them, in contrast to what was usual in France, many figures are mingled with the other motifs. In the Amalienburg, where the ornamentation is less heavy than in the Reichenzimmern, Cuvilliès showed an inexhaustible imagination in the creation of enchanting conceits; the springing of the arabesque never falters, and is for ever starting up again in an endless chain of melodies.

The fine embellishments of the interiors at Potsdam and Charlot-tenburg, on which Johann August Nahl had done work, have

remained intact. Collections of fine porcelain are often inserted in the schemes, and there are several examples of rooms decorated in Chinese lacquer – Schönbrunn even has one adorned with Hindu miniatures. Often, too, rooms were decorated with an interplay of mirrors, which by multiplying the reflected images expanded the modest space to infinity.

All these princes had theatres built for them and embellished with woodwork and stucco; that of the Munich Residenz, which is by Cuvilliès, was taken down before the bombing and has been saved (*Ill. 186*). The most gracious of these Court theatres is the small opera house at Bayreuth which the Markgräfin Wilhelmina, sister of Frederick II, had built for her by the Italian Giuseppe Galli Bibiena, and decorated in woodwork painted blue and gold.

Sumptuous as all these residences were, the ecclesiastical buildings surpassed them in gorgeousness and scale. Architects and decorators found greater freedom for the pursuit of their spatial and ornamental inventions in the large dimensions of the church interiors. The architect and decorator Dominicus Zimmermann (1685-1766) produced the two finest examples of Rococo church-building on an elliptical ground-plan, in the pilgrimage-churches of Steinhausen in Swabia (*Ill. 188*) and Neu Birnau by Lake Constance. The most grandiose of the palace-monasteries rebuilt in Germany in the eighteenth century is, unquestionably, the Benedictine Monastery of Otto-beuren (*Ill. 189*) near the frontier between Swabia and Bavaria; several architects worked on it, and – a rare thing – it was completed with all the buildings originally projected. The innumerable statues, ornamental motifs, and paintings in the church join together rhythmically in that symphonic unity to which the Germans have given the name *Gesamtkunstwerk*.

The diverse tendencies of Germanic architecture converged in an architect of genius, Balthasar Neumann (1687–1753). Beginning as an artillery officer and military engineer, he worked mostly for the Schönborn family, whose ramifications extended over Austria and

188 The Pilgrimage Church, Steinhausen, Swabia, with its oval plan, was the work of the two Zimmermann brothers – Dominicus who planned it, and Johann Baptist who painted the ceiling, which represents the Assumption of the Virgin and the four quarters of the world paying homage to her.

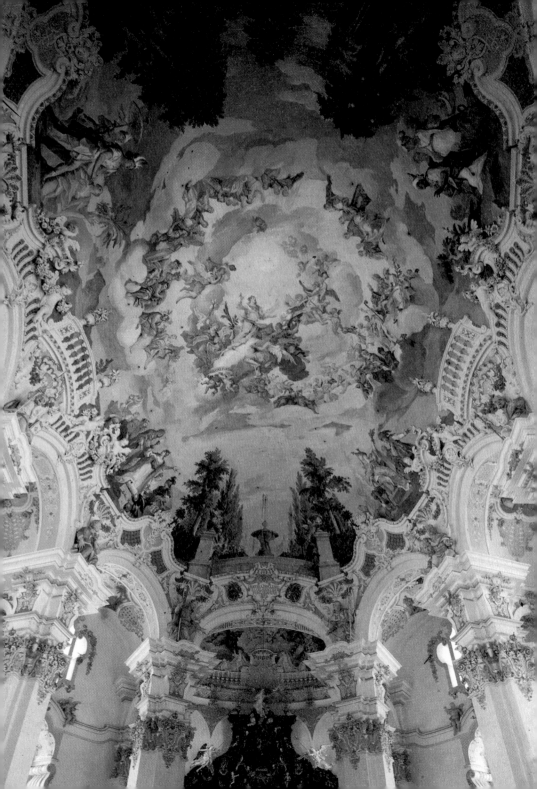

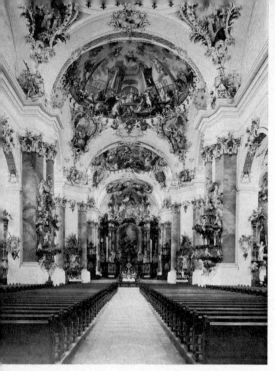

189 The Church of Ottobeuren, Swabia, begun in 1736, was built by several architects and decorated by the best artists of the time. The huge Benedictine monastery of Ottobeuren, of which the church forms a part, is a kind of summing-up of German Rococo.

Germany (during a certain time the episcopal thrones of Spire and Worms in the Rhineland, and Würzburg in Franconia, were all occupied by Schönborns). Obsessed by a mania for building, the Schönborns carried on a correspondence on this fascinating subject, keeping each other abreast of their plans. Bishop Johann Philipp Franz von Schönborn selected Neumann to provide designs for his Residenz at Würzburg. But since Neumann had not yet proved himself, he was not given full confidence, and was sent to Paris in 1723 to submit his plans to Robert de Cotte and to Germain Boffrand; then Boffrand himself was summoned to Würzburg. The result of this combination of talents is a palace with its masses distributed in the French manner, and with its outside ornamentation baroquized according to the German taste, though without excess. Neumann built other palaces – Bruchsal for the Bishop of Spire, Brühl (*Ill. 190*) for the Elector of Cologne. He also designed several churches. The most beautiful of these is Vierzehnheiligen (1743) in Franconia, the pilgrimage-sanctuary of the fourteen auxiliary saints.

In it Balthasar Neumann showed superb skill in contriving spaces suitable to receive the weightless stucco decorations. He managed to include the melody of his ellipses in a basilical ground-plan, and the abundant light spiritualizes and adds grace to the ornamentation while all the lines and ornamental motifs converge towards the reliquary containing the remains of the saints, which has the strange form of a carriage. Having achieved complete mastery of his genius, Balthasar Neumann was able to find, for every theme proposed to him, whether a palace, a church, or a chapel, the most elegant solution and the one best calculated to produce harmony.

German Rococo art died late and abruptly. There was little transition between the Rococo and the Neo-Classical – it can be perceived in such a building as the Monastery of St Blasien in the Black Forest, begun in 1769 by a Frenchman, Pierre-Michel d'Ixnard. But the movement that was to put an end to Baroque art in Germany came from Prussia, where David Gilly, of French origin, and K.G. Langhans (1732–1808) reversed the tendency. The famous Brandenburger Tor in Berlin (1788–1791) is evidence of a deep study of Greek art, which it was possible to make without going to Athens,

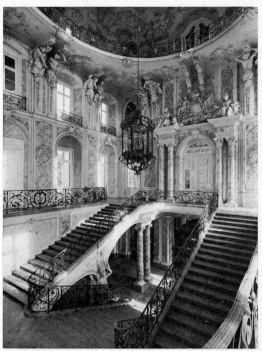

190 The staircase is the great show-piece of the palace, a huge space in which the genius of the architect had full scope. That of the Palace of Brühl, Rhineland, by Balthasar Neumann, 1743–1748, is certainly the most sumptuous in Germany.

simply through Stuart and Revett's *Antiquities of Athens* (1762) and
J. D. Le Roy's *Ruines des plus beaux monuments de la Grèce* (1758).

SCULPTURE

The decoration of the churches required a great number of craftsmen
in stucco. Germany received this technique from Italy and proceeded
to develop it with virtuosity. As already stated, Wessobrunn in
Bavaria was a nursery of these craftsmen. But indeed, in the Rococo
period, this art graduated out of the craft stage, since more and more
motifs with figures were required and a number of great artists
applied themselves to it. These included: in Germany, Egid Quirin
Asam (*Ill. 191*); in Swabia, Zimmermann, Josef Anton Feucht-
mayer (1696–1770), and his brother Johann Michael Feuchtmayer
(who was responsible for the stucco-work at Zwiefalten, 1747–
1758); and in Austria, Holzinger (responsible for the stucco-work
at Altenburg). The one with the most genius was Josef Anton
Feuchtmayer, whose masterpiece is the stucco-work in the pilgrim-
age-church at Neu Birnau (*Ill. 192*), where all the figures are caught
up in a frantic movement and hurl themselves about with cries and
convulsions. Feuchtmayer's art here is a throwback to the anguished
rhetoric of Alonso Berruguete.

Wood-carving, a craft traditional in the German-speaking
countries, enjoyed new prosperity in the Baroque period. Religious
statues were most often of wood, the most elegant being those
produced by the Bavarian Ignaz Günter (1725–1775). Stone and
bronze were used for secular work.

Many artists producing statues for the palaces or for the gardens
were foreigners. Frederick II imported to Berlin statues by the most
famous French sculptors of his time (besides buying some outstand-
ing pictures by Watteau and his School). Among the native artists,
two are worth singling out – Andreas Schlüter (1664–1714) in
Prussia, and Georg Raphael Donner (1693–1741) in Austria. The
former was responsible for one of the finest equestrian statues

191 *The Assumption of the Virgin*, from the pilgrimage-church of Rohr, Bavaria, was ▶
carried out from 1717 to 1725 by Egid Quirin Asam, Bavarian architect, sculptor and
decorative painter.

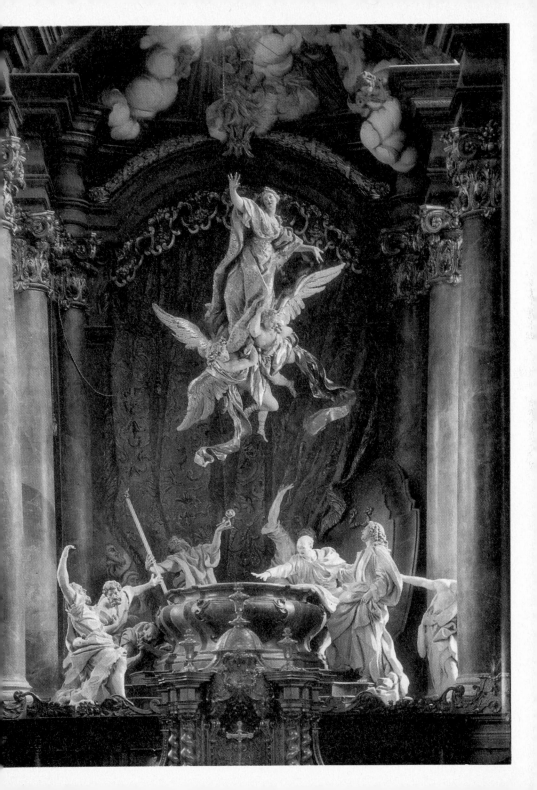

192 A detail of the stucco-work in the Church of Neu Birnau (near Lake Constance) by Josef Anton Feuchtmayer.

193 *Providence*, by Georg Raphael Donner, from the Fountain of the Mehlmarkt, Vienna – the original in lead, now in the Austrian Baroque Museum, Vienna.

produced under the *ancien régime*, that of the Grand Elector, which was cast in 1700. For it Schlüter took as his example the statue of Louis XIV designed by Girardon for the Place Vendôme, but he gave an entirely new character to that model by the impetuous movement with which he endowed it. Donner, who executed some fine bronzes for fountains and gardens, was a pupil of the Italian Giuliani. He may be compared with Bouchardon in virtue of his anti-Baroque spirit, which makes him quite exceptional (*Ill. 193*).

PAINTING

The museums have distorted most people's view of painting – we tend to base our appreciation only on what we see there; and even the art historians, who ought to guide the public, lead it astray. Thus

it is commonly stated by writers that the painting of the German School is mediocre. They are content to mention a few names such as Raphael Mengs or Antoine Pesne. They have merely forgotten to look up, and to absorb the forms and colours displayed on the church ceilings. Many of these paintings are admirable; their only fault is that there are so many of them that they discourage those who would describe them. To concentrate human admiration, a certain coefficient of loss is required; the very wealth of Baroque art harms its reputation, since admiration becomes too much diffused.

The Germanic artists of the eighteenth century took research into the possibilities of ceiling painting to its highest degree. Having learned what was to be learned from the Italians, they carried it a stage further. In Italy, from the fifteenth century onwards, one may observe a slow and tenacious effort to set painting free from the painted surface and to project it into space. This spatial extension was achieved at first horizontally, on the walls, by the perspective known as 'linear'; but by the end of the fifteenth century some artists had discovered that the surface above the spectator was even more propitious to such spatial expansion, and this gave rise to perspective ceiling painting. At first it made use of the techniques tried out in painting on walls, and Padre Pozzo's famous ceiling depended for its effect on a perspective converging to a single point which was the summit of the visual cone. It was the Venetians and the Lombards who had the idea of giving *mobility* to the ceiling space and who, rejecting the help of those architectural elements which the painters had been borrowing from the stage designers, dared to set whirling freely in the sky human figures delivered from the laws of gravity. The Germanic artists took up these researches and pushed them much further; they distorted the space and imparted to it swirling movements, by increasing the number of vanishing points so that the picture came to life for spectators situated in the different parts of the church. And indeed it was in the churches that this art found its field of expression, for in the palaces – except in their grand

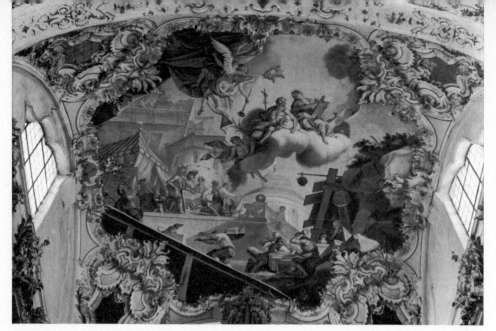

194 The frescoes from the ceiling of the nave, Church of Steingaden, by Johann Georg
Bergmüller, from which this detail is taken, are a remarkable example of composition with-
out an axis, and of diagonal spatial vision.

staircases – the dimensions were too small to allow full play for
these speculations into the possibilities of space.

The painters who, in the Germanic countries, applied themselves
to this art with greater or less felicity, acquiring an extraordinary
virtuosity in the handling of spaces, were legion. They are still not
well known, for their work has been very little reproduced, and
indeed the intoxication caused by the contemplation of these forms
·can hardly be experienced except on the spot. Among the out-
standing artists are : in Germany, Kosmas Damian Asam, Bergmüller
(*Ill. 194*), Johann Baptist Zimmermann, Matthäus Günther (*Ill. 195*),
and Johann Zick; in Austria, Paul Troger, Daniel Gran, and
Hohenburg (or Altomonte). The colouring used by the Austrian
artists – who were closer to the Lombards and Venetians, from
whom the technique came to them – is brighter, more joyful,
more voluptuous; that of the Germans is sharper or more artificial,
often indeed more Romantic, for there is sometimes a curious

242

admixture of the influence of Rembrandt. Romanticism, however, touched Austria also, in the case of Anton Maulpertsch (1724–1796). He was a kind of Germanic Magnasco, who differed from Magnasco in bursting the bounds of the easel picture (to which that artist had limited himself) releasing into the space of the ceilings his atmosphere of lurid gleams that burst through the swirling darkness of night.

Finally, let us not forget that Tiepolo painted the masterpiece of all ceiling painting for the Grand Staircase of the Würzburg Residenz. Nowhere else are the spaces of architecture so perfectly combined with those of painting. No doubt he was carried beyond himself by the enthusiasm he could feel around him.

Is it really right to mention, by the side of these artists of genius, such artisans as Antoine Pesne (1683–1757), who indeed was French by origin, and who laboured at the Court of Berlin to supply the images and effigies demanded of him? These men were mediocre interlopers by comparison with those Germanic artists who created imaginary worlds on the church ceilings.

195 *St Peter and St Paul Driving Out Evil Spirits*, by Matthäus Günther, Parish Church of Goetzen (Tyrol), is a good example of 'whirlwind' composition.

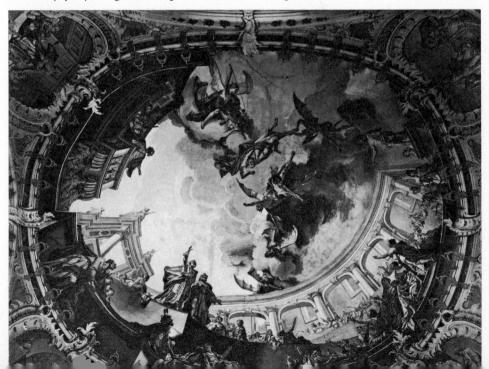

German eighteenth-century furniture was an imitation of the French, but its forms were heavier and much less well balanced. In fact the German Courts imported a great deal of their furniture from France. They also imported tapestry, since none was woven in Germany at the time.

On the other hand, Germany produced some good goldsmiths and silversmiths in the eighteenth century, and gave a powerful impulse to the art of ceramics. Though the German goldsmiths and silversmiths did not attain the perfection of the French, they achieved Rococo forms that were more exuberant. One of them, Johann Melchior Dinglinger, who worked at the Court of Saxony, reproduced in gold and precious stones extravagantly elaborate scenes with many figures – for instance, in 1711, 'The Great Mogul Aurungzebe receiving the gifts of the nobles on his anniversary', with a hundred and sixty-five figures.

The glory of having re-invented the manufacture of porcelain for the Western world belongs to Germany. Porcelain had been the principal import from China into the West since early in the seventeenth century, and the Chinese had guarded the secret of its manufacture jealously and effectively. But in 1709 the researches of Böttger, encouraged by Augustus the Strong who was a passionate collector of Chinese porcelain, were successful in discovering the process; and in 1710 Augustus the Strong founded the Meissen factory to exploit it. This factory not only produced porcelain tableware but also the miniature figures – started by Kändler – which were to have such success. The most delicate of these were modelled by an Italian, Bustelli. The Saxons kept the secret less well than the Chinese; factories, first private, then official, were set up in Vienna, at Ludwigsburg, at Nymphenburg, at Frankenthal, and in Berlin. The highest standard was reached by the Nymphenburg factory, near Munich; its statuettes have a refinement even greater than those of Meissen.

The Eighteenth Century in Poland and Russia

In the first part of the eighteenth century, Poland was politically dependent on Saxony since Augustus II and Augustus III, successive Kings of Poland, were Electors of Saxony. This situation made it easier for influences from Central Europe – and, by this route, from France – to penetrate into Poland. The architect Longuelune and the painter Louis de Silvestre, who were favourite artists of the Court of Dresden, were called in to work in Poland. In this way the country came in contact with the Rococo.

French influence was accentuated during the reign of Stanislaus Augustus Poniatowski, who in 1763 succeeded the Electors of Saxony. He had been brought up in Paris and had come under the guidance of Madame Geoffrin, whose *salon* was then the most famous in Europe. Wishing to impart a Classical air to Warsaw, he called in Victor Louis to enlarge his palace, and acquired collections of French works of art. Yet the Lazienki Palace in Warsaw, 1784 (*Ill. 196*), designed by an Italian, Domenico Merlini, was Palladian in style – a proof that artistic developments in England were also not unknown in Poland. Neo-Classicism came into painting with Simon Czechowicz (1689–1775), who had been a pupil of Carlo Maratta.

In Russia the policy of the open door to Europe had immediate consequences in the arts. There was a new city being built – St Petersburg, at the mouth of the Neva – and Peter the Great called in architects of various nationalities – Germans, Dutchmen, and Italians. It was the Swiss-Italian Domenico Tressini (1670–1734) who built the Cathedral in the Fortress of St Peter and St Paul, a church whose basilical ground-plan with its dome at the western

crossing was entirely opposed to Orthodox traditions. The first overall plan proposed for St Petersburg was based on that of Amsterdam, with its many canals; but French influence soon replaced that of Holland. Even before his journey to France, Peter the Great, when considering the building of a Palace at Peterhof, had been disturbed by the reports of what was being done at Versailles and had begun to recruit artists in France. In 1717 he visited Paris and Versailles, and was struck by their scale and grandeur. He gave up the Dutch idea for St Petersburg, and the plans of the Frenchman Leblond established the city on the right bank of the Neva, with avenues fanning out from the Admiralty – a plan that recalls Versailles. The Palace of Peterhof, built on the shore of the Gulf of Finland, was inspired by the château of Louis XIV.

The seeds of the Baroque in Russia blossomed magnificently during the reign of Elizabeth, the daughter of Peter the Great, a princess of great refinement and with a taste for magnificence. Her Chief Architect was the Italian Bartolommeo Rastrelli (1700–1771), the son of a sculptor whom Peter the Great had brought back from France. He had been trained by Robert de Cotte, but his principal inspiration came from Bernini and from Borromini. In St Petersburg

196 Designed by an Italian, Domenico Merlini, the Lazienki Palace, Warsaw, recalls the Neo-Palladianism that flourished in the Veneto in the eighteenth century.

197 The Imperial Palace of Tsarkoie-Selo, by Bartolommeo Rastrelli, where the elaborate decoration draws its inspiration from German Rococo.

he built the Winter Palace, on a closed Italian ground-plan and with an order of colossal columns. But in the Summer Palace at Tsarkoie-Selo (now Pushkin), to the south of St Petersburg, he showed a greater degree of Baroque fantasy (*Ill. 197*). This palace lies open in the French manner, with a façade, three hundred and fifty yards long, giving on the gardens. The decoration of its rooms in wood-work edged with gold and stucco – they included a small room decorated in amber, which Peter the Great had bought from Frederick I – was unfortunately destroyed during the Second World War. It made Tsarkoie-Selo one of the most sumptuously embellished royal residences in Europe. Following the example of the tsars, the great lords also had palaces built for them. Even religious architecture now became subject to the principles of civil architecture and often acquired a monumental look. Rastrelli built the Smolny Convent on a scale as grandiose as that of the monasteries in Central Europe. All these buildings were executed in brick, with ornamentation added in stucco. The bare wall surfaces had their stucco coloured sea-green, red ochre, yellow, or sky-blue, and this gave the city on the Neva a cheerful atmosphere.

247

French influence soon began to restrain the exuberance of the Baroque in Russia. In 1758 Elizabeth founded an Imperial Academy of the Fine Arts, under the direction of a Frenchman. Its Statutes were revised by Catherine II in 1764; its more important Chairs were occupied by artists from France. It was a Frenchman, Vallin de la Mothe, who in 1759 designed the building which was to house it, in a style whose Classicism broke away from Rastrelli.

In general the movement towards Classicism was reinforced by Catherine II, who was one of the greatest art patrons of the eighteenth century. By the quality and the quantity of the collections she acquired by her artistic enterprises and by her fondness for the company of philosophers, she placed the Court of St Petersburg in the front rank of the Courts of Europe.

As a setting for the pleasures of her intellectual life Catherine the Great ordered Vallin de la Mothe to build, on the banks of the Neva, the Small Hermitage, connected with the Winter Palace by a gallery. Here she housed her collections; but they soon required a much larger building, and this, the Old Hermitage, was built for her by Velten. Her favourite architect was an Italian Neo-Classicist, Giacomo Quarenghi (1744–1817). In St Petersburg he built several palaces and a theatre joined on to the Hermitage (*Ill. 198*). The Alexander Palace at Tsarkoie-Selo is also Neo-Classical. Cameron (*c.* 1750–1811), a Scot, built in the purest Adam style an annexe to the Summer Palace at Tsarkoie-Selo, which included the Agate Pavilion.

Won over by these foreigners and by the Imperial Academy of Fine Arts, the Russians themselves began to produce work in the European spirit. Starov built the Tauride Palace, in a very pure Neo-Classical style, for Potemkin, Catherine's favourite. After the death of Catherine the Great in 1793 the part played by Russian architects became more important. It remained for Tsar Alexander to complete the building of St Petersburg, imparting to it an imposing character such as Napoleon hoped to give to Paris.

Almost the only noteworthy examples of sculpture before Catherine the Great were due to Carlo Rastrelli, the father of the architect. In 1744 he raised his equestrian statue to the glory of Peter the Great, in imitation of the statue of Louis XIV of Girardon. A Frenchman, Nicolas-François Gillet, who was Professor at the Imperial Academy of Fine Arts, trained several Russians in sculpture, and they went on to France to complete their training. So it came about that the art of Shubin, Kozlovsky, and Shchedrin is closely related to the French style. The boldest enterprise in sculpture during the reign of Catherine II was the raising of an equestrian statue in bronze to Peter the Great. The French sculptor Falconet worked on this from 1766 to 1778 – the Tsar sits in Olympian calm on a rearing horse (*Ill. 199*).

A large number of French and Italian painters, who spent varying lengths of time in Russia, contributed examples of the style current in Europe, and this made it possible to create in St Petersburg a School of Court painting, hitherto wholly lacking in Russia. History painting remained mediocre; but Dimitri Levitsky (1735/7–1822) and Vladimir Borovikovsky (1757–1825) were talented portrait painters.

Catherine's personal taste led her in the direction of Classicism.

198 The Interior of the Hermitage Theatre, Leningrad, by Giacomo Quarenghi, built in the Neo-Classical style, with rich decoration in stucco.

She dreamed constantly of Rome, but, afraid of a *coup d'état* if she left St Petersburg, cherished the plan of having all Raphael's frescoes in the Vatican copied in her Palace. Except for the Loggia, the project was not carried out. Clérisseau, with whom she kept up a correspondence, nourished her desire to learn about the monuments of antiquity in Italy; she asked him for various designs, and bought up all the drawings and watercolours in his studio, which included studies from antiquity and designs for imaginary buildings.

MINOR ARTS

With remarkable ease the Russian architects under the direction of Rastrelli, who was responsible for the ornamentation of the Winter Palace and of Tsarkoie-Selo, developed into extremely accomplished stucco-workers, bronze-workers, gilders, furniture-makers, metalworkers, porcelain-makers, and jewellers, in response to the enormous demand for works of art which had suddenly arisen in St Petersburg. The Russian cabinet-makers and cabinet-decorators specialized in the use of new materials – walrus ivory, malachite, alabaster, and metal. The Tula factory produced extremely elegant garden furniture of steel or copper. But for silverware Catherine the Great and her Court sent their orders to Paris. This is why, in spite of sales by the Soviet Government, the Hermitage Museum still contains a magnificent collection of French silver.

199 The equestrian statue in bronze of Peter the Great, Leningrad, by Falconet, 1766–1778. The balance of the rearing horse is assured by various devices – by the tail, and by the serpent, which symbolizes rebellion defeated.

The Eighteenth Century in the Low Countries

Art in the Southern Netherlands remained Baroque during the first half of the eighteenth century, with a certain French influence already apparent in architecture, in the Maison des Ducs de Brabant (in the Grand' Place, Brussels) by G. de Bruyn. During the second half of the century Baroque exuberance in architecture was gradually cooled by Classicism. In Brussels the large-scale complex formed by the Place Royale (*Ill. 200*) and the Park was laid out by Barnabé Guimard, a Frenchman, in the Neo-Classical style (1776). He worked from plans drawn in Paris by N. Barré, altering them to an unknown extent. The Baroque extravagance of the pulpits lent itself perfectly to the Rococo style. In Laurent Delvaux's pulpit for the Church of Saint-Bavon in Ghent, and Théodore Verhaegen's pulpit for Notre-Dame of Hanswyck at Malines, the structure disappears, drowned beneath the decoration. But the influence of Versailles introduced Classicism into ornamental sculpture.

200 The Place Royale, Brussels, was laid out by the French architect, Guimard, who lived in Belgium, but on the basis of designs sent from Paris by another French architect, Barré.

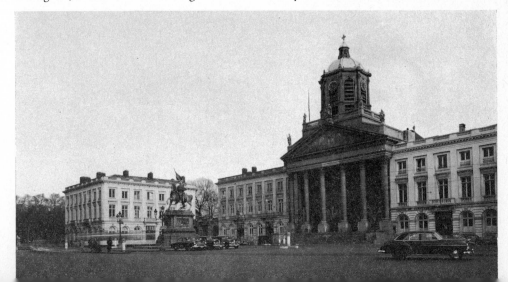

Antwerp produced a whole series of minor painters, who adapted *genre* painting to the spirit of the century. One fine decorative painter, Pierre-Joseph Verhaegen (1728–1811), remained faithful to Rubens's conception of art down to the nineteenth century.

In Holland Daniel Marot, a Huguenot, introduced the Louis XIV style – which, in architecture, when compared with the sober Classicism of the seventeenth century, produced a truly Baroque effect (in the case, for instance, of the Royal Library in The Hague, built to a design dating from 1734 (*Ill. 201*)). Most of the private houses were still built of brick, and often their only ornament was a delicate Rococo doorway, sometimes of wood. The rich burghers' houses lining the canals of Amsterdam are adorned with Baroque façades in stone, and sometimes their rooms have a decoration in stucco that makes them into real palaces (for example, the Hôtel de Neufville, 475 Heerengracht, Amsterdam). The Neo-Classical reaction appeared in about 1770 (in the City Hall of Weesp).

The genius for painting, which had burned so brilliantly during the preceding century, failed in the eighteenth. Cornelis Troost (1697–1750) is worth mentioning; he treated *genre* painting with an elegance adapted to the new spirit, and composed series of pictures telling a story, as Hogarth was to do in England (*Ill. 202*).

201 The Royal Library, The Hague, designed in 1734 by the French architect Daniel Marot.

202 '*Loquebantur Omnes*' ('And so they all fell to talking'), by Cornelis Troost, Mauritshuis, The Hague. One of a series of pictures in pastel recounting imaginary incidents during an evening party of friends held at the 'House of Biberius', depicted in a lightly satirical spirit.

In contrast, the minor arts remained quite brilliant. The Amsterdam silversmiths produced fine Rococo pieces and the hey-day of the Delft pottery lies between 1700 and 1740. The Rouen style of *lambrequin* decoration, which was brought in by Daniel Marot, was now combined, in the so-called Delft ware, with the ornamental motifs which were still not relinquished. Porcelain made its appearance after 1750, at Weesp, Loosdrecht, Amsterdam, and The Hague.

The Eighteenth Century in Scandinavia

Artistically, during the seventeenth century, Scandinavia had lived on a mixture of influences from Germany, Flanders, and Holland. In the eighteenth century, Sweden and Denmark changed direction, turning towards France.

The kings of Denmark, wishing to modernize their capital, called in the architect Nicolas Henri Jardin (1720–1799), the sculptors Le Clerc (1688–1771) and Joseph Saly (1717–1775); these Frenchmen founded an Academy which in time trained local artists. Saly raised

203–204 The equestrian statue of Frederick V by Joseph Saly, 1768, Amalienborg Square, Copenhagen, was inspired by Bouchardon's equestrian statue of Louis XV in Paris. The portrait of the King, National Museum, Stockholm, is by Gustav Pilo, whose painting is sometimes reminiscent of Goya.

205 *The Lady with the Veil*, by Alexandre Roslin, National Museum, Stockholm. This portrait has come to typify the smiling, coquettish grace of the women of the eighteenth century: it shows a certain Venetian influence.

a fine equestrian statue to the glory of Frederick V (*Ill. 203*). The best Scandinavian painter of this period, Gustaf Pilo (1711–1792), a Swede who worked in Denmark, was in contact with these Frenchmen at the Academy in Copenhagen (*Ill. 204*).

In Stockholm French influence had begun to make its way at the end of the seventeenth century. Hedvige-Eléonore, the Queen Mother, widow of Charles X, had the Palace of Drottningsholm, near Stockholm, built for her after the manner of Versailles by her architect Nicodemus Tessin the Elder. When he died in 1681 Nicodemus Tessin the Younger (1654–1728) carried on his work,

and designed a garden in the French style for Drottningsholm. He then undertook the building of the Royal Palace in Stockholm. This went on for nearly a century (1697–1771) and provided a field for the practice of the arts over a long period. Tessin brought over from France a whole team of painters, sculptors, ornamenters, goldsmiths, and silversmiths. One of them, Bernard Foucquet, a sculptor, achieved some notable pieces. In 1732, when the work, interrupted by the disasters of the armies of Charles XII, was resumed, the Superintendent of Fine Arts, Harleman, went to Paris to recruit a fresh team of artists; of these, the sculptor Larcheveque made the statues of Gustavus Vasa and of Gustavus Adolphus, and Jacques-Philippe Bouchardon, younger brother of Edme Bouchardon (the great French Classicist of the eighteenth century), stayed for twelve years and produced many important pieces, including several royal busts Count Karl Gustaf Tessin (1695–1770), the son of Nicodemus Tessin the Younger, was Swedish Ambassador in Paris from 1739 to 1742, where he was active in bringing other artists to Sweden, and still more in arranging the purchase of French art collections.

Swedish artists went to France to complete their training. Some, like Lavreince, spent long periods there, while others became part of the French School – notably the portrait painter Alexandre Roslin (1718–1793). Having married and settled down in France, he became Court Painter to Louis XVI, but his pictures never lost a certain naturalist stiffness which is foreign to the French character (*Ill. 205*).

The 'Gustavian style' – which prevailed throughout the reign of that enlightened despot Gustavus III (1746–1792), who visited France twice, in 1771 and 1784 – took Sweden in the direction of Neo-Classicism. Jean-Louis Desprez (1742–1804), who had studied for a long time in Italy and was Court Painter to the King of France, received authorization in 1784 to go to Sweden. There he became First Architect to the King and designed, as a royal residence at Haga, a vast palace in the Neo-Classical style, whose building was interrupted by the death of Gustavus III.

The Eighteenth Century in Great Britain

In the eighteenth century, while the whole of Europe – except Holland – was glorifying the institution of monarchy established by Divine Right (an institution so dispersed that the smallest German Principalities could boast of it), England was experimenting with Parliamentary monarchy, with a king who reigned but did not rule, government being assured by a Cabinet responsible to Parliament.

What made the development of the Parliamentary régime easier was the fact that the throne was occupied by a dynasty of foreign origin, the Hanoverian. The first two Georges remained German – George I could only make himself understood by his Ministers by talking to them in Latin. When George III, who was completely anglicized, tried to regain the reins of government, it was too late. Partly for these reasons, and partly because of the grossness of the first two Hanoverian kings, the monarchy at this time had hardly any influence on the arts. The refinement of manners which took place owed nothing to the Court – it was due to an aristocratic society, whose advantages, indeed, were not based merely on the privileges of birth; thanks to the Whigs, merchants and bankers were admitted to it and recognized as the equals of the nobles. An important part in the development of social life was played by one of the provincial cities, Bath, to which the Londoners went to take the waters, and where Beau Nash became the arbiter of elegance. During the second half of the eighteenth century, the drawing-rooms rivalled the coffee-houses and the clubs as meeting-places, though they did not acquire the full importance which they had in France.

British eighteenth-century art has, therefore, this in common with French art, that it was an expression of social life. In France, at the death of Louis XIV, the Court lost control over manners and minds, though it retained the political preponderance; in England it tended more and more to be merely an expression of national sovereignty, a safeguard of essential unity within that full play of party strife which is the very principle of the democratic system.

ARCHITECTURE

Eighteenth-century England went through a fever of architectural experiment. Books on the theory and practice of architecture, also specialist reviews, were published in considerable numbers during this period. Members of the aristocracy, such as Lord Burlington, Lord Pembroke, and Horace Walpole, did not disdain to contribute.

All these researches were grouped about a revival of the tradition started by Inigo Jones at the beginning of the seventeenth century, whose direction was towards Classicism. Yet, paradoxically, Gothic architecture – which had never fallen into disuse – was also to have a real revival at this time.

When in 1718 William Benson (1682–1754), was appointed Surveyor-General of the Works (in place of Wren, who had still four years to live), he set his office upon a Classicist course, opposed to that of his predecessor. He found support in a whole new move- ment of opinion, general at that time in the Whig society, of which Lord Burlington (1694–1753) was one of the chief representatives. Lord Burlington visited Italy in 1714–1715, and returned at the moment when Colen Campbell published the first volume of his *Vitruvius Britannicus* (1715), the aim of which was to display before the eyes of architects the best – the most Classical – examples of Eng- lish architecture. Palladio was now, more than ever, considered the outstanding model; the plates of his *Quattro Libri* were re-engraved and published, with a translation, in London in 1717 by Giacomo Leoni (1686–1746), a Venetian. In 1727 the designs of Inigo Jones were

206 Mereworth Castle, by Colen Campbell, 1723, is one of the earliest buildings directly inspired by Palladio's Villa Rotonda at Vicenza, later much imitated in England.

published. Vitruvius, Palladio, and Inigo Jones constituted the three theorists of the new aesthetic known as Palladianism.

This aesthetic immediately met with great favour. Only James Gibbs (1682–1754), a Scot and indeed a Tory, held apart from it and followed the taste of Wren with its derivation from the examples of Roman architecture (as in the Church of St Martin-in-the-Fields, London). By 1715 Colen Campbell had already begun to build Wanstead House (since destroyed) in the Palladian style. In 1723 he built Mereworth Castle (*Ill. 206*), which was inspired by Palladio's Villa Rotonda just outside Vicenza. This example was imitated by Lord Burlington at Chiswick House, begun in 1723. Palladianism became general in the English country-houses; Campbell and Lord Burlington built a dozen each. Lord Burlington worked closely with William Kent (1685–1748), whose principal achievement is Holkham Hall; its entrance and staircase with their Ionic columns are certainly the most characteristic example of the Burlington manner. Kent designed, in a severe style, the Horse Guards in Whitehall, executed later. Lord Pembroke (1693–1751) followed

207 The Royal Crescent, Bath, was laid out by John Wood II almost entirely in the Palladian manner between 1767 and 1775. The city of Bath has been called 'the English Vicenza'.

Burlington's example. He himself built country-houses, in partnership with a technician, Roger Morris (who died in 1749). Their enthusiasm for Palladio was so fervent that they carried out (in the gardens of Wilton, Prior Park and Stowe) a plan of Palladio's for a triumphal bridge which he had never executed. Henry Flitcroft (1697–1767), Isaac Ware (who died in 1766), and John Vardy (who died in 1765) also belong to this first-generation Palladianism.

The first generation of the English Palladians were restrained by an excess of erudition; the second – for example, Sir Robert Taylor (1718–1788) and James Paine (1725–1780) – were more creative. The style now spread throughout the country. The outstanding achievement of Palladianism was the building of Bath, the watering-place to which the aristocracy flocked, by the first John Wood (1704–1754) and by the second John Wood (1728–1781). The latter invented an element of town planning which was to have much success in Great Britain – the Crescent (*Ill. 207*).

Palladianism led on, quite naturally, to Neo-Classicism. This took its inspiration no longer from Palladio or Vitruvius, but from the Greek and Roman remains which had been discovered in Southern Italy, Greece, Dalmatia, and the Middle East (Palmyra and Baalbek) and were at that time the subject of various publications. The promoters of British Neo-Classicism were the four Adam brothers, together with Sir William Chambers (1723–1796), the author of

208 The Music Room, 20 Portman Square, London, is one of the purest examples of ▶ Neo-Grecian decoration. It was carried out in stucco to designs by Robert Adam, 1775–1777.

a *Treatise on Civil Architecture* (1759) who put his theories into practice at Somerset House, an administrative building on a large scale in London. Robert Adam (1728–1792), the oldest of the four brothers, paid a long visit to Italy from 1754 to 1758, in the course of which he met Clérisseau, who was producing a large body of drawings of ancient ruins. The sources of the Adam manner were complex – they included French influence, antiquity, and the Renaissance – and made possible the elaboration of a style far more supple than Palladianism and therefore adaptable to many different schemes. The most expressive work by Robert Adam is undoubtedly Sion House. He revolutionized the conception of an interior, by introducing into it the style of ornamentation based on antiquity and so harmonizing it completely with the style of the architecture (*Ill. 208*). The interiors of the Classical buildings by architects of the preceding generation had, in fact, been decorated in the Rococo manner, and sometimes with exuberant *chinoiserie*, the Classical elements usually being confined to the hall and staircase. The new schemes of decoration were Pompeian, or Neo-Greek, or even Etruscan, and there was a revival of *grotteschi* in an elegant and very free form.

Chambers trained several pupils (such as Thomas Coolcy and James Gandon) who followed his principles, while others (such as the second George Dance and James Wyatt) were closer to the Adam style. Neo-Classicism was to dominate Great Britain during the birth of the 'picturesque' style in the Romantic period.

And yet, as if to counterbalance the rigidity of the Classical principles, the second half of the eighteenth century in Great Britain brought with it a revival of the Gothic style, which indeed had never ceased to be used, to some extent, for university or ecclesiastical buildings. The promoters of Palladianism themselves – William Kent, for instance – produced Gothic buildings. Amateurs such as Sanderson Miller (1717–1780) and Sir Horace Walpole (1717–1797) started a fashion for Gothic in country-houses. Walpole had his own houses, Strawberry Hill and Twickenham, built and decorated in this style. The new taste caught on, and Gothic libraries and galleries became common in the great houses.

The evolution of garden design in Great Britain was no less paradoxical, for it went in the opposite direction from that of architecture. The creation of the type of garden known as 'English' or 'Anglo-Chinese' was in fact the principal contribution of Great Britain to the Rococo style – that 'French style' against whose seductions the British kept on their guard. The most curious fact is that the chief initiators of this type of garden design were also the champions of Palladianism in architecture – William Kent, William Chambers, and Lord Burlington. Palladian country-houses like

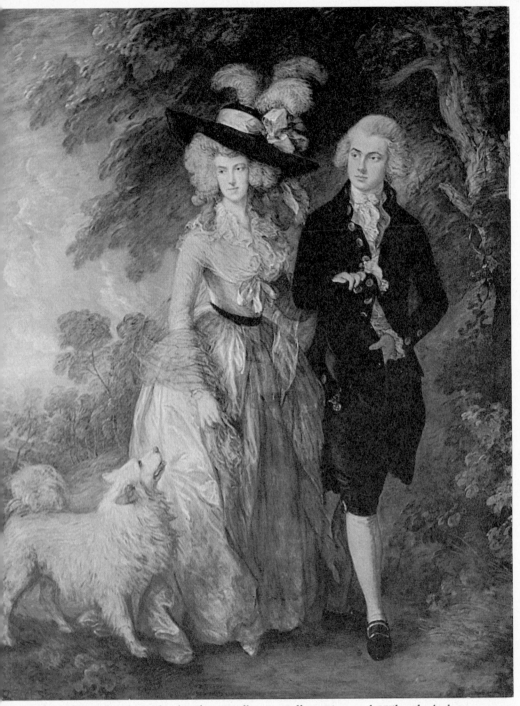

209 *View of Snowdon*, by Richard Wilson, Walker Art Gallery, Liverpool. Wilson looked at the British Isles through the golden haze of Claude Lorraine.

210 *The Morning Walk*, by Thomas Gainsborough, National Gallery, London.

Chiswick were set in gardens that had a multitude of winding paths and were full of streams, pools, valleys, cascades, and rocks pretending to reproduce nature. Rare species of trees were eagerly sought after, and there was a great variety of Chinese, Moorish, and Gothic pavilions, artificial ruins (Graeco-Roman or medieval), mausolea, and temples to the abstractions of philosophy or sentiment. This type of garden at once became fashionable throughout Europe and either replaced the garden in the French style or was laid out next to it.

THE FIGURATIVE ARTS

The outstanding sculptors in eighteenth-century Britain were foreigners, producing tombs, busts, and ornamental statues for gardens. The most remarkable of them was a Frenchman, L.F. Roubiliac (1702/5–1762).

211 *Shortly After the Marriage*, by William Hogarth, National Gallery, London. A picture from one of Hogarth's celebrated moralizing series, 'Marriage à la Mode'.

Early in the eighteenth century, England continued to receive painters from the Low Countries, but Italians, mostly Venetians, were now added to these, and Frenchmen also (Watteau, Philippe Mercier) came to work in London. However, the country began to produce painters of its own. Sir James Thornhill (1675–1734), who had studied in Italy all the methods of ceiling painting, carried out *trompe-l'œil* pictures in the Great Hall of Greenwich Hospital and in the Dome of St Paul's.

But the real founder of the British School of Painting was Hogarth (1697–1764). He transformed *genre* painting – which was picturesque in Holland and *galant* in France – into painting with a moral message. In England, where expression of thought was free, there had been since the end of the seventeenth century a great advance in satirical writing. This spirit of satire inspired Hogarth, and he scourged the customs of British society in several series of pictures – *The Rake's Progress* and *Marriage à la Mode* (*Ill. 211*). This literary *genre*, created by him and adopted later by Greuze in France, was very popular during the second half of the eighteenth century, as is shown by the sales of engravings which Hogarth had made after his pictures. He also painted portraits that are really more 'studies' than portraits, as did Fragonard later. The true glory of Hogarth is not that he invented literary painting, but that he was the pioneer of the British manner of painting – a generous manner, with broad brushwork inspired by that of Rubens, whose influence remained active during the eighteenth century both in France and in England.

It was in portrait painting that the British artists were destined to create a style of their own. Allan Ramsay (1713–1784) imitated the ceremonial portrait current at the time in France and in Italy. In contrast to this, English portrait painting after 1750 moved in the direction of naturalness. Sir Joshua Reynolds (1725–1792) and Thomas Gainsborough (1727–1788) – exact contemporaries – were the two greatest English portrait painters of the eighteenth century, but their pictures were of quite different types. Reynolds was a

temperamental painter who loved to yield to the excitement of actual painting. For all that, he was acutely concerned over all questions of technique, and throughout his life he studied the pictures of the masters, especially of Rembrandt and of Rubens, in an effort to penetrate their secret (*Ill. 212*). He was also fond of discussing art, and gave every year a lecture expounding his principles before the Royal Academy (which was sanctioned by George III on 17 December 1768, and of which he was the first President). In the Baroque manner he painted his figures in the action and attitude best fitted to the sitter's character. When his sitters were women, he approached the sensuousness of Rubens.

Thomas Gainsborough was more naïve, more spontaneous, less sophisticated than Reynolds. His portraits are poetic and aristocratic evocations like those of Van Dyck, for whom he had a deep admiration. He often painted group portraits, showing husband and wife (*Ill. 210*) or a whole family – the *genre* known as 'conversation pieces', started in England by Hogarth and already practised by the Dutch. He loved to place his sitters in a natural setting – and indeed

212 *The Death of Dido*, by Sir Joshua Reynolds, Buckingham Palace, London. The dramatic element in many of Reynolds's pictures marks the transition between Baroque eloquence and Romantic sentiment. (Reproduced by gracious permission of H.M. the Queen.)

213 *The Forest*, or *Cornard Wood*, by Thomas Gainsborough, National Gallery, London. Gainsborough's vision of nature was inspired by the landscapes of Rubens and of Ruisdaël.

during his Ipswich period (1754–1759) he painted landscapes in a spirit that recalls Rubens and leads on to Constable (*Ill. 213*). Less sensuous than Reynolds, what attracted him in the women who sat for him was the soul and its sensibility.

The Neo-Classicism dominant in architecture made its appearance later in painting; it marks the art of Romney (1734–1802). He began by being a history painter; the naturalness, enthusiasm, and move-ment which turned the studies of Reynolds and Gainsborough into living portraits became softened, in Romney, into a sentimental pose (*Ill. 214*). Hoppner (1758–1810) crystallized the fine British handling into broad, fat, somewhat conventional brushwork. Rae-burn (1756–1823) depicted Scottish society with a superb handling, done with a generously loaded brush. The relief of his surfaces has been ironed out for the most part by the restorers who have rebacked his pictures, so that much of their charm has been removed.

214 *Lady Hamilton as a Bac-chante*, by George Romney, Tate Gallery, London. A somewhat sentimental expressiveness combined with a Neo-Classical treatment, with which it contrasts, brings many of Romney's pictures close to those of Greuze (see *Ill. 166*).

Zuccarelli, a Venetian landscape painter who lived in England for a long time and was a member of the Royal Academy from its foundation, introduced the fantastic landscape. A Welshman, Richard Wilson (1713–1782), was led by his admiration for Claude Lorraine to seek out the places in Italy that had inspired that artist. When he returned to Britain, he painted the landscapes of his own country in a delicate golden or silvery light in which a certain nostalgia for Italy can be felt (*Ill. 209*). Watercolour painting – which in the other schools of painting was merely like wash drawing, a method used for preliminary studies – became in England, during the second half of the eighteenth century, a *genre* on its own, practised for its own sake and leading the artists on towards an attentive observation of nature (as, for instance, in the work of A. Cozens, 1715–1785, and his son John Robert Cozens).

The influence of the stage was considerable in English society, and the great actor Garrick was fond of the company of painters. At the

end of the century a German, Johann Zoffany (1734/5–1810), often depicted Garrick in actual scenes from plays. Sporting pictures were in much demand in a country where the love of horses was so marked. The best painter of these, George Stubbs (1724–1806), published an *Anatomy of the Horse* in 1766 and produced real portraits of the noble animal.

The *genre* in which the English painters were least happy was history painting; the efforts of Reynolds in this direction are strangely petrified for so living a painter. Yet it was through history painting that Neo-Classicism invaded the art. A Scot, Gavin Hamilton (1723–1798) and an American, Benjamin West (1738–1820), who enjoyed a prodigious success, were in advance of the French painter Jean-Louis David in the conception of a painting as a scene from Classical history, based upon thorough archaeological research.

MINOR ARTS

The styles of the decorative arts in eighteenth-century Britain divide clearly into three periods – Baroque, Rococo, and Neo-Classical. In the first half of the eighteenth century the Baroque style enjoyed a somewhat retarded flowering, chiefly under the influence of the architect William Kent, who was one of the first *ensembliers* – designing the whole of the decoration of a house, including its furniture. Against this rather heavy Baroque magnificence there came, round about 1750, a counter-offensive which was favoured by the Chinese influence, the revival of Gothic, and the introduction of French *rocaille* forms. Hogarth's *Analysis of Beauty*, published in 1753, sang the praises of the serpentine line just when, in France, Cochin was condemning it. All these researches into Rococo possibilities culminated in the publication of Thomas Chippendale's *The Gentleman and Cabinet-Maker's Director*, in 1754. This book at once began to circulate throughout Europe, except in France, and helped to propagate the English Rococo forms in Portugal, Spain, Italy, and Holland, where 'Chippendale' became the name for a style. England

made great use of exotic woods, especially mahogany (*Ill. 215*), from which some highly elegant forms were extracted.

In 1758, when he returned from his journey to Italy and Dalmatia, Robert Adam found the so-called Chippendale style dominant. He very quickly imposed on England the Classical style of building and decoration, of which he had made such a long study in Italy. With elaborate care he composed *ensembles* in which everything, down to the last detail, was subject to the Classical style; he brought stucco back into fashion, using it for palmettes, ovolos, dentils, and arabesques that he designed; he gave rhythm to his walls by means of columns or pilasters; he sought variety in the shapes of his rooms; and he employed light colours – blue, yellow, green. For the aristocracy he designed furniture in the same style, which the cabinet-maker George Hepplewhite made more widely available. Thomas Sheraton (1751–1806) further purified the Adam style in furniture, drawing from it forms of great lightness and elegance.

Silverware was so fashionable in Great Britain at this time that, with a view to placing the fine forms of solid silver within the reach of a wider public, Thomas Boulsover, a Sheffield cutler, invented in 1742 a technique of plating with silver which became known as 'Sheffield plate'. Round about 1750 Paul de Lamerie, a Frenchman by origin, invented the most extravagant *rocaille* forms (*Ill. 216*).

215 A side chair of Cuban or Honduran Mahogany, *c.* 1740, Irwin Untermyer Collection, New York, shows the Chinese influence, which was common in the decorative arts in England at a time when the architecture was Neo-Classical.

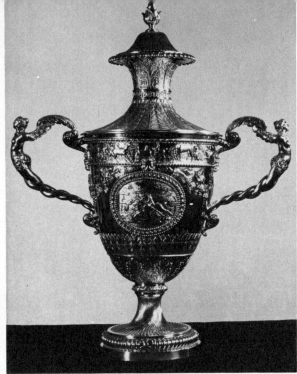

216 A Silver Tea Caddy, by Paul de Lamerie, *c.* 1735, shows the *rocaille* form of decoration.

217 The Richmond Cup in the Collection of the Marquess of Zetland is Neo-Classical in style. It was designed by Robert Adam in about 1770.

These were at once imitated, but extremely simple silverware remained very popular. In due course, also, the Classical style was rendered with extreme strictness by the silversmiths who made fashionable the urn shape, the oval, and the two-handled cup (*Ill. 217*). This highly elegant type of work had an enormous success throughout Europe, and was imitated in Holland, in Portugal, and even in France.

Before the Neo-Classical reform, pottery in England had been subject to the most varied foreign influences – from Saxony, Delft, China, Japan. The English invented the technique of printed decoration, which made it possible to lower the prices. Of the porcelain factories Chelsea came nearest to Meissen. It was Wedgwood's fine

pottery that proved to be the most original invention in British ceramics, both technically and artistically. In 1768 Josiah Wedgwood (1730–1795) founded a factory whose name – Etruria – showed clearly his intention to imitate the Greek vases then believed to be Etruscan; but in his coloured pieces, where the essentially Classical shapes are decorated with white figures in relief, he was also imitating the cameos of antiquity (*Ill. 218*). Wedgwood's invention had a vast success, and competed with the productions of France and Germany in the European market.

218 On the Wedgwood Porcelain Vase the classical motif, 'The Apotheosis of Homer', was designed by Flaxman, who took Greek vases as his model.

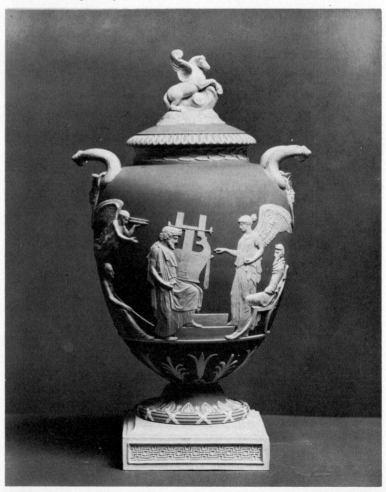

Bibliography

This bibliography has been prepared as a guide for further reading on subjects covered by the book. For this reason a number of short comments have been included to assist the reader who finds such direction welcome. General works in English on the Baroque and Rococo are rare and many of the most useful studies in French, German, Italian and Spanish have not been translated.

General Works

BIALOTOCKI, J. B. 'Le Baroque: Style, époque, attitude', article in *L'Information d'Histoire de l'art*, Jan.–Feb. 1962, pp. 19–33. An excellent study on the origin of the word and the evolution of the concept of Baroque art.

CASTELLI, E. and others. *Retorica e Barocco, Atti del III Congresso Internazionale di Studi Umanistici*, Rome, 1955. A penetrating symposium.

FRIEDRICH, C. J. *The Age of the Baroque 1610–1660*, New York, 1952. Consult for historical background of the early part of the period.

HAUSENSTEIN, W. *Von Genie des Barock*, Münich, 1956. Should certainly be consulted.

HIGHET, G. *The Classical Tradition*, Oxford, 1949. 'Note on the Baroque', p. 289, provides a succinct study of much of the underlying theory.

KAUFMANN, E. *The Architecture in the Age of Reason*, Cambridge, Mass., 1955. Useful, though much of the book is given to Neo-Classicism.

LEES-MILNE, J. *Baroque Europe*, London, 1962. Should be consulted for its illustrations.

SCHÖNBERGER, A., and SOEHNER, H. *The Age of Rococo*, London, 1960. Valuable for the arts of the eighteenth century. Many illustrations.

TAPIE, V. L. *The Age of Grandeur*, London, 1960. Brings together several studies of historic interest, grouped geographically, on the seventeenth and eighteenth centuries.

Italy

BRIGANTI, G. *Pietro da Cortona*, Florence, 1962.

FRIEDLAENDER, W. *Caravaggio Studies*, Princeton, 1955. The best and most thorough work on the subject; includes original research, documentation, illustration and bibliography.

GOLZIO, V. *Seicento e Settecento*, 2nd edition, 2 vols., Turin, 1961. Almost a thousand illustrations, comprehensive text and bibliography.

HEMPEL, E. *Francesco Borromini*, Vienna, 1924.

JULLIAN, R. *Caravage*, Lyon, 1961.

LEVEY, M. *Painting in XVIIIth Century Venice*, London, 1959.

MAHON, D. *Mostra dei Carracci*, Catalogue, Bologna, 1956. Introduction, much documentation, illustrations, bibliography.

PALLUCCHINI, R. *La pittura veneziana del Settecento*, Venice, 1960.

PANE, R. *Bernini architetto*, Venice, 1953. Should be consulted for Bernini's architecture, bibliography.

WATERHOUSE, E. *Italian Baroque Painting*, London, 1962.

WITTKOWER, R. *Art and Architecture in Italy 1600 to 1750*, Harmondsworth, 1958. Covers most of the period and should certainly be consulted. Full bibliography, illustrations and important essay on Bernini.

WITTKOWER, R. *Gian Lorenzo Bernini, the Sculptor of the Roman Baroque*, London, 1955. Essential catalogue raisonné of Bernini's sculpture.

Spain, Portugal and Latin America

ANGULO IÑIGUEZ, D. *Historia del arte hispano-americano*, 3 vols. to date, Barcelona, 1945–. An exhaustive study of art in South America.

BAIRD, J. A. *The Churches of Mexico, 1530–1810*, Berkeley, 1962.

BAZIN, G. *L'Aleijadinho et la sculpture baroque au brésil*, Paris, 1963.

BAZIN, G. *L'architecture religieuse baroque au brésil*, 2 vols., Paris, 1956–58.

GÓMEZ-MORENO, M. E. *Escultura del Siglo XVII*, Barcelona, 1963. An exhaustive study on sculpture with important bibliographies.

KUBLER, G. and SORIA, M. *Art and Architecture in Spain and Portugal and their American Dominions, 1500–1800*, Harmondsworth, 1959. The most complete survey in English. Illustrations and bibliography.

KUBLER, G. *Arquitectura de los Siglos XVII y XVIII*, Barcelona, 1957.

LEES-MILNE, J. *Baroque in Spain and Portugal and its antecedents*, London, 1960. Should be used with caution.

LÓPEZ-REY, J. *Velázquez. A catalogue raisonné of his œuvre with an introductory study*, London, 1963. Essential for the art of Velázquez.

LOZOYA, Marquis of. *Historia del art hispanico*, 5 vols. to date, Barcelona, 1931–. For the minor arts.

WETHEY, H. E. *Colonial Architecture and Sculpture in Peru*, Cambridge, Mass., 1949.

Southern Netherlands

FIERENS, P. *L'Art en Belgique du Moyen Age à nos jours*, 2nd edition, Brussels, 1947.

GERSON, H. and KUILE, ter, E. H. *Art and Architecture in Belgium, 1600 to 1800*, Harmondsworth, 1960. A useful work, with good study of Rubens, illustrations, bibliography.

GREINDL, E. *Les peintres flamands de nature morte au XVIIème siècle*, Brussels, 1956. Thorough study of still-life painting.

HAIRS, M. L. *Les peintres flamands de fleurs au XVIIème siècle*, Brussels, 1955. Should be consulted for flower painting of the period.

PUYVELDE, VAN, L. *Rubens*, Brussels, 1952. A short but useful introduction to the painter. Bibliography.

THIÉRY, Y. *Le paysage flamand au XVIIème siècle*, Brussels, 1953.

United Provinces

BERGSTRÖM, I. *Dutch Still-Life Painting in the Seventeenth Century*. English edition, London, 1956. Should be consulted. Illustrations and bibliography.

GELDER, VAN, H. E. *Guide to Dutch Art*, The Hague, 1952. An excellent introduction to Dutch art. Consult sections on the period of the Baroque.

SWILLENS, P. T. A. *Johannes Vermeer, Painter of Delft*, Utrecht, 1950. An exhaustive study of Vermeer's painting.

VERMEULEN, F. A. J. *Handboeck tot de Geschiedenis der Nederlandsche Bouwkunst*, 4 vols., The Hague, 1928–41. Should be consulted for Dutch architecture of the period. 2 vols. of illustrations.

Germanic Countries

BOECK, W. *Joseph Anton Feuchtmayer*, Tübingen, 1948.

BOURKE, J. *Baroque Churches of Central Europe*, London, 1958. A very full manual of religious architecture in all the Germanic regions. Lists of the works of principal artists and a good bibliography.

DECKER, H. *Barockplastik in den Alpenländern*, Vienna, 1943.

DEHIO, G. *Geschichte der Deutschen Kunst*, Section III, 2 vols., Leipzig, 1931. Remains a work of great value on German art.

FEULNER, A. *Bayerisches Rokoko*, Münich, 1923.

FREEDEN, VON, M. H. *Balthasar Neumann, Leben und Werk*, Münich, 1962.

GRIMSCHITZ, B. *Johann Lucas von Hildebrandt*, Vienna, 1959.

LANDOLT, H., and SEEGER, T. *Schweizer Barockkirchen*, Frauenfeld, 1948.

LIEB, N., and DIETH, F. *Die Vorarlberger Barockbaumeister*, Münich, 1960. A study of the Vorarlberger families of architects, whose work is found all over central Europe and Germany.

LIEB, N., and HIRMER, M. *Barockkirchen zwischen Donau und Alpen*, Münich, 1953. A thorough survey, illustrations and lists of works of art.

POWELL, N. *From Baroque to Rococo*, London, 1959. A study of the development of Baroque architecture in Austria and Germany.

SCHOENBERGER, A. *Ignaz Günther*, Münich, 1954. Contains a *catalogue raisonné* of the sculptor's work.

SEDLMAYR, H. *Johann Bernard Fischer von Erlach*, Vienna, 1956

TINTELNOT, H. *Die Barocke Freskomalerie in Deutschland*, Münich, 1951.

Poland and Russia

ANGYAL, A. *Die Slawische Barockwelt*, Leipzig, 1961. This general study by a Hungarian professor is one of the few works on Baroque art in the Slav countries written in a language of Western Europe.

HAMILTON, G. H. *The Art and Architecture of Russia*, Harmondsworth, 1954. Useful for all the arts, but especially architecture. Bibliography and many illustrations.

RÉAU, L. *L'art russe*. Paris, 1945.

TALBOT RICE, T. *A Concise History of Russian Art*, London, 1963.

France

ADHÉMAR, H. *Watteau, sa vie, son œuvre*, Paris, 1950.

BLUNT, A. *Art and Architecture in France, 1500 to 1700*, Harmondsworth, 1953. The best introduction to the seventeenth century, including an important study on N. Poussin, illustrations and bibliography.

BLUNT, A., BAZIN, G., and STERLING, C. *Catalogue de l'exposition Nicholas Poussin*, 2nd edition, Paris, 1960. Important documentary material and bibliography.

BOURGET, P., and CATTAUI, G. *Jules Hardouin Mansart*, Paris, 1956.

DACIER, É. *L'art au XVIIIème siècle: époques Régence, Louis XV, 1715–1760*, Paris, 1951. Part of a series of 4 works which provide an excellent survey of the arts of the period. Also see the works of Mauricheau-Beaupré and Réau listed below.

FLORISOONE, M. *La peinture française. Le XVIIIème siècle*, Paris, 1948.

MAURICHEAU-BEAUPRÉ, C. *L'art au XVIIème siècle en France*, Parts I and II, Paris, 1952.

RÉAU, L. *L'art au XVIIIème siècle en France. Style Louis XVI*, Paris, 1952.

RÖTHLISBERGER, M. *Claude Lorraine*, 2 vols., New Haven, 1961. With a *catalogue raisonné* of the painter's work.

VERLET, P. *Versailles*, Paris, 1961.

England

CROFT-MURRAY, E. *Decorative Painting in England, 1537–1837*, London, 1962. Covers large-scale decorative painting from Early Tudor to Sir James Thornhill.

EDWARDS, R. and RAMSEY, L. G. G. editors. Connoisseur Period Guides: *The Stuart Period, 1603–1714*, London, 1957; *The Early Georgian Period, 1714–1760*, London, 1957; *The Late Georgian Period, 1760–1810*, London, 1961. Invaluable for the minor arts.

HYAMS, E. *The English Garden*, London, 1964.

MERCER, E. *English Art 1553–1625*, Oxford, 1962. Consult for the beginning of the period, bibliography.

SEKLER, E. F. *Wren and his place in European Architecture*, London, 1956.

SUMMERSON, J. *Architecture in Britain, 1530 to 1830*, Harmondsworth, 1953.

WATERHOUSE, E. *Painting in Britain, 1530 to 1790*, Harmondsworth, 1953. Covers the whole period, full bibliography.

WHINNEY, M. and MILLAR, O. *English Art 1625–1714*, Oxford, 1957. Exhaustive bibliography, well illustrated, but with far too few examples from the decorative arts.

Scandinavia

PAULSSON, T. *Scandinavian Architecture: Buildings and Society in Denmark, Finland, Norway and Sweden*, London, 1958.

RÉAU, L. *Histoire de l'expansion de l'art française. Pays Scandinaves, Angleterre, Pays-Bas*, Paris, 1931.

List of Illustrations

The author and publishers are grateful to the many official bodies, institutions, and individuals mentioned below for their assistance in supplying original illustration material.

30 *The Meal of St Charles Borromeo* by Daniele Crespi, *c.* 1628. Oil on canvas. Chiesa della Passione, Milan. Photo: Mansell-Alinari.

31 *Harbour Scene* by Salvator Rosa, 1639/40. Oil on canvas, 91¼ × 115¾. Palazzo Pitti, Florence. Photo: Scala.

32 *The Destruction of Sodom* by Monsù Desiderio. Oil on canvas. Collection of the Princess Sanfelice di Bagnoli, Naples. Photo: Gabinetto Fotographico Nazionale.

33 *Christ Expelling the Money Changers* by Luca Giordano, 1684. Fresco, Gerolomini, Naples. Photo: Mansell-Alinari.

34 Armchair of the early seventeenth century by A. Brustolon. Height, 49¼. Museo di Ca' Rezzonico, Venice. Photo: Museum.

35 Chapel of San Isidro from the Church of San Andres, Madrid, *c.* 1640, by P. de la Torre. Photo: Mas.

36 Granada Cathedral, façade designed by Alonso Cano, *c.* 1667. Photo: Mas.

37 *St Ignatius* by Juan Martínez Montañés, figure carved in wood polychrome. University Chapel, Seville. Photo: Mas.

38 *Pietà* by G. Fernández in wood polychrome, 1617, detail. Life-size. Valladolid Museum. Photo: Martin Hürlimann.

39 High Altar of La Caridad, Seville, with *Descent from the Cross* by P. Roldán, 1670, wood polychrome. Photo: Mas.

40 *The Immaculate Conception* by Alonso Cano, in wood polychrome, 1655. Height, 20. Sacristy, Granada Cathedral. Photo: Mas.

41 *St Agnes in Prison* by Ribera. Oil on canvas, 79½ × 59⅞. Formerly in Gemäldegalerie, Dresden. Photo: Museum.

42 *The Adoration of the Shepherds* by Zurbarán. Oil on canvas, 112¾ × 68⅞. Grenoble Museum. Photo: Museum.

43 *Eliezer and Rebecca* by Murillo. Oil on canvas, 42⅛ × 67⅞. Prado. Photo: Mas.

44 *Old Woman Cooking Eggs* by Velázquez, *c.* 1620. Oil on canvas, 39 × 46. Courtesy of the Trustees of the National Gallery of Scotland, Edinburgh. Photo: Thames and Hudson Archives.

45 *Prince Baltazar Carlos on his Pony* by Velázquez, *c.* 1634. Oil on canvas, 82¼ × 68⅛. Prado. Photo: Thames and Hudson Archives.

46 *The Artist's Family* by J. B. del Mazo. Oil on canvas, 58¼ × 68⅛. Kunsthistorisches Museum, Vienna. Photo: Museum.

47 *Battle of the Amazons* by Rubens, *c.* 1618. Oil on wood, 47⅝ × 65¼. Alte Pinakothek, Munich. Photo: Thames and Hudson Archives.

48 *The Château de Steen* by Rubens, *c.* 1635. Oil on wood, 54 × 92½. Courtesy of the Trustees of the National Gallery, London. Photo: Thames and Hudson Archives.

49 *The Birth of Louis XIII* by Rubens, *c.* 1623. Oil on canvas, 155⅝ × 116⅛. Medici Gallery, Louvre, Paris. Photo: Bulloz.

50 *Hélène Fourment and her Children* by Rubens, *c.* 1636/37. Oil on wood, 44½ × 32¼. Louvre, Paris. Photo: Bulloz.

51 *Portrait of Jean Grusset Richardot and his son* by Van Dyck. Early. Oil on wood, 43¼ × 29½. Louvre, Paris. Photo: Bulloz.

52 *The Four Evangelists* by Jordaens, *c.* 1620–25. Oil on canvas, 52½ × 46½. Louvre, Paris. Photo: Giraudon.

53 *The Annunciation* by T. van Loon, *c.* 1625. Oil on canvas. Scherpenheuvel Onze Lieve Vrouwekerk (Montaigu), Antwerp. Photo: Copyright A.C.L., Brussels.

54 *The Larder* by Snyders. Oil on canvas, 66⅝ × 114½. Musées Royaux des Beaux-Arts, Brussels. Photo: Copyright A.C.L., Brussels.

55 *Trophies of the Hunt* by J. Fyt. Oil on canvas, 61 × 59. Albert Newport Gallery, Zürich. Photo: Gallery.

56 *The Kitchen of the Archduke Leopold William* by David Teniers the Younger, 1644. Oil on copper, 22½ × 30⅝. Mauritshuis, The Hague. Photo: Museum.

57 *The Sleeping Peasant Girls* by J. Siberechts. Oil on canvas, 42½ × 33½. Alte Pinakothek, Munich. Photo: Museum.

58 *Madonna and Child in a Garland of Flowers* by D. Seghers. Oil on copper, 32½ × 24. Gemäldegalerie, Dresden. Photo: Museum.

277

59 *Sight*, one of the 'Allegories of the Senses' by Jan 'Velvet' Brueghel, 1617. Oil on canvas, 25⅝ × 42⅝. Prado, Madrid. Photo: Mas.

60 St Michael, Louvain, built by G. Hesius and others, 1650–71. Photo: Copyright A.C.L., Brussels.

61 The Tower of St Charles Borromeo, Antwerp. The church was built by F. Aguillon and P. Huyssens, *c.* 1620. Photo: Copyright A.C.L., Brussels.

62 *God the Father* by Artus Quellin II, *c.* 1682. Marble. From the rood screen of Bruges Cathedral. Photo: Copyright A.C.L., Brussels.

63 The Pulpit of St Peter and St Paul, Malines. Carved by H. F. Verbruggen, 1699–1702. Photo: Copyright A.C.L., Brussels.

64 The Westerkerk, Amsterdam, built from a plan by H. de Keyser, 1620. Photo: Rijksdienst v.d. Monumentenzorg.

65 The Mauritshuis, The Hague, built by J. van Campen and P. Post, 1633–44. Photo: Rijksdient v.d. Monumentenzorg.

66 Bust of Maria van Reygersberg (?) by R. Verhulst, in terracotta. Height 17¾. Rijksmuseum, Amsterdam. Photo: Museum.

67 *Women Governors of the Haarlem Almshouses* by Frans Hals, 1664. Oil on canvas, 67 × 98½. Frans Hals Museum, Haarlem. Photo: Thames and Hudson Archives.

68 *The Great Tree* by Hercules Seghers. Etching, 8⅝ × 11.

69 *The Supper at Emmaus* by Rembrandt, 1648. Oil on canvas, 16½ × 23⅝. Louvre, Paris. Photo: Thames and Hudson Archives.

70 *The Night Watch* or *The Company of Captain Frans Banning Cocq* by Rembrandt, 1642. Oil on canvas, 141⅜ × 172½. Rijksmuseum, Amsterdam. Photo: Thames and Hudson Archives.

71 *Self-Portrait* by Rembrandt, *c.* 1668. Oil on canvas, 32½ × 25⅞. Wallraf-Richartz Museum, Cologne. Photo: Museum.

72 *Vice-Admiral Jan de Liefde* by B. van der Helst, 1668. Oil on canvas, 54¾ × 48. Rijksmuseum, Amsterdam. Photo: Museum.

73 *Portrait of a Young Man* by G. Ter Borch, *c.* 1662. Oil on canvas, 26½ × 21⅜. By courtesy of the Trustees of the National Gallery, London. Photo: Museum.

74 *The Mill at Wijk Bij Duurstede* by Jacob van Ruisdael, *c.* 1670. Oil on canvas, 32⅝ × 39¾. Rijksmuseum, Amsterdam. Photo: Museum.

75 *A Young Woman Standing at a Virginal* by J. Vermeer, *c.* 1670. Oil on canvas, 20⅜ × 17 18⁄16. By courtesy of the Trustees of the National Gallery, London. Photo: Thames and Hudson Archives.

76 *Division of the Spoil* by J. Duck. Oil on wood, 21⅝ × 33¼. Louvre, Paris. Photo: Bulloz.

77 *View of the Westerkerk, Amsterdam* by J. van der Heyden. Oil on wood, 16 × 22⅝. By courtesy of the Wallace Collection, London. Photo: Museum.

78 *Interior of the Grote Kerk, Haarlem* by P. Saenredam, *c.* 1636. Oil on wood, 23 7⁄16 × 32⅛. By courtesy of the Trustees of the National Gallery, London. Photo: Museum.

79 *Still Life* by P. Claesz. Oil on wood, 25⅝ × 21¾. Gemäldegalerie, Dresden. Photo: Museum.

80 *The Sick Child* by G. Metsu, *c.* 1660. Oil on canvas, 13 × 10¾. Rijksmuseum, Amsterdam. Photo: Museum.

81 *View of Delft* by Vermeer, *c.* 1658. Oil on canvas, 38⅞ × 46⅜. Mauritshuis, The Hague. Photo: Museum.

82 Silver dish with scene of Diana and Actaeon by P. van Vianen. 16⅛ × 20½. Rijksmuseum, Amsterdam. Photo: Museum.

83 Dutch Tile Picture. Polychrome, height 42. By courtesy of the Victoria and Albert Museum, London. Photo: Museum.

84 Design for a Ceremonial Doorway by W. Dietterlin. Engraving from *Architectura*, 1594.

85 The Palace of Wallenstein, or Waldstein, Prague. Built by A. Spezza and others, 1623–29. Photo: Bildarchiv Foto Marburg.

86 Church of the Theatines, Münich. Built 1663–90 by A. Barelli, E. Zuccalli and others. Photo: Bildarchiv Foto Marburg.

278

87 *The Flight into Egypt* by A. Elsheimer, 1609. Oil on copper, 12⅛×16¼. Alte Pinakothek, Münich. Photo: Museum.

88 Interior of the Jesuit Church of St Peter and St Paul, Cracow. Built by G. Trevano, 1605–9. From *Sztuka Sakralna W/Polsce Architektura.*

89 The Church of the Virgin of the Sign, Dubrovitzy, built 1690–1704. Photo: Society for Cultural Relations with the U.S.S.R.

90 The iconostasis in the Cathedral at Polotsk. Photo: Thames and Hudson Archives.

91 Interior of the Chapel of the Jesuits, La Flèche by Le Père Martellange, early 17th century. Photo: Archives Photographiques, Paris.

92 The Chapel of the Sorbonne, Paris, by J. Le Mercier, 1629. Photo: Giraudon.

93 Château of Maisons-Laffitte by F. Mansart, 1642–50. Photo: Archives Photographiques, Paris.

94 Interior of the Oval Room, Château of Vaux-le-Vicomte. Built 1656–61 by L. Le Vau and decorated by C. Le Brun. Photo: Archives Photographiques, Paris.

95 Drawing by Bernini showing his first project for the East Front of the Louvre, 1664. Collection of Dr M. H. Whinney. Photo: by courtesy of the owner and the Courtauld Institute of Art.

96 The Colonnade, East Front of the Louvre, Paris. Designed, 1665 Photo: Giraudon.

97 Aerial view of Versailles. The Château was built 1623–88. Gardens designed by A. Le Nostre, begun in 1667. Photo: French Government Tourist Office.

98 Galerie des Glaces (Hall of Mirrors), Versailles. Designed by J. H. Mansart and decorated by C. Le Brun. Begun 1678. Photo: John Webb.

99 The Gardens of Versailles, general view. Photo: Martin Hürlimann.

100 The Grand Trianon, Versailles, by J. H. Mansart, 1687. Photo: John Webb.

101 *Milo of Crotona*, by P. Puget, 1671–83. Marble, height 106½. Louvre, Paris. Photo: Giraudon.

102 *Apollo and the Nymphs* by F. Girardon, 1666. Marble. Gardens of Versailles. Photo: Giraudon.

103 Model for the equestrian statue of Louis XIV by F. Girardon, c. 1669. Bronze. Louvre, Paris. Photo: Giraudon.

104 Bust of the Grand Condé by A. Coysevox. Bronze, height 23¼. Louvre, Paris. Photo: Giraudon.

105 *Wealth* by S. Vouet, c. 1640. Oil on canvas, 66⅞× 48⅞. Louvre, Paris. Photo: Giraudon.

106 *Death of St Bruno* by E. Le Sueur, c. 1647. Oil on canvas, 76×51⅛. Louvre, Paris. Photo: Bulloz.

107 *Ex Voto* by P. de Champaigne, 1662. Oil on canvas, 65×90¼. Louvre, Paris. Photo: Thames and Hudson Archives.

108 *The Guard* by M. Le Nain, 1643. Oil on canvas. Collection of the Baronne de Berckheim, Paris. Photo: Giraudon.

109 *The Forge* by L. Le Nain. Oil on canvas, 27⅛×22¼. Louvre, Paris. Photo: Giraudon.

110 *St Sebastian Attended by St Irene* by G. de La Tour. Oil on canvas. Church of Broglie, France. Photo: Thames and Hudson Archives.

111 *The Triumph of Flora* by N. Poussin, c. 1630. Oil on canvas, 65×94⅞. Louvre, Paris. Photo: Thames and Hudson Archives.

112 *The Finding of Moses* by N. Poussin, 1638. Oil on canvas, 36⅝×47¼. Louvre, Paris. Photo: Giraudon.

113 *Landscape with Polyphemus* by N. Poussin, 1649. Oil on canvas, 59 1/16×77 1/16. Hermitage, Leningrad. Photo: Museum.

114 *The Tiber above Rome* by Claude Lorraine. Wash drawing, 7½×10¼. Courtesy of the Trustees of the British Museum. Photo: John R. Freeman & Co.

115 *The Embarkation of the Queen of Sheba* by Claude Lorraine, 1648. Oil on canvas, 58½×76¼. By courtesy of the Trustees of the National Gallery, London. Photo: Eileen Tweedy.

116 *Adoration of the Shepherds* by C. Le Brun. Louvre, Paris. Photo: Giraudon.

117 *Louis XIV* by H. Rigaud, 1701. Oil on canvas, 109⅞×74¼. Louvre, Paris. Photo: Thames and Hudson Archives.

279

118 *Louis XIV Visiting the Gobelins Factory.* Gobelins Tapestry designed by C. Le Brun, *c.* 1665. Gobelins Museum, Paris. Photo: Giraudon.

119 Design by J. Berain. École des Beaux-Arts. Photo: Giraudon.

120 Rouen Pottery Dish with *lambrequin* decoration. Photo: Thames and Hudson Archives, Eileen Tweedy.

121 Boulle Commode made for the King's Room in the Trianon. Louvre, Paris. Photo: Giraudon.

122 The Queen's House, Greenwich, by Inigo Jones, 1615–16. Photo: Royal Commission on Historical Monuments.

123 Eltham Lodge, Kent, by Hugh May, *c.* 1664. Photo: Copyright *Country Life.*

124 Interior of St Bride's, Fleet Street, London, by Wren, 1670–84. Photo: A. F. Kersting (before bombing 1940).

125 St Paul's, London, by Wren, 1675–1712. Photo: Royal Commission on Historical Monuments.

126 Eastern Dome and Colonnade, Greenwich, by Wren, after 1716. Photo: Ministry of Works.

127 Castle Howard, Yorkshire, by Sir John Vanbrugh. Built 1699–1712. Photo: Copyright *Country Life.*

128 *Endymion Porter* by William Dobson, *c.* 1643. Oil on canvas, 59×50. By courtesy of the Trustees of the Tate Gallery, London. Photo: Thames and Hudson Archives.

129 *James Stuart, Duke of Richmond and Lennox* by Sir Anthony Van Dyck, *c.* 1639. Oil on canvas, 85×50¼. By permission of the Metropolitan Museum of Art, New York. Gift of Henry G. Marquand, 1889. Photo: Thames and Hudson Archives.

130 *Family of Charles Dormer, Earl of Carnarvon* by Sir Peter Lely, *c.* 1658/59. Oil on canvas, 84×60. By kind permission of the owner, Sir John Coote, Bt. Photo: Courtesy of Professor Ellis Waterhouse.

131 Silver ewer, gilt, by David Willaume. London hallmark for 1700–1. Height, 8½. By courtesy of the Victoria and Albert Museum, London. Photo: Museum.

132 Caffé Haus, Villa Albani, Rome by C. Marchioni, 1743–63. Photo: Alinari.

133 Interior of the Chapel of the Palace of Caserta by L. Vanvitelli, 1752. Photo: Mansell-Alinari.

134 Basilica of the Superga by F. Juvara, 1717–31. Photo: Alinari.

135 *Il Disinganno* by Francesco Queirolo. Marble. Capella Sansevero, Naples. Photo: Mansell-Alinari.

136 The Interior of the Oratory of San Lorenzo, Palermo by G. Serpotta. Stucco decorations, 1699–1706. Photo: Mansell-Anderson.

137 *The Extreme Unction* by Giuseppe Maria Crespi. Oil on wood, 26×21¾. Gemäldegalerie, Dresden. Photo: Museum.

138 *Reception on a Terrace* by A. Magnasco. Oil on canvas. Palazzo Bianco, Genoa. Photo: Thames and Hudson Archives.

139 *The Massacre of the Giustiniani at Chios* by F. Solimena. Oil on canvas, 108½×64½. Capodimonte Museum, Naples. Photo: Scala.

140 *The Feast of the Ascension, Venice,* by Canaletto. Aldo Crespi Collection, Milan. Photo: Thames and Hudson Archives.

141 *Nobleman with the Three-Cornered Hat* by V. Ghislandi, *c.* 1740. Oil on canvas, 42⅞×34¼. Poldi-Pezzoli Museum, Milan. Photo: Mansell-Alinari.

142 *The Institution of the Rosary* by Tiepolo, 1737–39. Fresco, ceiling of the Chiesa dei Gesuati, Venice. Photo: Alinari.

143 *Charles III Visits Benedict XIV at the Quirinale* by G. Pannini, 1776. Oil on canvas, 48½×68½. Capodimonte Museum, Naples. Photo: Scala.

144 *The Rio dei Mendicanti, Venice,* by F. Guardi. Oil on canvas, 7½×5⅞. Academia Carrara, Bergamo. Photo: Scala.

145 *Achilles on Scyros* by Pompeo Batoni. Oil on canvas. Uffizi, Florence. Photo: Mansell-Alinari.

146 Porcelain Room of the Palazzo Portici, Capodimonte Museum, Naples. Decorated in the *chinoiserie* style by G. and S. Grice, 1754–59. Photo: Scala.

147 Salon Oval, Hôtel Soubise, Paris. Decorated by G. Boffrand, 1738–39. Photo: John Webb.

148 Place de la Carrière, Nancy. Completed by Héré de Corny, 1753–55. Photo: Giraudon.

149 Part of the Place de la Bourse, Bordeaux, by J.-A. Gabriel, 1731–55. Photo: by courtesy of the French Government Tourist Office.

150 The Place de la Concorde, Paris, by J.-A. Gabriel, 1753–65. Photo: Martin Hürlimann.

151 Church of Ste-Geneviève, now the Panthéon, Paris, by J. Soufflot, 1755. Photo: Giraudon.

152 Pavilion of the Director, Salt-Mines, Arc-et-Senans, by C. Ledoux, 1773–75. Photo: Archives Photographiques, Paris.

153 The 'Hameau', Petit Trianon, Versailles, by R. Mique, 1780. Photo: Giraudon.

154 Bust of the Regent by J.-B. Lemoyne II. Marble. Versailles Museum. Photo: Giraudon.

155 *Cupid Making a Bow out of the Club of Hercules* by E. Bouchardon. Marble. Louvre, Paris.

156 *Diana* by Houdon. Marble. Height, 83. By courtesy of the Gulbenkian Foundation, Lisbon. Photo: Foundation.

157 Mausoleum of the Comte d'Harcourt by Pigalle. Marble. Notre-Dame, Paris. Photo: Giraudon.

158 *L'Enseigne de Gersaint* (sign for the picture dealer Gersaint) by Watteau,

1720. Oil on canvas, 64⅛ × 121¼. Staatliche Schlösser und Gärten, Berlin. Photo: Gallery.

159 *Embarquement pour Cythère* (Embarking for the Island of Venus) by Watteau, 1717. Oil on canvas, 50¾ × 76⅜. Louvre, Paris. Photo: Thames and Hudson Archives.

160 *Le Moulinet devant la charmille* (The Quadrille in front of the Beech Grove) by N. Lancret. Oil on canvas, 51¼ × 38¼. Staatliche Schlösser und Gärten, Berlin. Photo: Thames and Hudson Archives.

161 *Sylvia freed by Amyntas* by Boucher. Oil on canvas. Banque de France, Paris. Photo: Giraudon.

162 *Dog Guarding Game* by F. Desportes, 1724. Oil on canvas, 42½ × 55¼. Louvre, Paris. Photo: Giraudon.

163 *Madame Victoire as an Allegory of Water* by J. M. Nattier. Oil on canvas, 41¾ × 54¼. Museum of São Paulo, Brazil. Photo: Museum.

164 *Madame de Pompadour* by Maurice Q. de La Tour, 1752. Pastel on paper, 68⅝ × 50⅜. Louvre, Paris. Photo: Giraudon.

165 *Still Life with a Jar of Pickled Olives* by J. B. S. Chardin. Oil on canvas, 66⅞ × 78. Louvre, Paris. Photo: Archives Photographiques, Paris.

166 *The Broken Pitcher* by J.-B. Greuze. Oil on canvas, 43¼ × 33½. Louvre, Paris. Photo: Giraudon.

167 *The New Model* by J.-H. Fragonard. Oil on canvas, 20½ × 24⅜. Musée Jacquemart-André, Paris. Photo: Giraudon.

168 Silver tureen made for Don José of Portugal by François-Thomas Germain, 1757. Height 11¾. Museu Nacionale de Arte Antiga, Lisbon. Photo: Museum.

169 Commode made in 1739 for the Chambre de Roi, Versailles, by A. R. Gaudreaux. Ornaments in bronze by J. Caffieri. Oak veneered with kingswood, mahogany, etc. Top of Lavanto rosso marble. 35 × 77 × 31⅜. By courtesy of the Wallace Collection, London. Photo: Collection.

170 High altar of San Esteban, Salamanca, by José de Churriguera, 1693. Height over 90 ft. Gilded and polychrome wood. Photo: Mas.

171 San Luis, Seville, by Leonardo, Matías and José de Figueroa, 1699–1731. Façade and two bell towers. Photo: Mas.

172 Doorway of the Palace of the Marquis of Dos Aguas, Valencia, by Vergara, 1740–44. Photo: Mas.

173 Transparente, Toledo Cathedral, by N. Tomé, 1721–32. Photo: Mas.

174 The Royal Palace, Madrid, by F. Juvara and G. B. Sacchetti, 1735–64. Photo: Mas.

175 *The Duchess of Alba* by Goya, 1795. Oil on canvas, 76¼ × 51. Collection of the Duke of Alba, Madrid. Photo: Thames and Hudson Archives.

176 *The Family of Charles IV* by Goya, 1800. Oil on canvas, 110¼ × 132¼. Prado, Madrid. Photo: Thames and Hudson Archives.

177 Church of São Pedro dos Clerigos, Oporto, by N. Nazzoni, 1732–48. Photo: the Author.

178 Tile picture (*azulejos*), 1740–50. From the Cloister of São Vicente de Fora. Museu Nacionale de Arte Antiga, Lisbon. Photo: Mas.

179 Portal of the Church of San Lorenzo, Potosi, Bolivia, 1728–44. Photo: Mas.

180 *The Prophet Isaiah* by Aleijadinho, *c.* 1800. Soapstone. Terrace of the Church of the Bom Jesus de Matozinhos, Congonhas do Campo, Brazil. Photo: Mas.

181 Church of the Jesuit College, Salzburg, by J. F. von Erlach, 1696. Photo: Bildarchiv Foto Marburg.

182 Interior of the Dome, Karlskirche, Vienna, by J. F. von Erlach, 1716. Photo: Anton Macku, *Vienna*, Thames and Hudson.

183 Atlantes of the Sala Terrena, Upper Belvedere, Vienna by L. von Hildebrandt. Photo: Anton Macku, *Vienna*, Thames and Hudson.

184 Detail of the South Front, Palace of Sans Souci, Potsdam, by von Knobeldorff. Photo: Bildarchiv Foto Marburg.

185 Exterior of the Monastery of St Florian, Austria by J. Prandtauer, 1706–14. Photo: Martin Hürlimann.

186 Interior of the Residenz Theatre, Münich by F. Cuvilliès. Photo: Thames and Hudson Archives.

187 Central Section of the Zwinger, Dresden by D. Pöppelmann, 1709–18. Photo: Bildarchiv Foto Marburg.

188 Ceiling of the Pilgrimage Church at Steinhausen by Dominicus and Johann Baptist Zimmermann, begun *c.* 1727. Photo: Hirmer Foto Archiv, Münich.

189 Interior of the Church of Ottobeuren, Swabia, begun in 1736 by J. M. Fischer and others. Photo: Hirmer Foto Archiv, Münich.

190 Staircase of the Palace of Brühl, Rhineland, by Neumann, 1743–48. Photo: Bildarchiv Foto Marburg.

191 *The Assumption of the Virgin* by E. Q. Asam, 1717–25. Marble. Church of Rohr, Bavaria. Photo: Hirmer Foto Archiv, Münich.

192 Detail of the stucco decorations of the Church of Neu Birnau by Josef Anton Feuchtmayer, 1747–49. Photo: Württemberg Archives, Stuttgart.

193 *Providence* by Georg Raphael Donner, from the Mehlmarkt Fountain, Vienna, 1738. Original, lead. Austrian Baroque Museum, Vienna. Photo: Reclam Jun. Verlag, Stuttgart.

194 Detail from fresco by J. G. Bergmüller, Church of Steingaden. Photo: F. Bruckmann Verlag, Münich.

195 *St Peter and St Paul Driving Out the Evil Spirits* by Matthäus Günther, 1775. Fresco from the ceiling of the Parish Church of Goetzen, Tyrol. Photo: F. Bruckmann Verlag, Münich.

196 Lazienki Palace, Warsaw, by Merlini, 1784. Photo: Polish Cultural Institute, London.

197 Imperial Palace, Tsarkoie-Selo (Pushkin), by Rastrelli. Photo: Gassilov.

198 Interior of the Hermitage Theatre, Leningrad, by G. Quarenghi. Photo: National Museum of the Hermitage.

199 Equestrian statue of Peter the Great, Leningrad, by Falconet, 1766–78. Bronze. Photo: Thames and Hudson Archives.

200 Place Royale, Brussels, designed by N. Barré and executed by B. Guimard. Begun 1776. Photo: Copyright A.C.L., Brussels.

201 Royal Library, The Hague, by D. Marot, 1734. Photo: Rijksdienst v.d. Monumentenzorg.

202 'Loquebantur Omnes' (and so they all fell to talking) by C. Troost, 1740. Pastel on paper, 22½ × 48¾. No. 3 of a set of six. Mauritshuis, The Hague. Photo: Museum.

203 Equestrian statue of Frederick V by J. Saly, Copenhagen, 1768. Bronze. Photo: National Travel Association of Denmark.

204 Frederick V by C. G. Pilo. Oil on canvas, 33½ × 26¾. National Museum, Stockholm. Photo: Museum.

205 *The Lady with the Veil* by A. Roslin, 1768 (Suzette Gironist, the artist's wife). Oil on canvas, 25¼×21¼. National Museum, Stockholm. Photo: Thames and Hudson Archives.

206 Mereworth Castle, Kent, by Colen Campbell, 1722–25. From the south-west. Photo: National Buildings Record.

207 Royal Crescent, Bath, by John Wood II, 1767–75. Photo: Thames and Hudson Archives.

208 Music Room, 20 Portman Square, London. Decorated by Robert Adam for the Countess of Home, 1775–77. Photo: Copyright *Country Life*.

209 *View of Snowdon* by R. Wilson, *c.* 1770. Oil on canvas, 39½×48⅝. Courtesy of the Walker Art Gallery, Liverpool. Photo: Thames and Hudson Archives.

210 *The Morning Walk* by Gainsborough, 1786. Oil on canvas, 93×70½. By courtesy of the Trustees of the National Gallery, London. Photo: Thames and Hudson Archives.

211 *Shortly After the Marriage*, No. 2 of 'Marriage à la Mode' by Hogarth, 1743. Oil on canvas, 27½×35¾. By courtesy of the Trustees of the National Gallery, London. Photo: Thames and Hudson Archives.

212 *The Death of Dido* by Reynolds, 1781. Oil on canvas, 55⅞×94⅛. Reproduced by gracious permission of H.M. the Queen. Photo: A. C. Cooper.

213 *The Forest* or *Cornard Wood* by Gainsborough, finished 1748. Oil on canvas, 48×61. By courtesy of the Trustees of the National Gallery, London. Photo: Gallery.

214 *Lady Hamilton as a Bacchante* (study) by Romney, *c.* 1786. Oil on canvas, 19½×15¾. By courtesy of the Trustees of the Tate Gallery, London. Photo: Gallery.

215 Side chair of Cuban or Honduran mahogany, *c.* 1740. 39×26½×32½. By kind permission of Judge Irwin Untermyer and the Metropolitan Museum of Art, New York. Photo: Museum.

216 Silver Tea Caddy made by Paul de Lamerie, 1735–36. Height 5¼. By courtesy of the Victoria and Albert Museum, London. Photo: Museum.

217 The Richmond Cup. Silver Gilt. Designed by Robert Adam and made by D. Smith, 1770. Height 19. Lent by His Grace the Marquess of Zetland to the Bowes Museum, Barnard Castle, Durham. Reproduced with the kind permission of the owner and the museum. Photo: Museum.

218 Vase by Wedgwood, designed by Flaxman, *c.* 1789. Height 18. By courtesy of the Castle Museum, Nottingham. Photo: by courtesy of the Trustees of the Victoria and Albert Museum, London.

Index

Italic titles indicate works of art and publications, italic figures denote page number of illustration

285

286

287